Heian Temples:
Byodo-in and Chuson-ji

Volume 9

THE HEIBONSHA SURVEY OF JAPANESE ART

For a list of the entire series see end of book

CONSULTING EDITORS

Heian Temples: Byodo-in and Chuson-ji

by TOSHIO FUKUYAMA

translated by Ronald K. Jones

New York · WEATHERHILL / HEIBONSHA · Tokyo

This book was originally published in Japanese by Heibonsha under the title *Byodo-in to Chuson-ji* in the Nihon no Bijutsu series.

A full glossary-index covering the entire series will be published when the series is complete.

First English Edition, 1976

Jointly published by John Weatherhill, Inc., 149 Madison Avenue, New York, New York 10016, with editorial offices at 7-6-13 Roppongi, Minato-ku, Tokyo 106, and Heibonsha, Tokyo. Copyright © 1964, 1976, by Heibonsha; all rights reserved. Printed in Japan.

Library of Congress Cataloging in Publication Data: Fukuyama, Toshio, 1905– / Heian temples, Byodo-in and Chuson-ji. / (The Heibonsha survey of Japanese art; v. 9) / Translation of Byōdōin to Chūsonji. / 1. Pure Land Buddhism in art. 2. Art, Japanese—Heian period, 794–1185. I. Title. II. Series. / N8193.3.P8F8413 / 726'.1'43920952 / 75-41337 / ISBN 0-8348-1023-9

Contents

Heian Temples:
Byodo-in and Chuson-ji

The Pure Land Art of the Heian Period

INTRODUCTION OF AMIDISM Faith in Amida (the Buddha Amitabha) as savior of mankind seems to have reached Japan about the middle of the seventh century A.D. The *Daido Engi* (Legends Recorded in the Daido Era) of the Shitenno-ji temple in Osaka tells us that the Amida triad (a statuary group of Amida and two attendant bodhisattvas) in the temple's Golden Hall was brought from T'ang China (618–c. 907) by the Japanese monk Eko. Eko made his return to Japan in 623 accompanied by an envoy from the Korean kingdom of Silla (57 B.C.–A.D. 935). The *Nihon Shoki* (Chronicles of Japan; 720) tells us that a golden stupa, relics, and large and small ceremonial banners for ordination services—the items the king of Silla presented to the Japanese court on that occasion—were donated to the Shitenno-ji. There is room for suspicion, however, that the compilers of the *Daido Engi*, written centuries after Eko's time, used the reference in the *Nihon Shoki* as a convenient peg upon which to hang their tale. Eko's donation of the triad therefore still awaits authentication, but we would be remiss in omitting mention of this venerable tradition.

Almost contemporary with Eko was Eon. He began his studies in China in 608 and saw the fall of the Sui dynasty (581–618). Extending his sojourn until well into the T'ang period, he returned to Japan in 639 with an envoy from Silla. The following year he preached on the important Amidist scripture *Muryoju-kyo* (Sutra on the Infinite Life of the Buddha Amida) either at the Umayasaka palace of Emperor Jomei (r. 629–41) near Asuka in what is now central Nara Prefecture, or at the Kudara-no-odera, a monastery in Nara now called the Daian-ji. These events provide a clue to dating the introduction into Japan of Amidism—the doctrine that faith in Amida was sufficient for believers to gain entry into the Western Paradise, the "pure land" (*jodo*) of the Buddha Amida. In 652 Eon's presence was requested at the imperial court in Naniwa (present-day Osaka), the city Emperor Kotoku (r. 645–54) had selected as the new capital. Here again Eon expounded the *Muryoju-kyo,* over a period of six days. Held before an audience of one thousand monks, with Eshi as "debating interlocutor," this presentation was more explicit than the previous one, and the court seems to have shown much greater interest. The gilt-bronze half-*joroku* Amida triad once housed in the refectory of the Yakushi-ji in Nara is said to have been commissioned by Emperor Kotoku. (*Joroku,* "sixteen Japanese feet," or approximately five meters, was the traditional height for statues of buddhas and bodhisattvas, measuring from the base to the forehead hairline.) If this tradition is true, the implica-

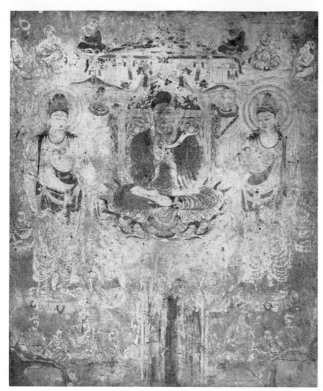

1. *Amida's Pure Land, mural on west wall (panel 6) of Horyu-ji Golden Hall. Height, 312 cm.; width, 266 cm. Late seventh century. Ikaruga, Nara Prefecture.*

tion that the three statues were made under Eon's directorship would lend them significance as the earliest Amida triad produced in Japan; but again, the historical validity of this claim is doubtful.

The small mandorla of a buddha image at the Kanshin-ji in Kawachi Nagano, near Osaka, bears an inscription suggesting that a widow commissioned a small Amida image in 658 as an offering for her departed husband's rebirth in the Pure Land. (It should be noted that although the term "pure land" technically refers to the world of any buddha or bodhisattva, specifically it means that of Amida, the Western Paradise.) Likewise, at the Sairin-ji in Habikino, also near Osaka, a small Amida triad was made in the "fifth year of Hogen," a date by an unofficial era name that seems to correspond to 659. This information is based on a mandorla inscription recorded in the *Sairin-ji*

Bun'ei Chuki (Sairin-ji Bun'ei-Era Statement of Property; 1271). That the inscription includes passages of varying degrees of antiquity considerably weakens its historical value. These irregularities aside, we may take it that Amidist image making had become common in Japan by the middle of the seventh century.

THE APPEARANCE OF PURE LAND ART The Yakushi-ji in Nara once kept in its lecture hall an embroidered picture roughly nine meters high and six meters wide that depicted an Amida triad in the center with over one hundred surrounding angels. The embroidery is held to have been commissioned by Empress Jito (r. 690–97) for the repose of the soul of her husband, Emperor Temmu (r. 673–86), and to have been donated to the temple in 692. This

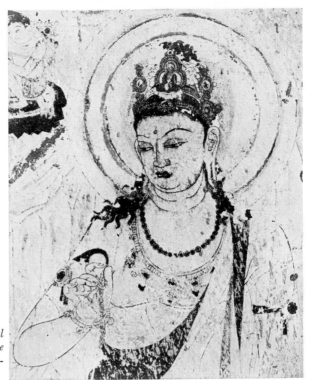

2. *Bodhisattva Kannon, detail from mural on west wall (panel 6) of Horyu-ji Golden Hall. Dimensions of entire painting (see Figure 1): height, 312 cm.; width, 266 cm. Late seventh century. Ikaruga, Nara Prefecture.*

is the oldest and largest pictorial representation of Amida's Pure Land to be made in Japan that has been definitely dated.

In the Horyu-ji Golden Hall in Ikaruga, Nara Prefecture, the murals on the west wall (Figs. 1, 2) exemplified the beauty of the art of the Hakuho, or Early Nara, period (646–710) until their destruction by fire in 1949. They are believed to have been contemporary with the embroidered Pure Land representation at the Yakushi-ji.

The bronze Amida triad formerly in the Horyu-ji Golden Hall and later given the spurious name of Lady Tachibana's Votive Buddhas (Fig. 3) is another exquisite example of Hakuho art. Each figure sits on a lotus blossom flowering in the rippling Pond of Ablution. The bas-relief on the reredos shows a scene from the *Muryoju-kyo* (also called *Dai Muryoju-kyo*) in which pious devotees reborn

as bodhisattvas in the lotus blossoms representing the Seven Treasures of Buddhism are seated with their legs folded, while manifest buddhas (buddhas who manifest themselves in earthly form to help others achieve rebirth in the Pure Land) are ranged above. The work is a typical Amida *jodohen* (representation of Amida's Pure Land) in the sculptural medium. The base of the small shrine containing this work (Fig. 4) also shows pictures of reborn beings on lotus blossoms.

In the Tempyo, or Late Nara, period (710–94) interest in the Pure Land deepened. Our attention is first drawn to a sculpture group executed in 730 and enshrined in the five-story pagoda of the Kofuku-ji in Nara. Part of a set showing the Buddhas of the Four Directions, of which Amida is one, this *jodohen* comprised Amida attended by two buddhas and two bodhisattvas, eight chanting bo-

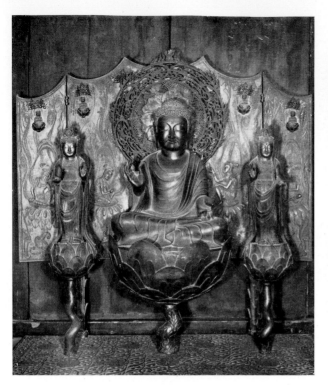
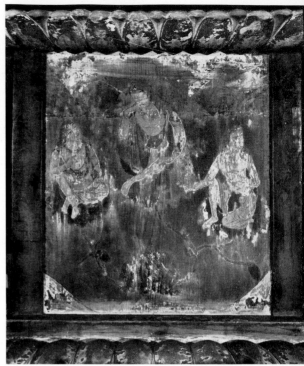

dhisattvas, two bodhisattvas accompanied by manifest buddhas, and eight bodhisattvas holding lotus seats, as well as representations of bird and plant life and an ornate censer.

The *jodohen* in the Amida Hall, added in 741, was contained in a lacquered octagonal structure about five meters high set on a two-tiered wood pedestal. The work comprised a gilded Amida triad, a group of ten chanting bodhisattvas, and a pair of arhats (enlightened sages) holding censers. Birds, clouds, and flowers were worked in powdered gold and silver on the canopy, and a large lotus was affixed at its center. On the upper face of the top tier of the pedestal, a design of a pond and its shore was worked in colored glass. These were complemented by copies of the *Amida-kyo* (also called *Sho Muryoju-kyo*), *Kan Muryoju-kyo,* and *Sokan Muryoju-kyo* sutras and an assortment of ritual utensils and decorations. Later this hall was included in the precincts of the Todai-ji, built not long after

the Kofuku-ji, and was known as the new temple's South Amida Hall; but it was destroyed, probably in a typhoon, in 989. The pedestal was then moved to the Todai-ji's Lotus Hall (also called the Third Month Hall), where it has since served as the base for the hall's principal image, Fukukenjaku Kannon (Amoghapasa; Fig. 5).

The *Shoso-in Monjo* (Records of the Shoso-in Treasury) mentions the construction of the Amida Jodo-in, a subtemple erected within the precincts of the Nara temple Hokke-ji. The construction, we are told, spanned the years 759 and 760. The hall of the subtemple was fairly large, similar in size and style to the Toshodai-ji Golden Hall, also in Nara. In the *moya,* the core section of the building where the altar was placed, the ceiling of the Amida Jodo-in hall was decorated with five wooden lotuses, each about two meters in diameter, three of which had mirrors in the center; the rest of the interior, called *hisashi,* which forms four aisles around

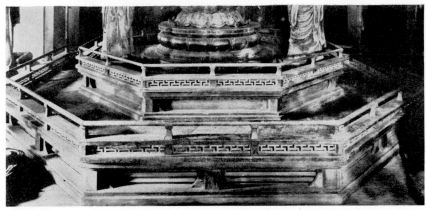

5. *Pedestal formerly in shrine housing representation of Amida's Pure Land, now used as pedestal for image of Fukukenjaku Kannon. Longest diameter of lower tier, 6.36 m. 741. Todai-ji Lotus Meditation Hall, Nara.*

◁ *3 (opposite page, left). Amida triad in Lady Tachibana's Shrine. Gilt bronze; height of Amida image, 33.3 cm. Second half of seventh century. Horyu-ji, Ikaruga, Nara Prefecture.*

◁ *4 (opposite page, right). Reborn beings on lotuses, painting on base of Lady Tachibana's Shrine. Colors on wood; height, 55 cm.; width, 51 cm. Late seventh or early eighth century. Horyu-ji, Ikaruga, Nara Prefecture.*

the *moya,* had on the ceiling fourteen such blossoms, each one and a half meters across. Inside the *moya,* or altar space, the upper walls bore twenty-eight seated images of celestial musicians, each about sixty centimeters high, and ninety clouds. The *joroku* statues of the Amida triad combined with these elements to form a brilliant re-creation of the land of bliss, the Western Paradise.

During the construction of the Amida Jodo-in its patron, Empress Dowager Komyo (701–60), died, and the following year, when the subtemple was completed, her memorial service was held there. The memorial activity went far beyond the ordinary: pictures of the Pure Land were painted in every province; for her forty-ninth-day observances copies of the *Shosan Jodo-kyo,* a newly translated version of the *Amida-kyo,* were dedicated at the *kokubunji* (literally, "provincial temple"), or tutelary temple, of each province; and at each *kokubunniji* (tutelary nunnery) *joroku* statues of Ami-

da with attendant bodhisattvas were enshrined.

In 761 Fujiwara no Nakamaro* (706–64), who had become prime minister soon after receiving the name Emi no Oshikatsu from the court, built the West Hall in the Kofuku-ji's To-in (East Precinct), with an image of Kannon as its principal object of worship, and in the same year commissioned an embroidered Amida *jodohen* to be hung on the hall's east wall in prayer for the soul of the empress dowager. This hall survived until the storm of 989. In 760 the Indian missionary priest Bodhisena (704–60), who had come to Japan via China and had greatly influenced Japanese Buddhism, bequeathed his personal property to the temple at his death, with instructions to make an Amida *jodohen* from it. Thus we can safely say that

* The names of all premodern Japanese in this book are, as in this case, given in Japanese style (surname first); those of all modern (post-1868) Japanese are given in Western style (surname last).

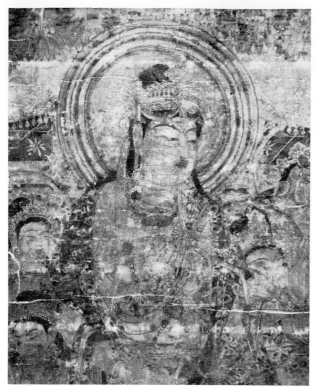

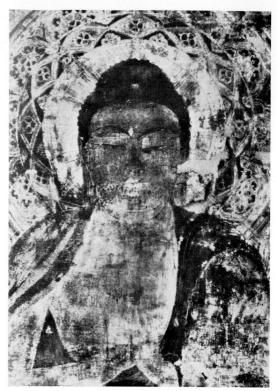

6. *Bodhisattva Seishi, detail from Taima Mandala. Tapestry; dimensions of entire work: height, 391 cm.; width, 397 cm. Second half of eighth century. Taima-dera, Taima, Nara Prefecture.*

7. *Buddha Amida, detail from Chiko Mandala. Colors on wood; dimensions of entire painting: height, 214 cm.; width, 195 cm. Late twelfth century. Gokurakubo, Gango-ji, Nara.*

in the Nara period the Amidist Pure Land faith was at its height around the years 760–61.

About this time a monk of the Gango-ji in Nara called Chiko contributed greatly to the doctrinal development of Pure Land Buddhism in Japan with his commentaries on the *Muryoju-kyo.* An Amida *jodohen,* later reputed to have been painted at his order to recall a scene that came to him in a dream, has become famous as the Chiko Mandala (Figs. 7, 137) through its mention in the late-tenth-century work *Nihon Ojo Gokuraku-ki* (Japanese Tales of Rebirth in the Paradise) and subsequent writings. Its composition is much simpler than that of the Taima Mandala, to which we will come in a moment, and consists of a seated Amida, his hands together

in prayer, and his two attendants in the "half lotus" posture, surrounded by adoring bodhisattvas on clouds. Its background shows imposing buildings, while in its foreground appear a lotus pond, reborn beings, six bodhisattvas singing and dancing on a stage, and two monks. The work is no doubt a direct descendant of the rigorously symmetrical *jodohen* much in vogue in T'ang China.

The Taima Mandala (Fig. 6), a tapestry *jodohen* belonging to the Taima-dera temple in Taima, Nara Prefecture, is in the style of the Mature T'ang culture. Made in China sometime in the latter half of the eighth century, it was brought to Japan toward the end of that century. Based on the *Kan Muryoju-kyo* with some modifications according to

8 (above). Jogyo-*meditation hall (left) and lotus-meditation hall (right) of Enryaku-ji. Length of each façade, 12.38 m. Mid-sixteenth century. Enryaku-ji West Compound, Mount Hiei, Otsu, Shiga Prefecture.*

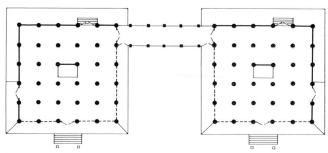

9. *Floor plan of* jogyo- *and lotus-meditation halls of* Enryaku-ji.

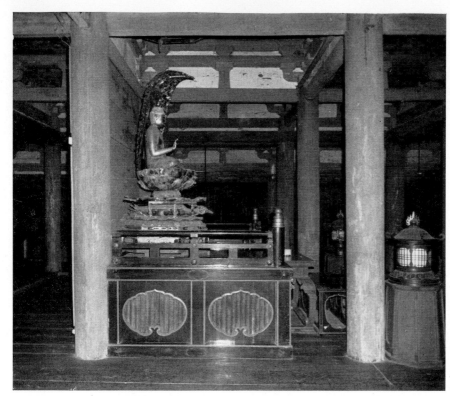

10. *Interior of Enryaku-ji Jogyo Meditation Hall. Intercolumniation, 2.73 m. Mid-sixteenth century. Enryaku-ji West Compound, Mount Hiei, Otsu, Shiga Prefecture.*

other works, including a commentary on the sutra by the Chinese Pure Land priest Shan-tao (613–81), this mandala had great influence on Japanese Pure Land doctrines in later years.

The enlightenment one achieves when reborn in Amida's Pure Land has customarily been divided into three classes, each further divided into three ranks, according to the degree of one's devotion before death. In the original mandala, the nine scenes on the lower border representing these nine categories have long decayed, and we are forced to turn to replicas (Fig. 138) from the Kamakura period (1185–1333) and later. But if the original scenes were indeed similar to the copies, the work certainly merits attention, for it would be the first Japanese representation of the *kuhon ojo,* the nine categories of rebirth. Doubtless the Kofuku-ji set of *kuhon-ojo* pictures, recorded as having been pre-

sented to Imperial Adviser Fujiwara no Tadahira (880–949) in 945, was of this type.

CONSTRUCTION OF MEDITATION HALLS

Buddhist historians have identified three principal branches of Pure Land doctrine in the Heian period: the Nara (or Southern Capital), the Shingon, and the Tendai, of which the Tendai was the most influential. In the time of its founder, Saicho (767–822), the rule of the Tendai order included four different types of meditation—the *hokke* (lotus), the *jogyo* (ambulatory), the *joza* (seated), and the *zuijii* (voluntary)—but only the lotus and *jogyo* forms of meditation were transmitted to later times. At the Enryaku-ji, the Tendai headquarters on Mount Hiei in Otsu, Shiga Prefecture, the first meditation hall, built in 812, was of the lotus type. This is only natural, considering

11. *Interior of lotus-meditation hall of Enryaku-ji West Compound, detail from scroll 10 of Honen Shonin Eden (Pictorial Biography of Saint Honen). Colors on paper; width of scroll, 32.8 cm. Early fourteenth century. Chion-in, Kyoto.*

the importance the Tendai sect attached to the *Myoho Renge-kyo* (The Sutra of the Lotus Flower of the Wonderful Law), or *Lotus Sutra*. The claim that a *joza*-meditation hall was built in Enryaku-ji's East Compound in 818 is doubtful, but a biography of the Tendai priest Ennin (794–864) notes that in 823 he withdrew to Mount Hiei and for six years practiced meditation nightly, implying that a *joza*-meditation hall did exist at the time.

Ennin studied *nembutsu-zammai* (meditation while invoking Amida's name) in 840 after the methods of the Chinese priest Fa-chao (died c. 822) at the Chinese T'ien-t'ai (Tendai) temple Chulin-ssu on Mount Wu-t'ai in northern Shansi, and after returning to Japan, applied these methods in beginning *jogyo* meditation on Mount Hiei in 851. The *jogyo*-meditation hall that he used seems to have been located originally on a site in front of

the Kompon Chudo, the main hall of the East Compound, whence in 883 it was moved north of the lecture hall to be renovated. This was during the time of Ennin's disciple Abbot So-o. Since the principal image of the meditation hall was an Amida and since Amida *nembutsu* (invocation) was recited there, it was also called the Mida (a variant of Amida) Meditation Hall and, as such, exerted a great influence in later years. There are hints that a *zuijii* meditation hall was built by Emperor Seiwa (r. 858–76) in the 860s, but details are unknown.

In 867 Ennin received various Buddhist implements from Te-yuan, abbot of a temple in Wenchou, Chekiang. Among the items was an embroidered *jodohen* about seven meters long and four and a half meters wide, one of four hundred made by Empress Dowager Wu (r. 684–704), who was a zealous Buddhist herself. So that people might view

it Ennin decided to hang the embroidery from the eaves of the Enryaku-ji pagoda annually around the time of the "relic convocation" that he had begun holding in the fourth month. Probably similar to the Taima Mandala in composition, this work may have had some influence on Pure Land art in Japan.

Tradition has it that the lotus-meditation hall in the Enryaku-ji West Compound was built by Ennin, Encho, and Enshu as early as 825, and that the *jogyo*-meditation hall was built much later, in 893, by Zomei. In the temple's Yokawa Compound—whose main hall, the Shu Ryogon-in, Ennin had built around 825–35 for the practice of the four types of meditation—a lotus-meditation hall is believed to have been raised in 954 by Minister of the Right Fujiwara no Morosuke and placed under the administration of the priest Ryogen (912–85). A *jogyo*-meditation hall followed soon afterward. Thus the period from the early ninth to the mid-tenth century saw the completion of halls for both lotus and *jogyo* meditation in all three major compounds of the Enryaku-ji. Both types of hall stood on a square plan measuring five bays on a side, with roofs in a pyramidal style.

The lotus halls enshrined various items: one housed a gilt-bronze Taho pagoda, containing an image of the Buddha Taho (Prabhutaratna) and a copy of the *Lotus Sutra;* another, a *Lotus Sutra* and images of both Amida and Bodhisattva Fugen (Samantabhadra); and the third, a *Lotus Sutra* and only the image of Fugen. The *jogyo* hall enshrined a seated figure of Amida wearing a coronet and images of the bodhisattvas Kongoho, Ri, In, and Go—a grouping that originated in the Mandala of Dainichi's Diamond World—but the Yokawa *jogyo* hall substituted another group of bodhisattvas: Kannon (Avalokitesvara), Seishi (Mahasthamaprapta), Jizo (Ksitigarbha), and Ryuju (Nagarjuna). The walls of the East Compound *jogyo* hall bore pictures of the *kuhon ojo* and portraits of eminent priests that are of unknown date, but the Pure Land paintings executed by order of Zomei on the West Compound *jogyo* hall's walls and pillars are known to date from 927. The halls in the East and Yokawa precincts have since been destroyed, but

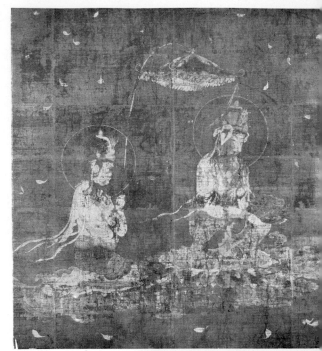

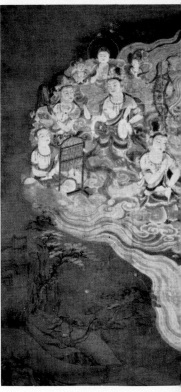

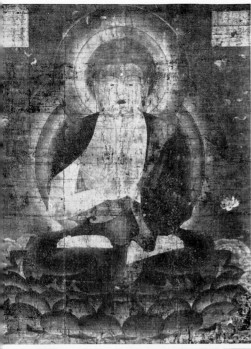

12. *Triptych showing Amida triad and cherub.*
Colors on silk. Center panel (see Figure 34):
height, 186.7 cm.; width, 143.3 cm.; first half of
eleventh century. Left panel: height, 187.9 cm;
width, 171.2 cm.; twelfth century. Right panel:
height, 183.6 cm.; width, 52.1 cm.; twelfth cen-
tury. Hokke-ji, Nara.

13 *(below). Triptych showing* raigo *of Buddha*
Amida and celestial host. Colors on silk; center
panel (see Figure 36): height, 210.8 cm.; width,
210.6 cm.; right and left panels: height, 210
cm.; width, 105.2 cm. Twelfth century. Yushi
Hachimanko Juhakka-in, Kongobu-ji, Mount
Koya, Wakayama Prefecture.

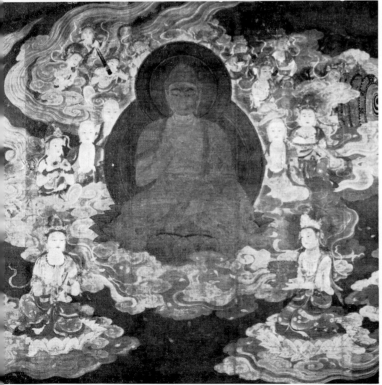
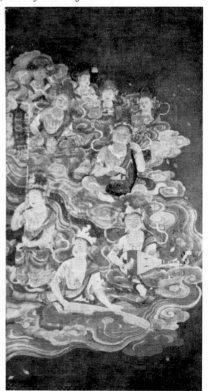

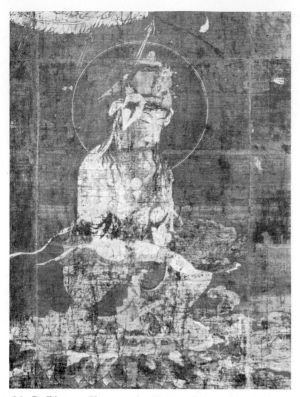

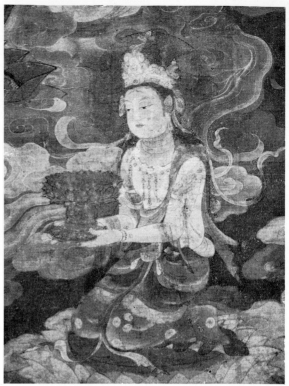

14. *Bodhisattva Kannon, detail from left panel of triptych (see Figure 12) showing Amida triad and cherub. Colors on silk; dimensions of this panel: height, 187.9 cm.; width, 171.2 cm. Twelfth century. Hokke-ji, Nara.*

15. *Bodhisattva Kannon, detail from center panel (see Figure 36) of triptych (see Figure 13) showing* raigo *of Buddha Amida and celestial host. Colors on silk; dimensions of this panel: height, 210.8 cm.; width, 210.6 cm. Twelfth century. Yushi Hachimanko Juhakka-in, Kongobu-ji, Mount Koya, Wakayama Prefecture.*

in the West Compound two halls of identical size and style remain standing abreast on high ground in front of the Shaka hall: the lotus-meditation hall on the east and the *jogyo*-meditation hall on the west, connected by a corridor at the rear (Figs. 8, 9). A comparison of these halls with a picture in the Kamakura-period work *Honen Shonin Eden* (Pictorial Biography of Saint Honen; Fig. 11) confirms that the present buildings (Fig. 10), though rebuilt in the mid-sixteenth century, are faithful to the original structures. Floor plans of the two Yokawa halls included in the Kamakura-period chronicle *Mon'yoki* show a one-bay-wide room attached to the rear of each of the five-bay-square structures.

EARLY MASTERS OF THE HEIAN PURE LAND DOCTRINE

At the turn of the tenth century a number of monks labored with great energy to spread the Pure Land doctrine. From about the 920s the Tendai priest Kuya (903–72) started making pilgrimages to the major temples and sacred caves throughout the country and, like Gyoki (668–749) in the Nara period, repaired roads, erected bridges, dug wells, and otherwise assisted the populace, bringing Buddhist doctrine even to the remotest regions of northern Japan. Because he held services among the people for the salvation of all men, he was called the Saint of the Common Folk. He was also known

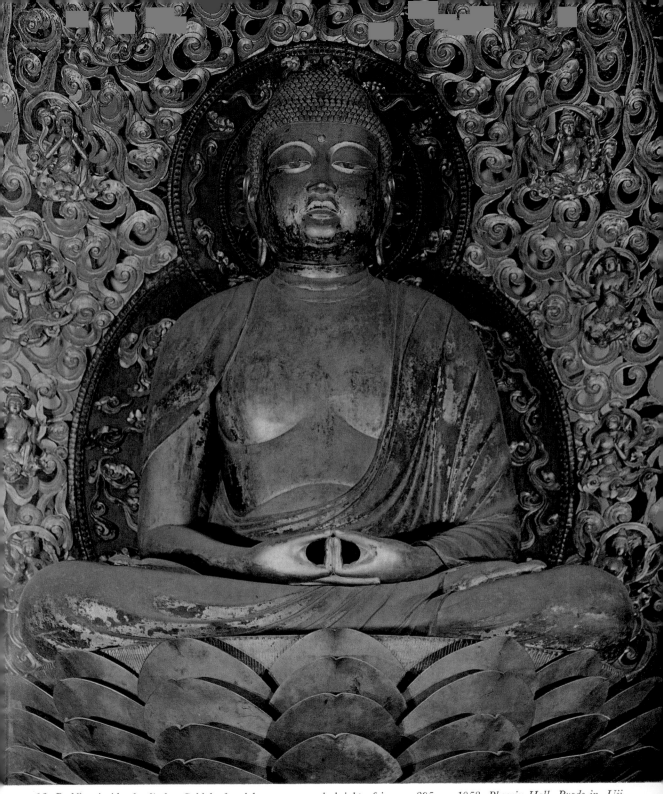

16. Buddha Amida, by Jocho. Gold leaf and lacquer on wood; height of image, 295 cm. 1053. Phoenix Hall, Byodo-in, Uji, Kyoto Prefecture.

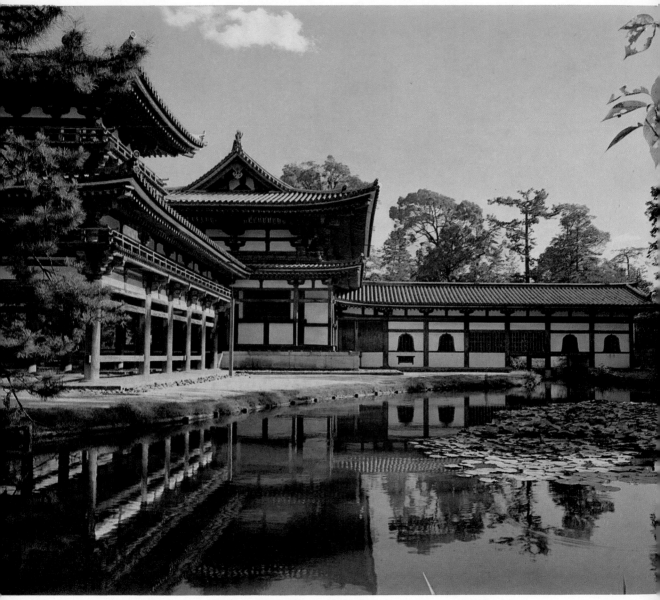

17. Northern view of Phoenix Hall. 1053. Byodo-in, Uji, Kyoto Prefecture.

18. Northwest corner of central structure of Phoenix Hall. 1053. Byodo-in, Uji, Kyoto Prefecture. ▷

19 (overleaf). Façade of Phoenix Hall. Length, 48.78 m. 1053. Byodo-in, Uji, Kyoto Prefecture. ▷

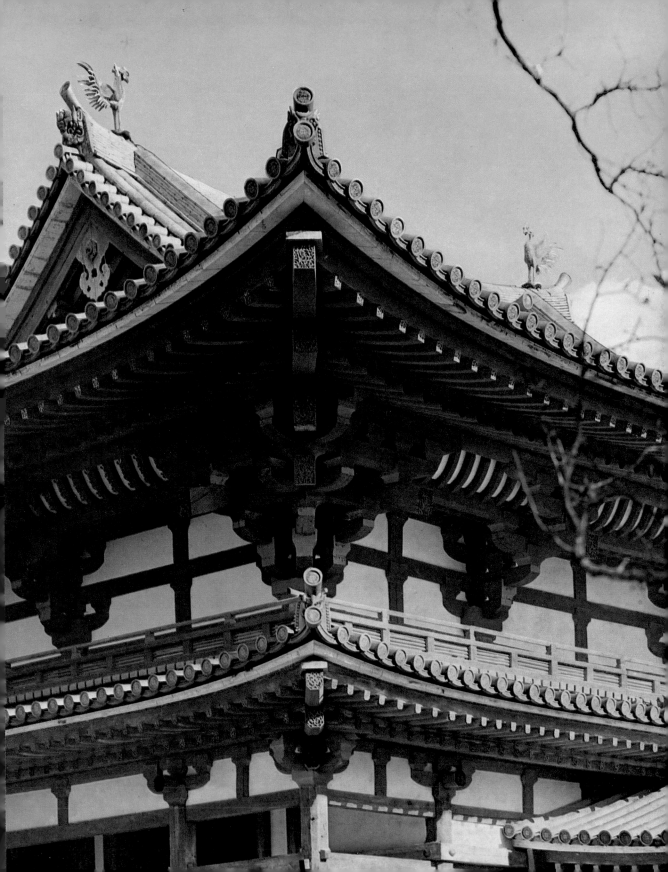

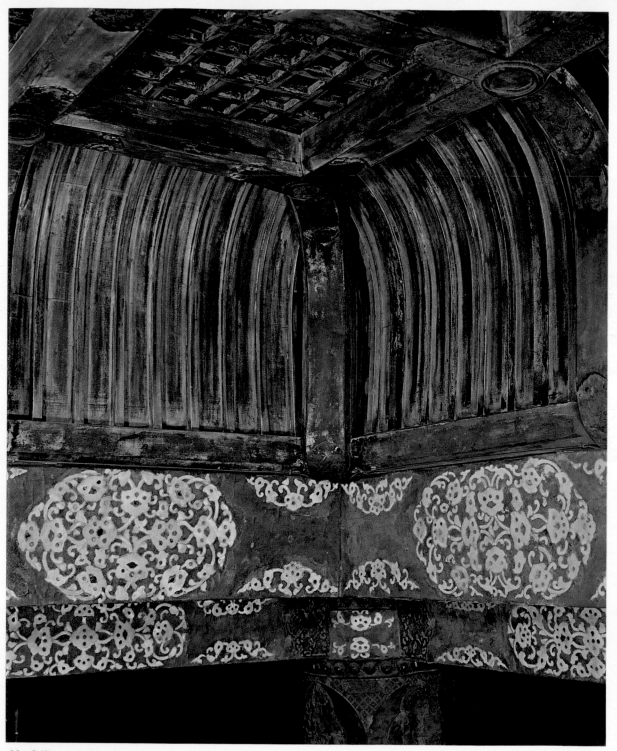

20. *Ceiling and decorative beams of Konjikido. Gold leaf and lacquer on wood with mother-of-pearl inlay. 1124. Konjiki-in, Chuson-ji, Hiraizumi, Iwate Prefecture.*

21. *Interior of Konjikido. 1124. Konjiki-in, Chuson-ji, Hiraizumi, Iwate Prefecture.* ▷

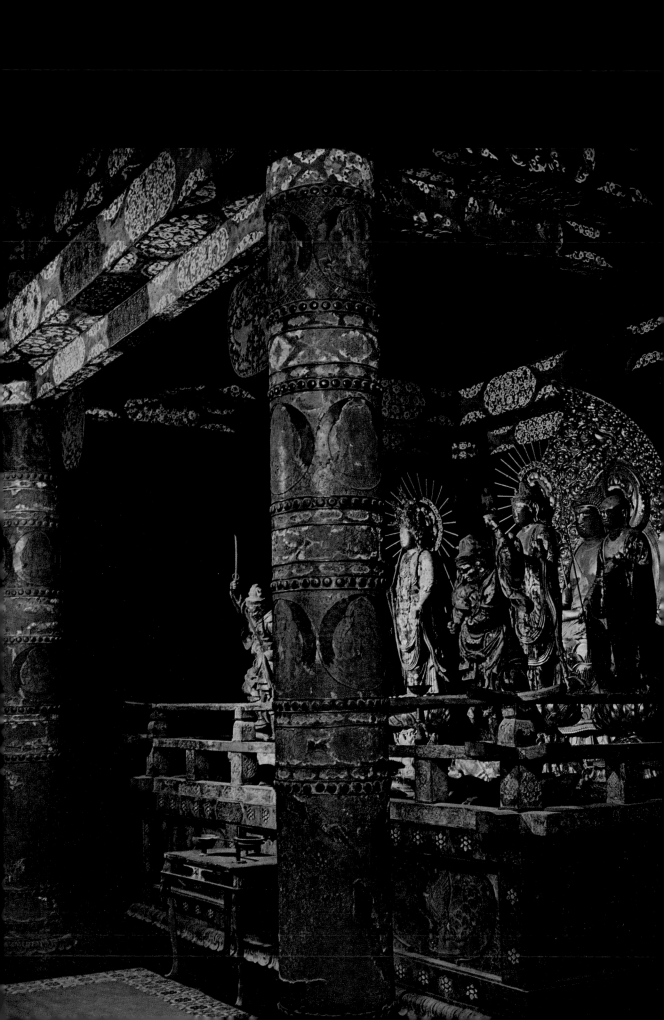

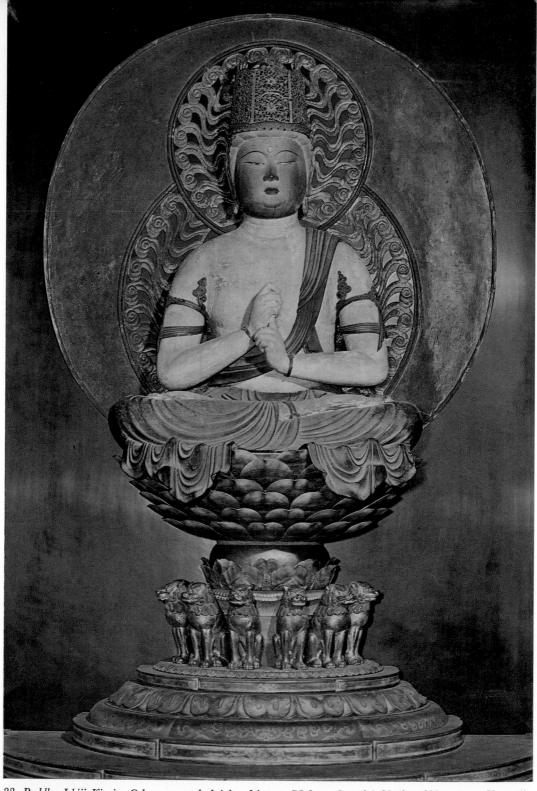

22. *Buddha Ichiji Kinrin. Colors on wood; height of image, 75.6 cm. Second half of twelfth century. Chuson-ji, Hiraizumi, Iwate Prefecture.*

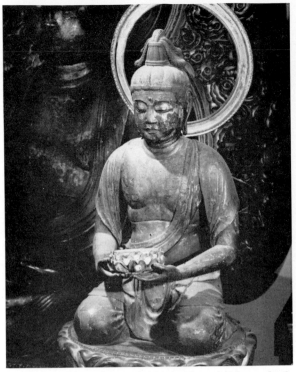

23. *Bodhisattva Kannon, from Buddha Amida and the Twenty-five Bodhisattvas. Gold leaf and lacquer on wood; height of image, 97.2 cm. Twelfth century. Sokujo-in, Kyoto. (See also Figure 38.)*

24. *Bodhisattva Kannon, from Amida triad. Gold leaf and lacquer on wood; height of image, 128.8 cm. 1148. Sanzen-in Main Hall, Kyoto. (See also Figure 94.)*

as the Amida Saint, because he never ceased to recite *nembutsu,* the invocation of Amida's name. In 944 he produced an Amida *jodohen.* Soon all and sundry began to devote themselves to the recitation of *nembutsu*—a phenomenon attributable to Kuya's exceptional proselytizing power.

A priest of the Enryaku-ji called Senkan (d. 984) composed a "Hymn to Amida" of some twenty lines, which was soon on the lips of all people, young and old, and contributed greatly to spreading Pure Land teachings. In 964, on his deathbed, the chief priest of the Enryaku-ji, Ensho, set statues of Amida and the manifest buddha Sonsho at his pillow and tied threads to the buddhas' hands, holding the ends in his own. Ensho thus became one of the first Japanese who followed ancient In-

dian sages in this fashion when confronted by death. Another Tendai patriarch of approximately the same period, Ryogen, wrote the *Gokuraku Jodo Kuhon Ojo-gi* (Commentary on the Nine Categories of Rebirth in the Pure Land) and, under the patronage of Minister of the Right Fujiwara no Kaneie (929–90), built the Eshin-in hall at Yokawa, dedicating it in 983.

A disciple of Ryogen named Genshin (942–1017), also known as Eshin because of his residence in the Eshin-in, was thoroughly conversant with the traditions of the Enryaku-ji from the time of Saicho and Ennin and must have acquainted himself thoroughly with the activities of Kuya and other famous Tendai monks. He was a native of Taima, in what is now Nara Prefecture. Tradition says

妙法蓮華經藥王喜薩本事品第二十三

that his birth took place as a result of the prayers his mother offered at a temple called Takao-dera, situated to the north of the Taima-dera. Presumably, then, he had been familiar with the famous Taima Mandala since childhood. Exposed to the Nara currents of Pure Land thought, he grew in wisdom and wrote more than a hundred works. One of these, the *Ojo Yoshu* (Essentials of Rebirth), which he compiled in 984–85, drew on both Chinese treatises on Pure Land doctrine and Japanese works on the subject from the time of Chiko in the Nara period. Summarizing and reconciling these teachings, Genshin helped codify the knowledge and beliefs of the time, thereby exerting great influence on the subsequent course of both Buddhism and its art in Japan.

A record from 1013 notes that up to the first month of that year, at which time Genshin became seventy-two years of age by Japanese reckoning, the acts of piety attributed to him were prodigious indeed, including hundreds of thousands or even millions of recitations of the *nembutsu*, various prayers, and the *Lotus, Hannya* (Prajna), and *Amida* sutras, to say nothing of such devotional activities as making Buddhist images, copying sutras, and giving alms.

PORTRAYALS OF AMIDA'S WELCOME

Tradition has it that when death approached to claim Taira no Koremochi, who was marshal of the frontier command in northern Japan, Genshin, unable to attend him in person, sent him a portrayal of the Mandala of Welcome to Amida's Paradise, instructing him to gaze on it when yielding himself to fate. This was the first time, it is said, that a Japanese Buddhist used a mandala in this way.

A Kamakura-period work, the *Asaba Sho,* tells us that Genshin commissioned a certain Kasukabe Tsunenori to paint a scene of the *raigo*—that is, the descent of Amida and a celestial host of bodhisattvas and monks from the Pure Land in welcom-

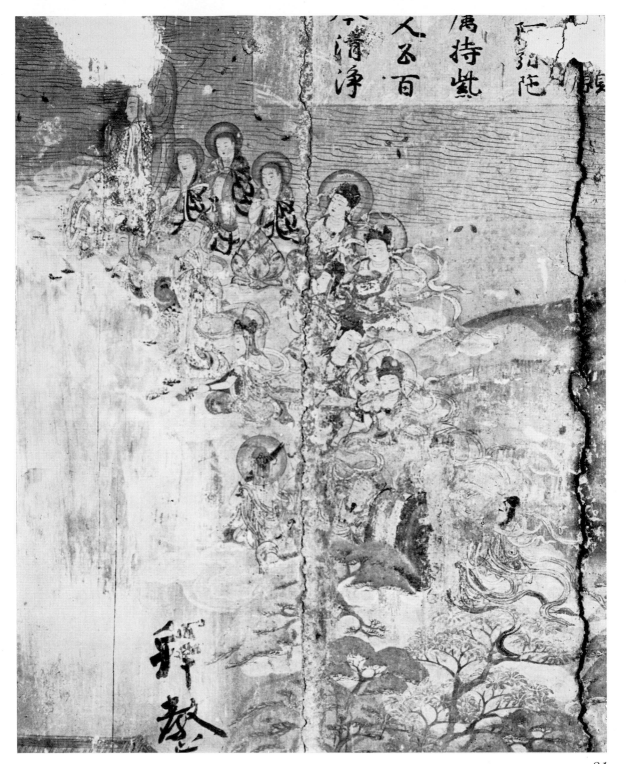

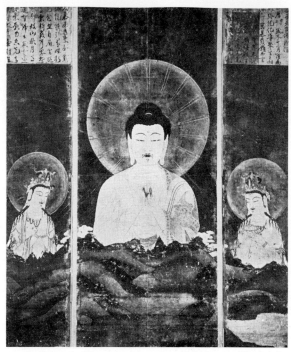

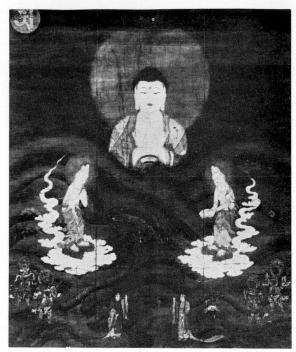

27. *Buddha Amida over mountains. Colors on silk; height, 101.2 cm.; width, 86.4 cm. Thirteenth century. Konkaiko-myo-ji, Kyoto.*

28. *Buddha Amida over mountains. Colors on silk; height, 134.8 cm.; width, 117.3 cm. Thirteenth century. Zenrin-ji, Kyoto.*

ing dying supplicants. Despite a discrepancy in the Chinese characters used in writing the name, a similarity in pronunciation suggests that the reference may be to Asukabe Tsunenori, a court painter active in the second half of the tenth century. (However, since this artist must have reached a considerable age by the time of Genshin's prime, it remains difficult to give credence to the *Asaba Sho* account.) Genshin's earliest biography notes that the celestial host in his *raigo* depiction, inspired by his reading of sutras, comprise relatively few bodhisattvas and a proportionately larger number of monks; and indeed, the number of monks has been a clue to identify *raigo* portrayals made under Genshin's influence. This and various other sources indicate that the *raigo* pictures that Genshin conceived, all vividly executed, without exception depicted a sizable number of Amida's followers, showing a great advance over such static representations of a

solitary Amida as that on the center panel of the Hokke-ji Amida triad (Figs. 12, 34).

A *raigo* painting originally at Yokawa's Anraku Valley but moved in the Edo period to the Kongobu-ji on Mount Koya, Wakayama Prefecture, comes close to what Genshin envisaged. (The Yokawa Compound, lying about four kilometers north of the other Enryaku-ji compounds, occupies an area including several valleys.) In this work (Figs. 13, 15, 36), Amida and the attendant figures are shown seated on clouds arranged in a roughly oval formation as they approach the supplicants desiring rebirth in the Pure Land. The horizontally dispersed figures make the painting disproportionately wide and lacking in dynamism. To the extent that the central figure of Amida is portrayed tranquilly seated, full face, with the figures of Kannon and Seishi placed symmetrically in front of the main figure, this work adheres to

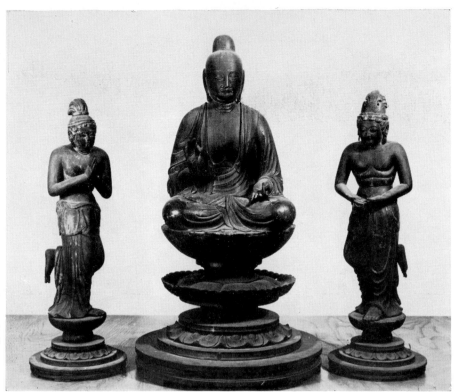

29. *Amida triad. Wood; heights: Amida (center), 49.1 cm.; Kannon (right), 59.2 cm.; Seishi (left), 55.3 cm. Eleventh or twelfth century. Shitenno-ji, Osaka.*

the orthodox form of the Amida triad, but there is a feature not found in the Hokke-ji Amida triad: Amida's mudra, or symbolic gesture, is in the *gosho* (or *raigo*) position, with the right hand before his chest and the left hand lowered, both palms turned outward, and thumb and forefinger touching at the tips. The arrangement of the celestial host is similar to that in the door paintings of the Phoenix Hall (Fig. 37) at the Byodo-in in Uji, near Kyoto. The placement of three monks close to Amida is another feature worth noting.

We can safely say that the *raigo* painting on the Phoenix Hall doors, though older than that at the Kongobu-ji, is of the Genshin school. The large surface of the work, beautifully executed in the style of *yamato-e,* or traditional Japanese painting, pictures—mainly below the inscriptions taken from Buddhist scripture (Fig. 67)—the descending figures riding on clouds against a background of scenery dotted with supplicants' dwellings. Although most of the figures are seated, there is great dynamism. Amida, with the *gosho* mudra as in the work at the Kongobu-ji, looks slightly downward, letting the light emitted from the auspicious protuberance in the center of his forehead illuminate the supplicants.

The panel representing the "upper class, lower rank"—that is, the third highest of the nine categories of rebirth—depicts a scene of the *kaeri raigo* (return from the welcoming), showing Amida seated in profile and the celestial host leading the supplicants to the Pure Land (Fig. 26). In terms of composition, this *raigo* picture shows a tremendous advance over the one at Mount Koya. Its dynamism is evidence that a need for compositional variation had become apparent little more than thirty years after the death of Genshin.

In the Kamakura period, the Phoenix Hall door

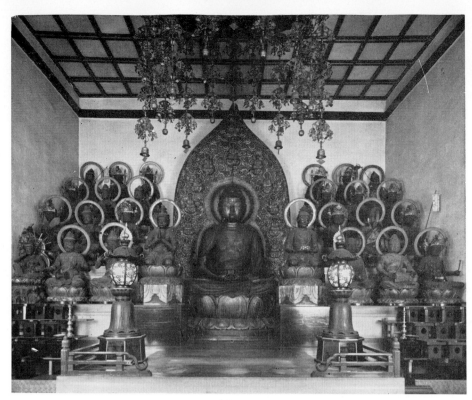

30. *Buddha Amida and the Twenty-five Bodhisattvas. Gold leaf and lacquer on wood; height of Amida image, 229.5 cm. Twelfth century. Sokujo-in, Kyoto. (See also Figure 38.)*

31. *Daigo-ji Five-Story Pagoda. Dimensions of first story, 6.63 m. by 6.63 m. overall height, 38.16 m. 951. Kyoto. (See also Figure 40.)* ▷

paintings served as models for contemporary *raigo* pictures, but to satisfy the needs of the pious a feeling of more rapid motion was sought: a liking developed for *yamagoshi raigo,* pictures that showed the outsized figure of Amida encouraging the supplicants from beyond the western mountains (Figs. 27, 28, 142), and the quiet dignity characteristic of Genshin's time was lost. The frontispiece to the "Medicine King" chapter of the Heike Nokyo (Sutras Dedicated by the House of Taira; 1164) version of the *Lotus Sutra* depicts a *raigo* for female believers (Fig. 25), illustrating yet another aspect of the preferences of the times.

The popularity of *raigo* pictures inevitably influenced carvers of Buddhist images, who soon began to produce *raigo* statues in wood. As early as the second half of the tenth century, a priest of the Hoko-ji called Hyochin built a small hall and enshrined in it a carved representation of the Pure Land. It is possible, however, that this work was not actually a *raigo* but a *jodohen.* In 1045, Imperial Prince Koichijoin Atsuakira (d. 1051) enshrined *raigo* statues in his mansion in Kyoto, and about 1092 Chamberlain Fujiwara no Tadasue did the same in a hall he built at the Urin-in temple, also in Kyoto. In 1095 the widow of Michiie commissioned the carving of a *joroku* Amida triad on auspicious purple clouds for the repose of her deceased foster father, who had been major counselor of the state. The attending Kannon in this work held out a lotus seat, a pedestal shaped like the flower, and Seishi pressed his hands together in prayer, just as in *raigo* paintings. About a year later Minamoto no Chikamoto (d. 1105), formerly governor of Awa (present-day Chiba Prefecture), built a hall called the Hikarido in the Eastern Hills of Kyoto to house *raigo* statues. In 1094, shortly before his death, Tachibana no Toshitsuna, a high official re-

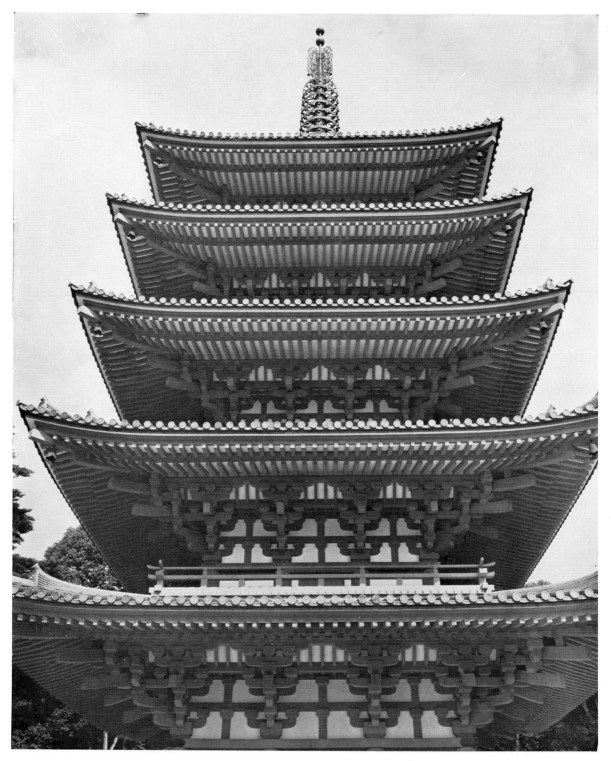

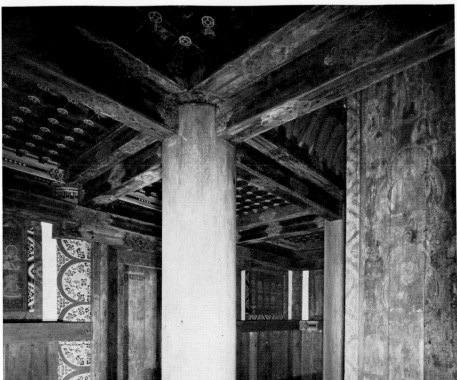

32. *Interior of first story of Daigo-ji Five-Story Pagoda. Dimensions of first story, 6.63 m. by 6.63 m. 951. Kyoto. (See also Figure 39.)*

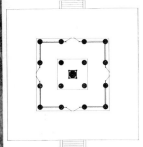

33. *Floor plan of Daigo-ji Five-Story Pagoda.*

nowned for his wealth and taste, commissioned figures of Amida and the Twenty-five Bodhisattvas (Figs. 23, 30, 38) for the Fushimi-dera (Sokujo-in) in Kyoto. It is recorded that in the mansion he constructed in 1110 in Kyoto, Minister of the Left Minamoto no Toshifusa (d. 1121) also built a buddha hall to enshrine a *raigo* statuary group in wood. This work, with Amida in the center flanked by his two attendants and chanting bodhisattvas, all borne on clouds, is said to have had a composition similar to the one at the Fushimi-dera. Examples of twelfth- and thirteenth-century *raigo* triads in wood are still to be found in all parts of Japan.

To return to Enryaku-ji's Yokawa Compound, I should like to discuss two sanctuaries founded by Genshin. The first, the Ryozen-in, was built sometime around 990–95 under the auspices of the priest Ken'yu to house a life-size image of Shaka (the Buddha Sakyamuni) by the Buddhist sculptor Kosho and wall paintings of the Buddha's Ten Great Disciples. A thirty-panel representation of the Six Worlds of Wandering and Four Worlds of Enlightenment, inspired in large part by the *Ojo Yoshu,* is known to have been executed here during the Kamakura period. The fifteen remaining panels of the Six Worlds are now in the Shoju Raigo-ji in Otsu under the name *The Ten Worlds.* The second sanctuary, the Kedai-in (*kedai,* "lotus pedestal," signifies the Pure Land) was built under the patronage of Myoku at a date surmised to be either 983 or 1001. However, if we accept the theory that

34. *Buddha Amida, center panel of triptych (see Figure 12) showing Amida triad and cherub. Colors on silk; dimensions of this* ▷
panel: height, 186.7 cm.; width, 143.3 cm. First half of eleventh century. Hokke-ji, Nara.

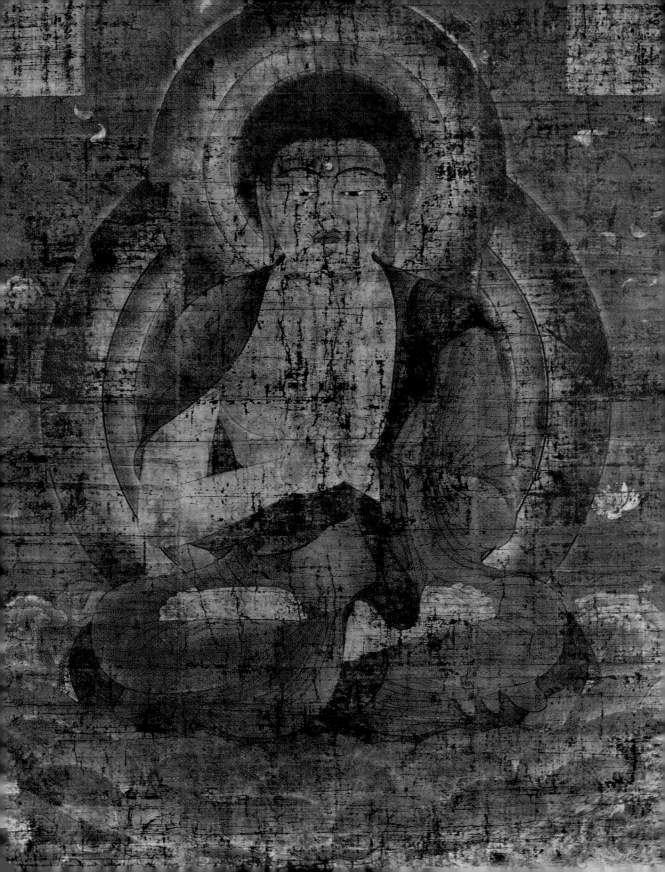

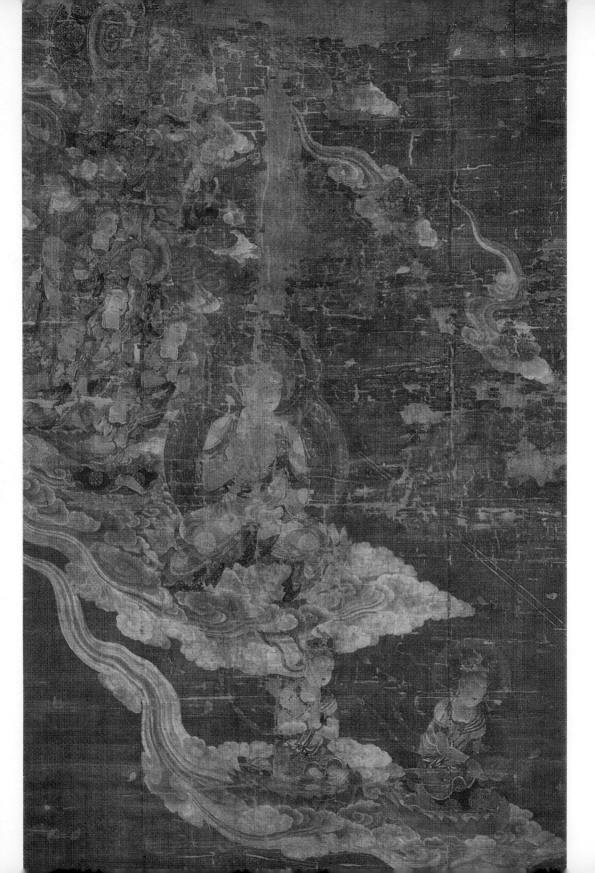

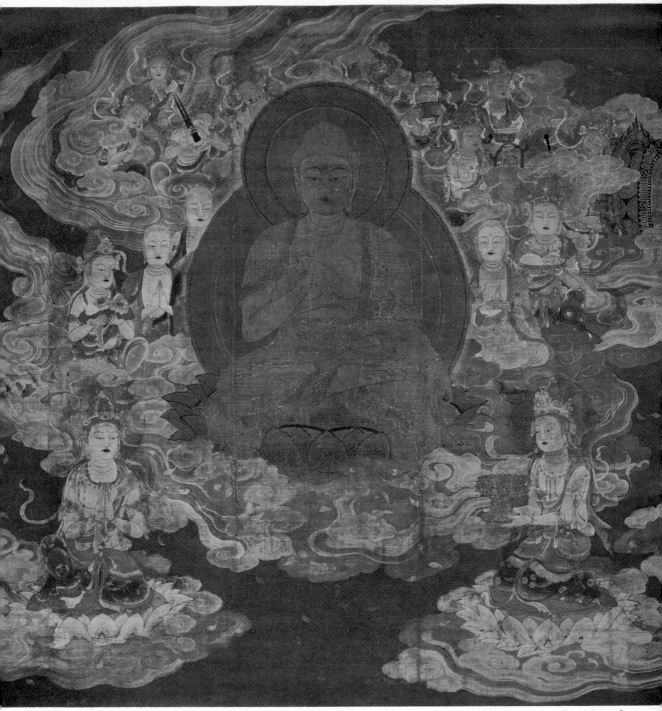

36. Center panel of triptych (see Figure 13) showing raigo *of Buddha Amida and celestial host. Colors on silk; dimensions of this panel: height, 210.8 cm.; width, 210.6 cm. Twelfth century. Yushi Hachimanko Juhakka-in, Kongobu-ji, Mount Koya, Wakayama Prefecture.*

◁ *35. Raigo of Buddha Amida and the Twenty-five Bodhisattvas. Colors on silk; height, 118.6 cm.; width, 70.8 cm. Second half of twelfth century. Kombu-in, Nara.*

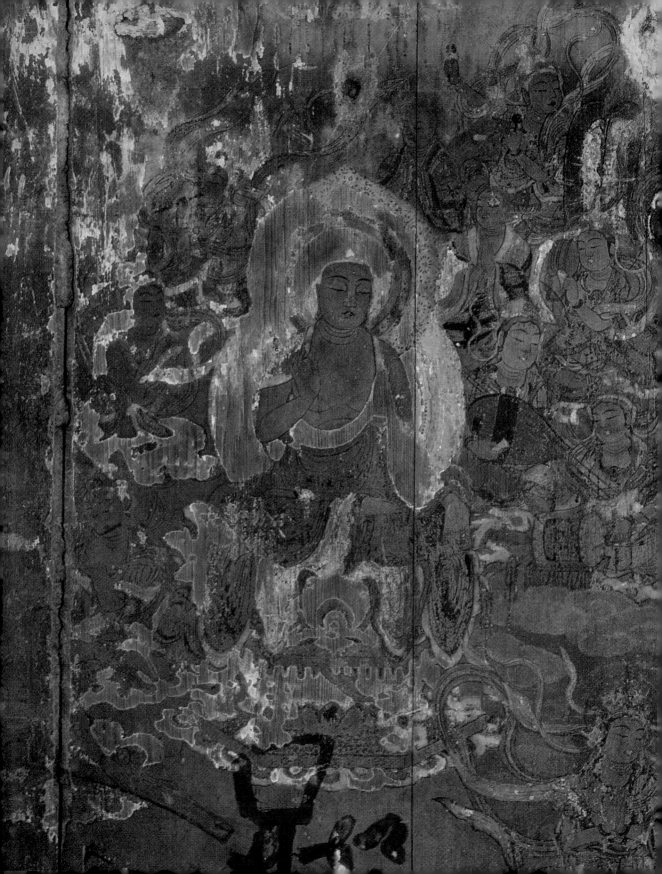

37. Raigo of Buddha Amida and celestial host, detail from Phoenix Hall door painting of "lower class, upper rank" of rebirth. Colors on wood; dimensions of entire painting: height, 75 cm.; width, 97.5 cm. 1053. Byodo-in, Uji, Kyoto Prefecture.

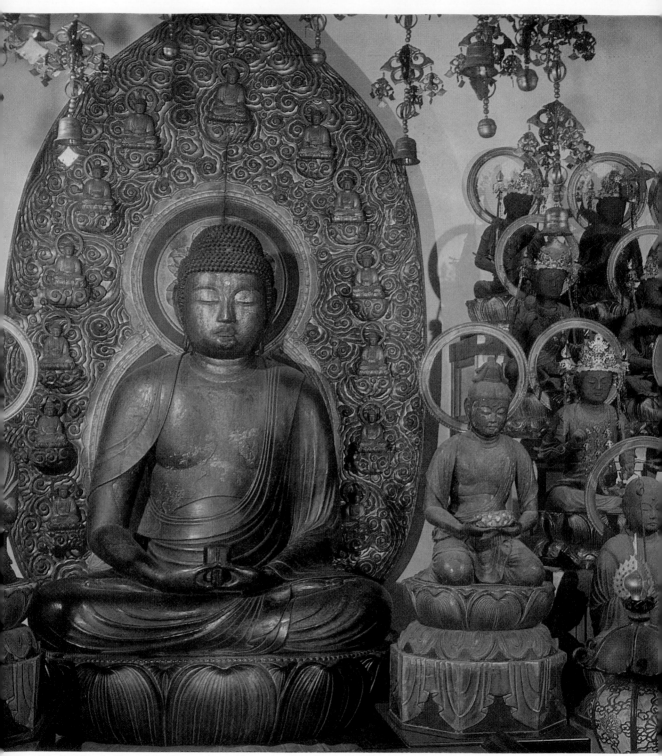

38. *Buddha Amida and the Twenty-five Bodhisattvas. Gold leaf and lacquer on wood; height of Amida image, 229.5 cm. Twelfth century. Sokujo-in, Kyoto. (See also Figure 30.)*

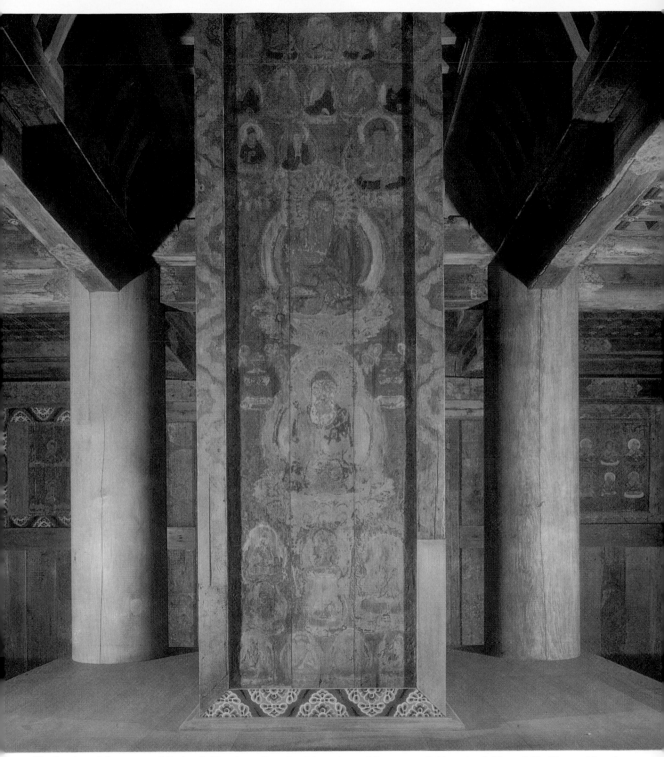

39. Interior of first story of Daigo-ji Five-Story Pagoda. Dimensions of first story, 6.63 m. by 6.63 m. 951. Kyoto. (See also Figure 32.)

40. *Daigo-ji Five-Story Pagoda. Dimensions of first story, 6.63 m. by 6.63 m.; overall height (see Figure 31), 38.16 m. 951. Kyoto.*

Genshin built this hall as a retreat when he resigned his position as high priest, the date would be 1005. Three *joroku* statues of Amida are enshrined in it. The central figure is believed to have been commissioned by Myoku and carved by Kosho; the one to the south was commissioned by the retired and cloistered emperor Kazan (r. 984–86) and carved by Chokaku; and the one to the north was commissioned by Genshin for a *mukaeko,* a pageant meant to symbolize the rite of Amida's *raigo.* In 1017, on his deathbed Genshin grasped threads tied to the hands of these Amida images.

THE PURE LAND FAITH AND THE EXISTING SECTS
The entry of Pure Land teachings into the practices of the Shingon (True Word) sect came later. At the Daigo-ji in southeastern Kyoto, the Golden Hall (Fig. 95), also called the Main Hall or Shaka Hall, was dedicated in 926 at the behest of Emperor Daigo (r. 897–930) in the temple's Shimo Daigo precincts at the foot of Mount Daigo. The hall had an attached chapel in front and, along with the inner gate, bellhouse, and sutra repository, was enclosed by a corridor in the manner of the temples of Nara. A five-story pagoda (Figs. 31, 40) built in 951 to the southeast, just outside the inner gate, retains its beauty of line to the present day.

In the intervening years, a lotus-meditation hall was built at the behest of Emperor Suzaku (r. 930–46) around 939, and in 949 the Seiryoden, which had been Suzaku's living quarters in the imperial palace while he was on the throne, was moved to the temple and made into another lotus-meditation hall. The presence of two such halls in one monastery is an early instance of Tendai influence on Shingon temples. But the prime focus of Shingon faith was rebirth in the Tosotsu Jodo (Tusita Heaven), the pure land where, it is believed, Shaka had resided before birth on the earth and Miroku (the Bodhisattva Maitreya) is preaching now. We are told that the high priest Gango retreated to the Emmei-in in the temple's Kami Daigo precincts atop the mountain to recite the *Lotus Sutra,* repeat the Amidist *nembutsu,* and construct an Amida hall.

This shows Amidist influence, but at the Kongobu-ji on Mount Koya and other major Shingon centers it was not until the beginning of the eleventh century that there was any tendency to pray for rebirth in the Western Paradise of the Buddha Amida.

In Nara a prelate named Zenshu was active near the end of the eighth century, writing two commentaries on the *Muryoju-kyo.* He first studied at the Kofuku-ji, the Hosso-sect headquarters, and later resided at the Akishino-dera temple in Nara. One of his followers, Shokai (昌海), is known to have produced two works on Amidist doctrine. A priest of the Sanron sect at the Gango-ji named Ryukai meditated on the Buddha Amida and chanted Amidist incantations on his deathbed in 886. Josho, a Kofuku-ji priest contemporary with Kuya and Ryogen, declared at his death in 983 his desire to be reborn in Amida's Pure Land as taught in the *Lotus Sutra.* Another man known as Shokai or Seikai (清海), who died in the same year as Genshin, had transferred from the Kofuku-ji to the now defunct Chosho-ji in western Nara Prefecture. He commenced lotus meditation in 989, carried out a seven-day chanting of the *nembutsu* around 990, and in his later years is reputed to have painted a *jodohen* known as the Shokai Mandala. His practice of lotus meditation suggests Tendai influence in his Pure Land doctrine.

A lay contemporary of Genshin, Senior Scribe Yoshishige no Yasutane, was greatly influenced by Kuya and other teachers. From childhood Yasutane repeated the *nembutsu* daily; as an adult he was rigorous in making pilgrimages to temples containing Amidist images or Pure Land paintings and wrote the *Juroku So San* (Ode to the Sixteen Ways to Meditate). He was the author of the *Nihon Ojo Gokuraku-ki,* based on the work of T'ang monks, which he wrote before his renunciation of the world in 986. His work inspired the eleventh-century *Honcho Hokke Kenki* (Japan's Tale of the Lotus Flower) and many stories of rebirth in the twelfth century, which testify to how firmly the seeds of Pure Land doctrine had been implanted in every corner of Japan.

CHAPTER TWO

Temples of the Fujiwara

GOVERNMENT BY THE FUJIWARA FAMILY through regents had its beginnings in the second half of the ninth century and, with two brief interruptions in the early and mid-tenth century, continued until the eleventh century, when government by retired emperors removed the reins of power from the hands of the Fujiwara. The halcyon days of this long regency were the first half of the eleventh century, under Fujiwara no Michinaga (966–1027) and his son Yorimichi (992–1074), when a distinctive Fujiwara style was created in art and culture.

The Fujiwara had long been prolific raisers of temples: the Gokuraku-ji by Mototsune (836–91), the Hosho-ji by Tadahira (880–949), the Hoju-ji by Tamemitsu, the Hoko-in by Kaneie (929–90), and the Seson-ji by Yukinari (972–1027) are all illustrious examples. But the greatest of all Fujiwara builders was Michinaga, who was known as the Mido Kampaku. ("Mido" was a respectful name of the Hojo-ji; *kampaku* means "regent to an adult emperor.")

Fujiwara no Michinaga was a son of Kaneie. In 1005 Michinaga, then Minister of the Left, transformed the traditional burial grounds of the Fujiwara clan at Kowata in Uji into a temple, the Jomyo-ji. Its focus was the lotus-meditation hall, just inside the south gate, which enshrined an image of the Bodhisattva Fugen. To the right and left of this hall he built quarters for twelve monks; two years later he raised a pagoda containing images of Shaka and Taho. Faith centered on the *Lotus Sutra,* as in Tendai Buddhism, with only traces of Pure Land doctrine. In the same year as the dedication of the Jomyo-ji meditation hall, however, Michinaga had Yukinari write out a copy of the *Ojo Yoshu.* An inscription on the case containing sutras that he had buried at Mount Kimpusen in Nara Prefecture in 1007 notes that Michinaga intended to recite the *nembutsu* at his death to assure rebirth in Amida's Paradise and so to proceed to Miroku when the bodhisattva descends from *his* pure land to save mankind billions of years later. It is thus clear that the Pure Land faith, which had already begun to find popular favor, attracted Michinaga's sympathies, particularly after the death of Genshin, its prime exponent, in 1017.

THE FOUNDING OF THE HOJO-JI In 1019 Michinaga, who was in poor health, renounced the world and determined to found a temple on the eastern side of the Kyogoku-dono, his private mansion in Kyoto, to take up residence there. Construction of an eleven-bay-wide hall to house nine *joroku* Amida images was begun in the seventh month of that year, with the governor of each province allotted responsibility for one bay. At first his son, Regent Yorimichi, was uncooperative. But eventually the financial support of the regent, other nobles, courtiers, Buddhist prelates, and commoners was added to the labor of Buddhist sculptors, artisans, the serfs of the Fujiwara house, and levies from feudal

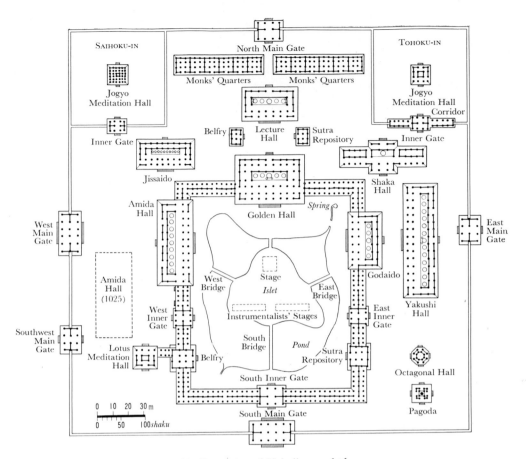

Figure labels (clockwise/as positioned):

SAIHOKU-IN · North Main Gate · TOHOKU-IN
Jogyo Meditation Hall · Monks' Quarters · Monks' Quarters · Jogyo Meditation Hall · Corridor
Inner Gate · Belfry · Lecture Hall · Sutra Repository · Inner Gate
Jissaido · Shaka Hall
Amida Hall · Golden Hall · Spring
West Main Gate · East Main Gate
Amida Hall (1025) · West Bridge · Stage · Islet · East Bridge · Godaido · Yakushi Hall
West Inner Gate · Instrumentalists' Stages · East Inner Gate
Southwest Main Gate · Lotus Meditation Hall · Belfry · South Bridge · Pond · Sutra Repository · Octagonal Hall
South Inner Gate · Pagoda
0 10 20 30 m
0 50 100 shaku
South Main Gate

41. Restoration of Hojo-ji ground plan.

holdings to lay out a temple complex on the west bank of the Kamo River, on a site that measured about 250 meters square. The work involved excavating a pond with an islet, building up hillocks, planting trees and shrubs, and determining the position of the numerous halls and corridors (Fig. 41).

When the initial dedication ceremony, that of the Amida hall, was held in the third month of the following year, 1020, the institution was named the Muryoju-in. This use of the name of an important Amidist sutra, plus the fact that the Amida hall was completed before the Golden Hall, the temple's main hall, makes it clear that Michinaga's

faith was already focused on Pure Land doctrines. The bellhouse and the sutra repository were finished about the same time, and the end of the year saw the dedication of the Jissaido, a hall enshrining the statues of the buddhas of the Ten Days of Purification, as well as the completion of the lotus-meditation hall.

In 1021 Michinaga's wife, Minamoto no Rinshi, followed her husband in taking vows and dedicated a small subtemple, the Saihoku-in, in the northwest corner of the temple precincts. Its main building, roofed with cypress bark, was a small hall of "three bays and four sides" (which in the terminology of Japanese architects means that the

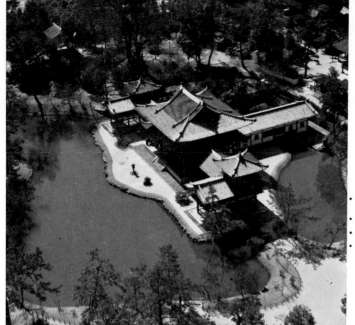

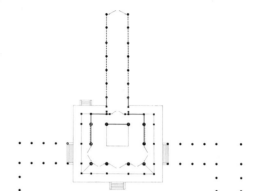

42. *Aerial view of Phoenix Hall from north. 1053. Byodo-in, Uji, Kyoto Prefecture.*

43. *Ground plan of Byodo-in Phoenix Hall.*

44. *Central structure of Phoenix Hall viewed from southeast. Length of façade, 14.24 m. 1053. Byodo-in, Uji, Kyoto Prefecture.* ▷

moya, or altar space, was three bays wide and was circumscribed by aisles on its four sides). The hall housed an Amida triad only about 90 centimeters in height, probably flanked by the images of Jizo and Ryuju. A residential atmosphere was imparted by sliding partitions, bearing attractive pictures, that separated the *moya* from the aisles. Ritual was also given a place in the custom of chanting the *nembutsu* for three days and three nights without interruption, in imitation of the seventeen-day *jogyo* meditation of Tendai Buddhism carried out every year in the eighth month at the Enryaku-ji, and there is thus no doubt that the dedicated structure was a *jogyo*-meditation hall. It is reported that a residence and corridors were constructed in the eastern part of the Saihoku-in precinct for the accommodation of Michinaga.

In the seventh month of 1022 the "Golden" hall and the Godaido (a hall enshrining the Go Dai Myo-o, or Five Great Kings of Light) were finished, and the temple's name was changed to Hojo-ji, Muryoju-in remaining the designation of the Amida hall alone. In 1024 a Yakushi hall called the Joruri-in was dedicated, and in 1025 the nine images in the Amida hall were transferred to a newly constructed hall, while the old edifice was moved just to the south of the West Main Gate. In 1027 Michinaga had an ordination dais for nuns completed, but in the face of Tendai opposition to this, the great Michinaga could not escape embarrassment. Also in 1027 he dedicated a Shaka hall, and in the twelfth month of that year Michinaga, at sixty-two, secluded himself in the Amida hall and died there holding a thread attached to the hand of the Amida image.

Michinaga's eldest daughter, Shoshi (988–1074),

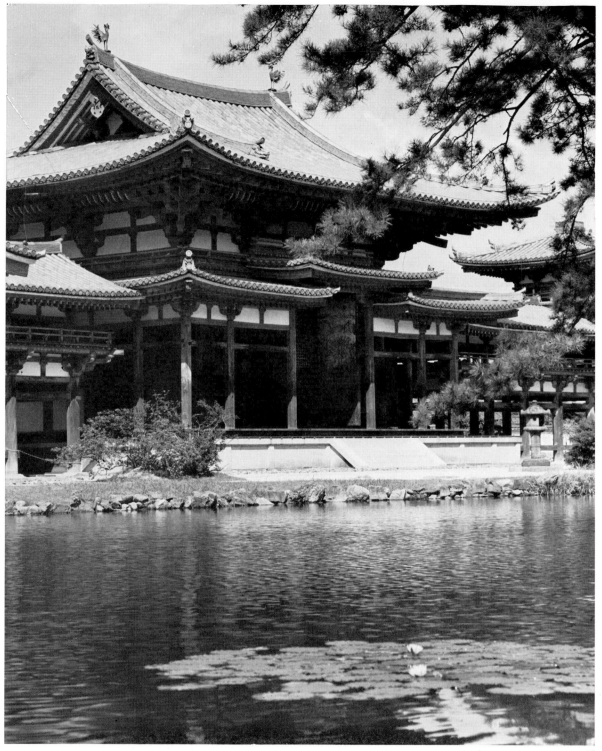

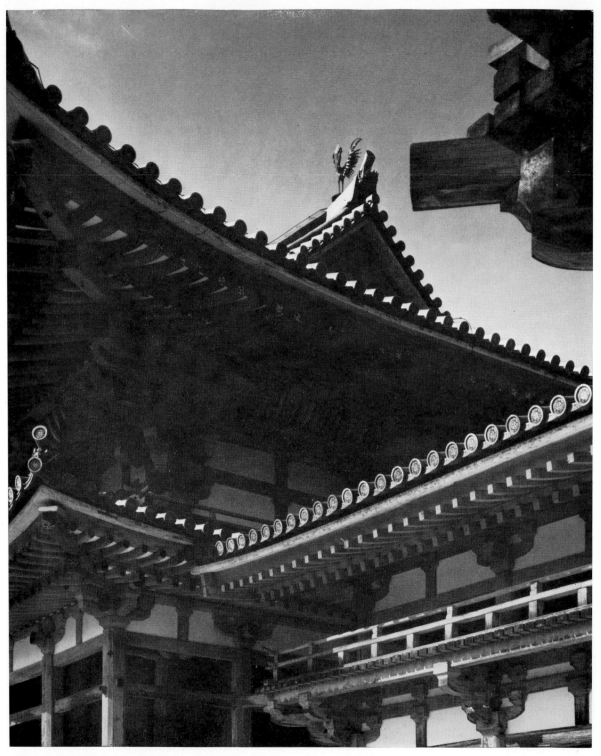

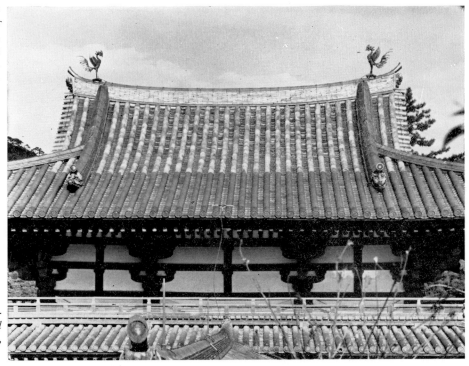

45. *Juncture of central structure and north wing of Phoenix Hall; visible at upper right-hand corner is part of understructure of north-tower veranda. 1053. Byodo-in, Uji, Kyoto Prefecture.*

46. *Roof of central structure of Phoenix Hall viewed from west. 1053. Byodo-in, Uji, Kyoto Prefecture.*

whom he had made one of the two consorts to Emperor Ichijo (r. 986–1011) and who was then known by her religious title, Jotomon'in, commissioned Pure Land paintings and sutra copying to commemorate her dead father. In 1030 she built within the Hojo-ji a separate subtemple, the To-hoku-in, in whose main structure, a *jogyo*-meditation hall, she enshrined images of Amida and the four attendant bodhisattvas Kannon, Seishi, Jizo, and Ryuju—in the same manner as in the Yokawa *jogyo*-meditation hall—and decorated the interior of the hall with pillar paintings, nail heads of colored glass, altar railings of aloes and red sandalwood, gold lacquerwork, and mother-of-pearl. Her brother Yorimichi dedicated a pagoda and, in 1050, a lecture hall, sutra repository, and bellhouse.

In 1057 Jotomon'in built an octagonal hall based on the Nan'endo (South Round Hall) of the Kofuku-ji, but, departing from the Nan'endo model, enshrined therein a *joroku* image of Amida—a decision reflecting the beliefs of the times. The following year, however, all these buildings and images were lost to fire, putting to an end the history of the first great temple of the period of imperial regency. Now it can only be said that this temple, gradually built up over a period of nearly forty years under Michinaga and Yorimichi in the halcyon days of the Fujiwara, was a truly monumental undertaking.

THE ART AND SPLENDOR OF THE HOJO-JI

The Muryoju-in (Amida hall), housing nine *joroku* Amida images accompanied by figures of Kannon, Seishi, and the Four Celestial Guardians (Shitenno), was a plank-floored building furnished with a surrounding veranda. The façade, which faced east, measured eleven bays. The building bore a plaque in the hand of Yukinari, first cousin once removed of Michinaga. Painted on the doors were scenes of the *kuhon raigo*

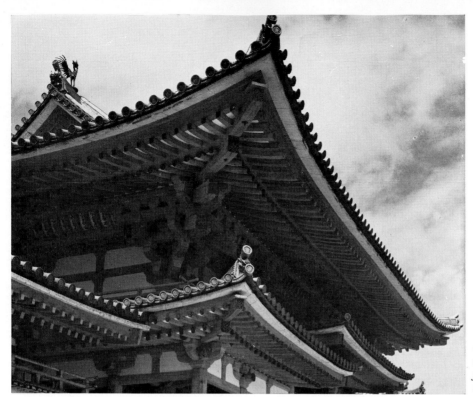

47. Eaves of central structure of Phoenix Hall viewed from southeast.1053. Byodo-in, Uji, Kyoto Prefecture.

(welcome to the nine categories of rebirth), each bearing a text explaining the scene. The low lattice, to keep away stray animals, was decorated in gold paint on lacquer, and a variety of precious stones was used in the mother-of-pearl inlay. Above, a jeweled net was tied with plaited lotus-fiber cords of light and dark purple. The center bay of the front aisle was made into an oratory for Michinaga's devotions. A compartment with a raised platform and screens on three sides and above served as the ceremonial seat for state services, and to the north of it one-meter-square straw cushions were piled to form a seat for less imposing services. The plaited lotus-fiber cords running from the hands of the nine Amidas to the central image extended to Michinaga's oratory. Sliding partitions along the northern end of the building and the corridor extending from it carried pictures illus-

trating Buddhist virtues. Bamboo blinds separated the area into compartments for use by his lady and daughters when they were in seclusion for prayer.

The Golden hall was either "five bays and four sides" or "seven bays and four sides" and was equipped with double eaves. This hall also had a plaque in the script of Yukinari. The hall's main image was a double-*joroku* (thirty-two *shaku,* or about ten meters) statue of Dainichi (Mahavairocana) flanked by smaller, twenty-*shaku* images of Shaka, Yakushi, Monju (Manjusri), and Miroku and by nine-*shaku* images of Bon Ten (Brahma), Taishaku Ten (Sakra Devanam Indra), and the Four Celestial Guardians. Painted on the pillars of the hall were various figures from the Mandala of Both Worlds of Dainichi (or perhaps scenes of bodhisattvas discoursing on Amida's saving mis-

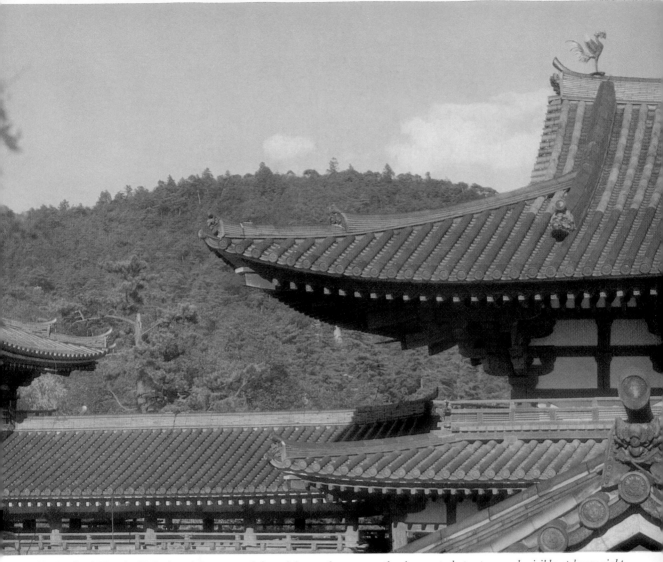

48. Roofs of Phoenix Hall viewed from west; left to right: north tower, north wing, central structure, and, visible at lower right-hand corner, west wing. 1053. Byodo-in, Uji, Kyoto Prefecture.

49 (overleaf). Aerial view of Uji River (foreground) and Byodo-in (background) from northeast. Uji, Kyoto Prefecture. ▷

50 (second overleaf). Aerial view of Phoenix Hall from east. 1053. Byodo-in, Uji, Kyoto Prefecture. ▷

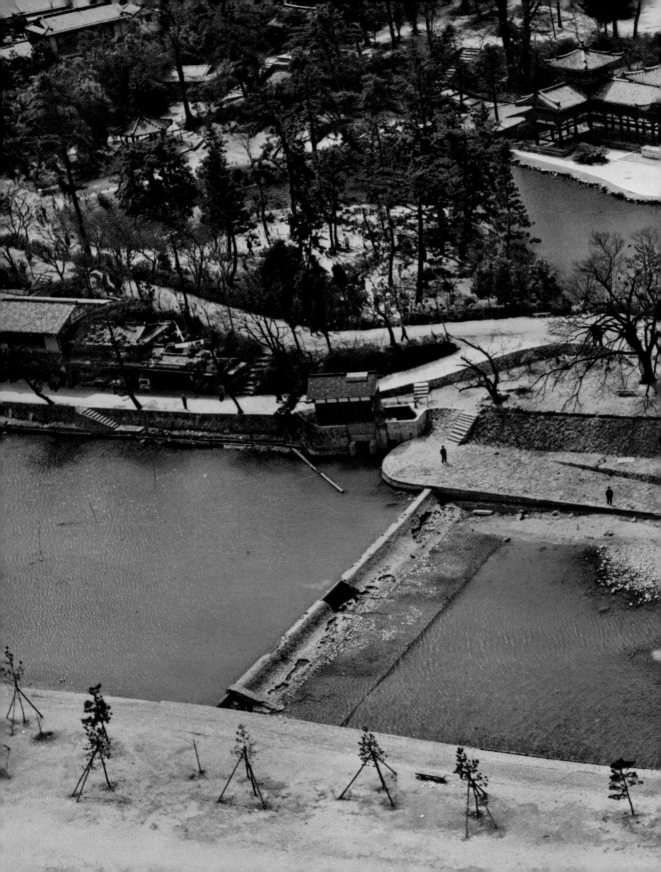

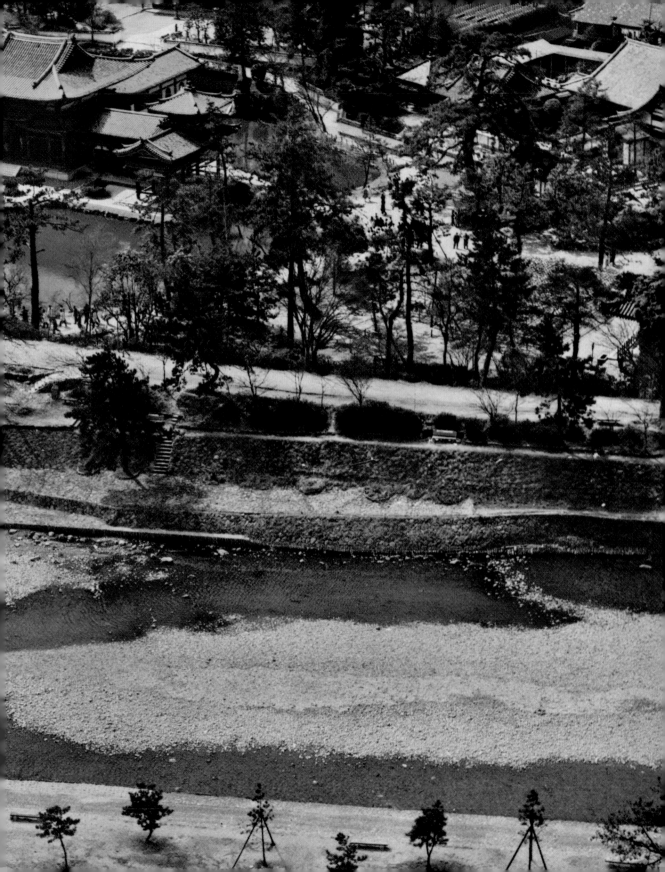

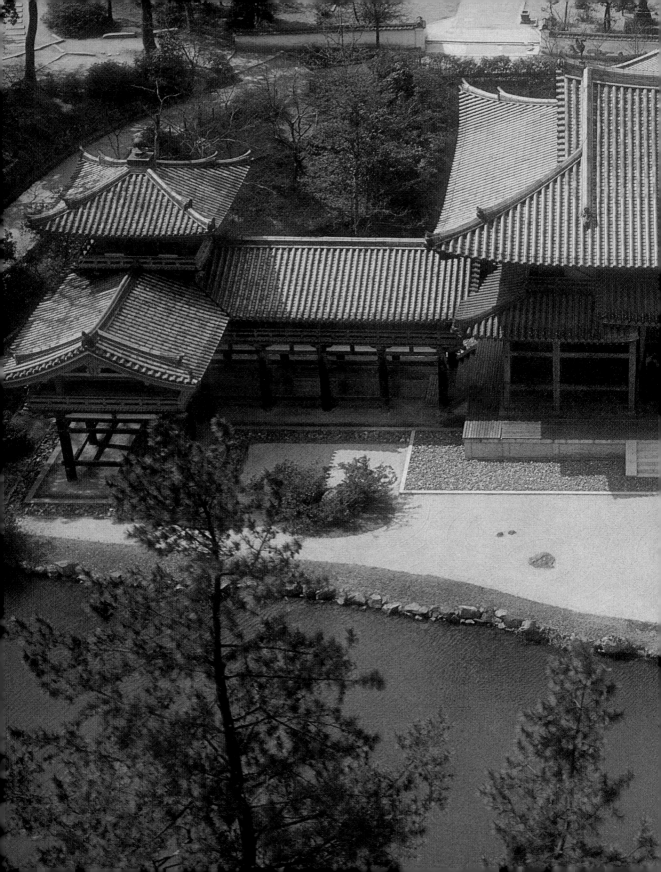

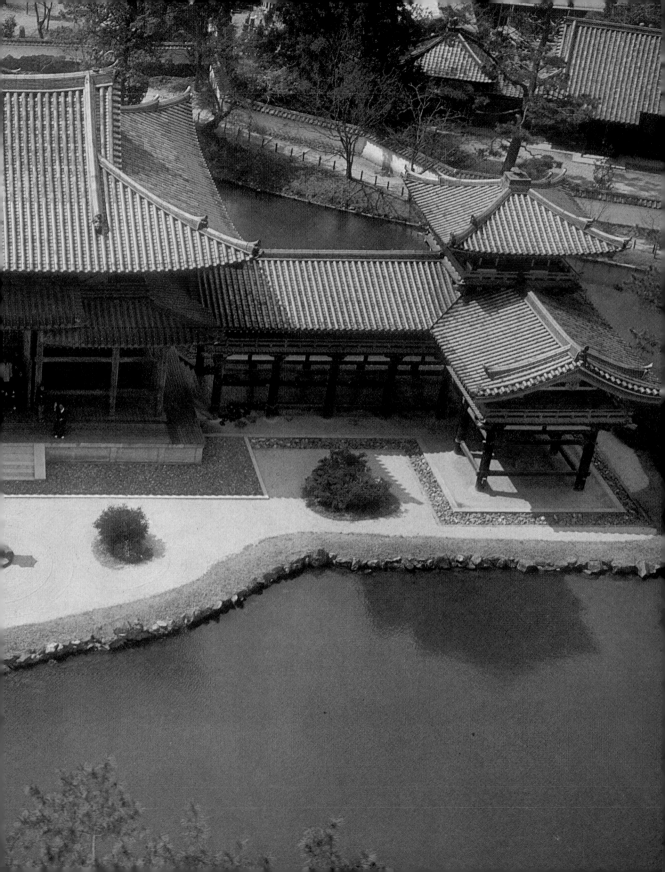

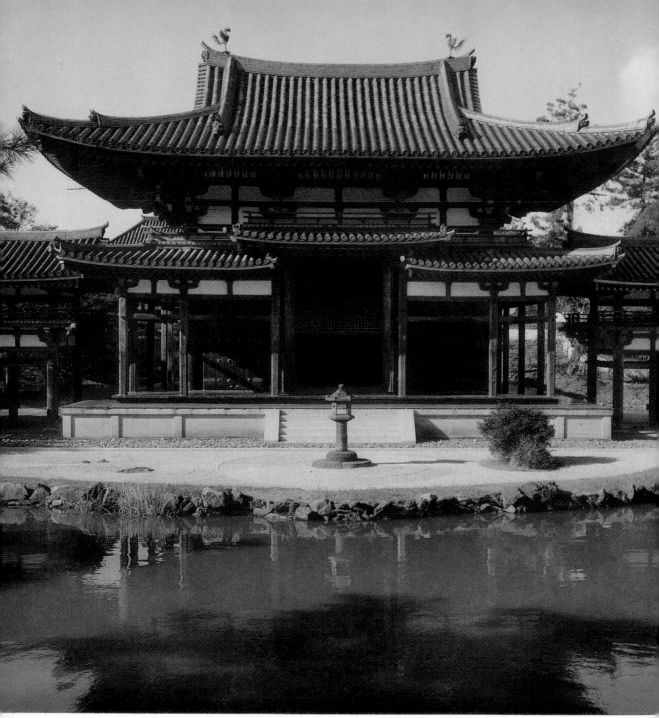

51. Central structure of Phoenix Hall. Length of façade, 14.24 m. 1053. Byodo-in, Uji, Kyoto Prefecture.

52. Buddha Amida, by Jocho. Gold leaf and lacquer on wood; height of image, 295 cm. 1053. Phoenix Hall, Byodo-in, Uji, ▷ Kyoto Prefecture.

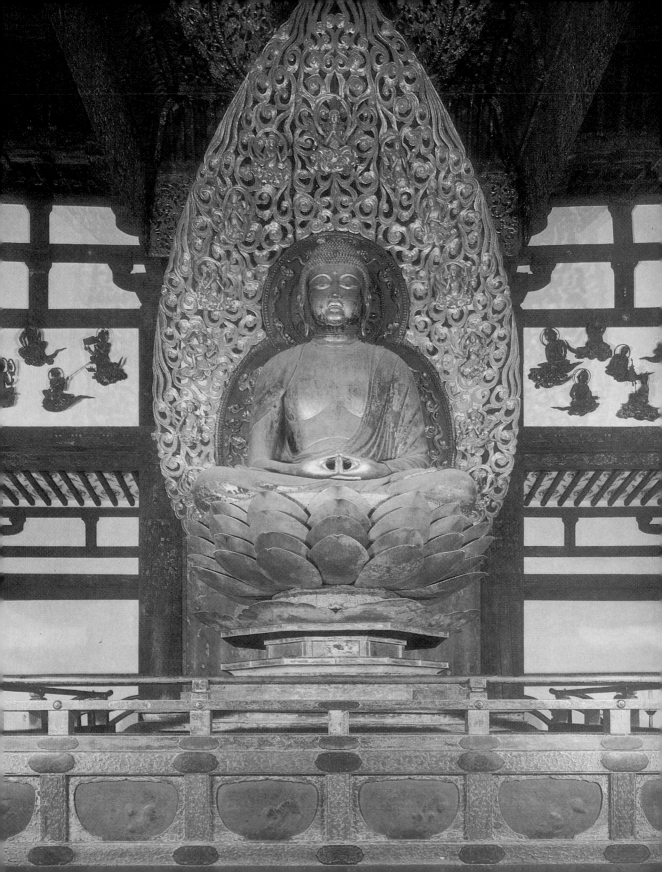

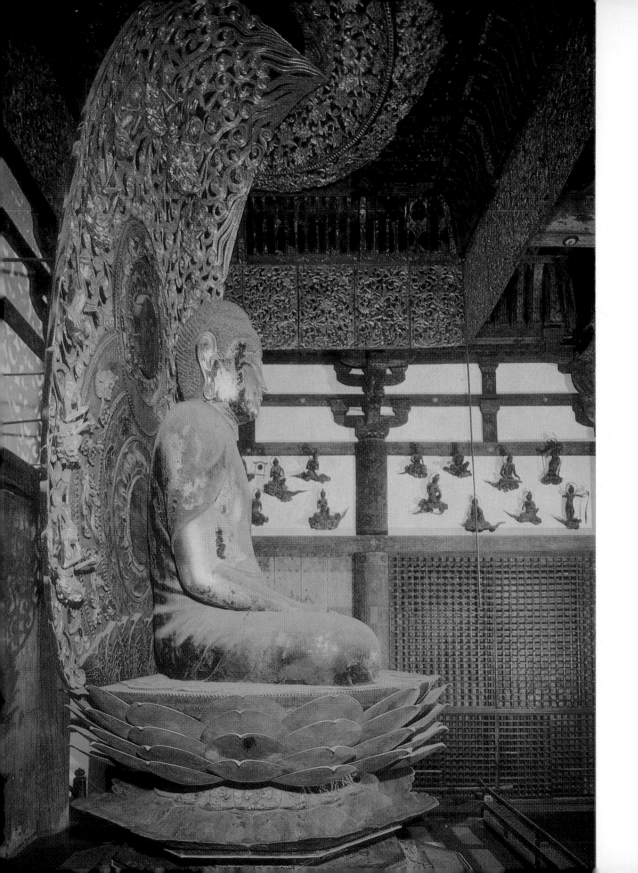

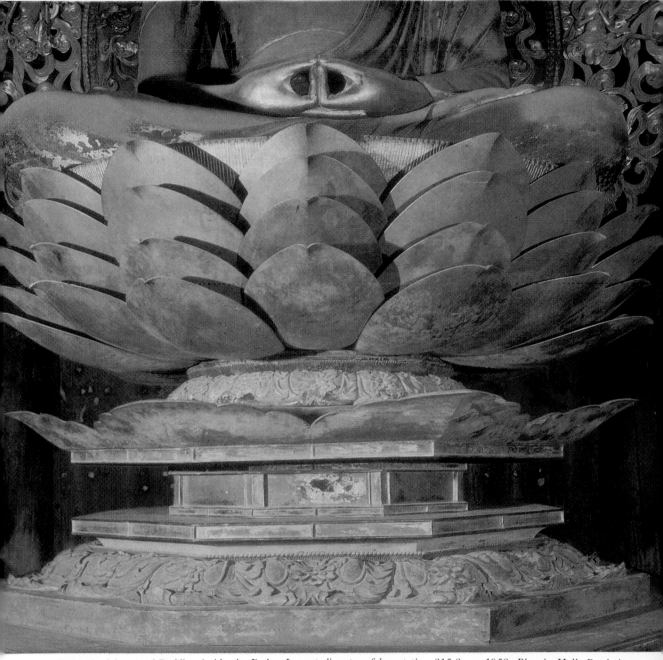

54. *Pedestal of image of Buddha Amida, by Jocho. Longest diameter of lowest tier, 315.3 cm. 1053. Phoenix Hall, Byodo-in, Uji, Kyoto Prefecture.*

◁ 53. *Buddha Amida, by Jocho. Gold leaf and lacquer on wood; height of image, 295 cm. 1053. Phoenix Hall, Byodo-in, Uji, Kyoto Prefecture.*

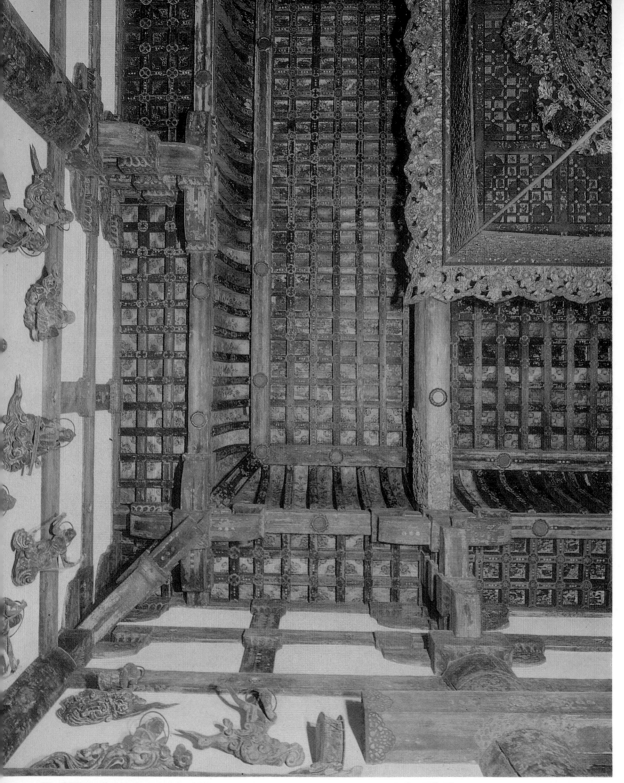

55. *Ceiling of central structure of Phoenix Hall. Colors on wood. 1053. Byodo-in, Uji, Kyoto.*

56. *Canopy of Buddha Amida. Gold leaf and lacquer on wood with mother-of-pearl inlay; length, 487 cm.; width, 436 cm.;* ▷
diameter of disk, 294 cm. 1053. Phoenix Hall, Byodo-in, Uji, Kyoto Prefecture.

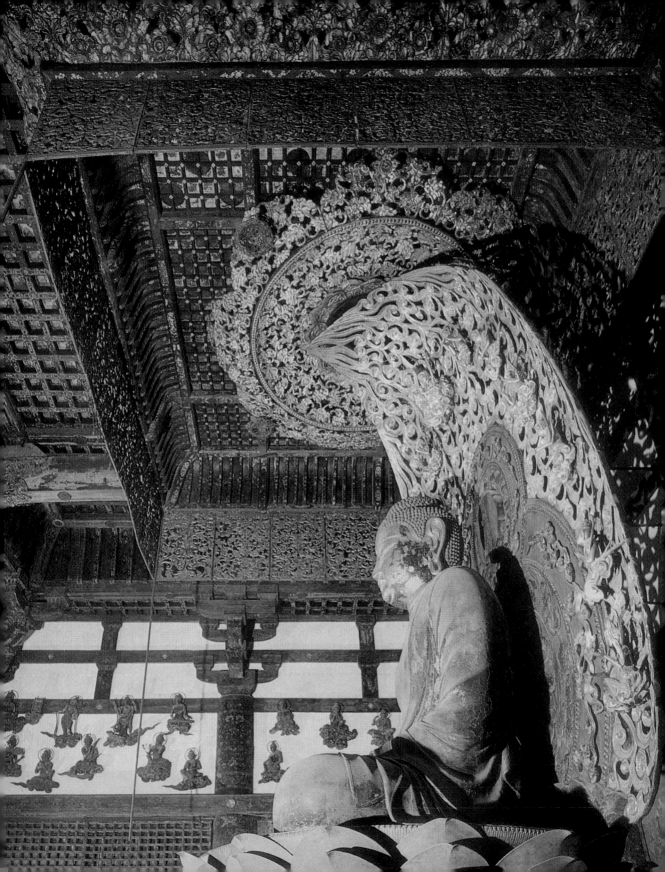

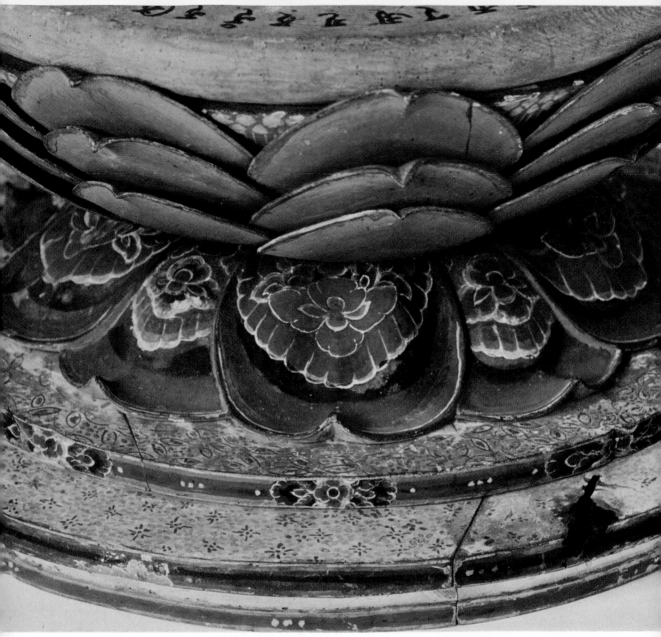

57. *Lotus pedestal supporting disk bearing mystic formulas, placed inside image of Buddha Amida. Colors on wood; overall height (see Figure 66), 19.1 cm.; diameter of disk (see Figure 65), 30.7 cm. 1053. Phoenix Hall, Byodo-in, Uji, Kyoto Prefecture.*

58. *Cloud-supported adoring bodhisattva. Colors on wood; overall height, 75.2 cm. Eleventh century. Phoenix Hall, Byodo-in,* ▷
Uji, Kyoto Prefecture.

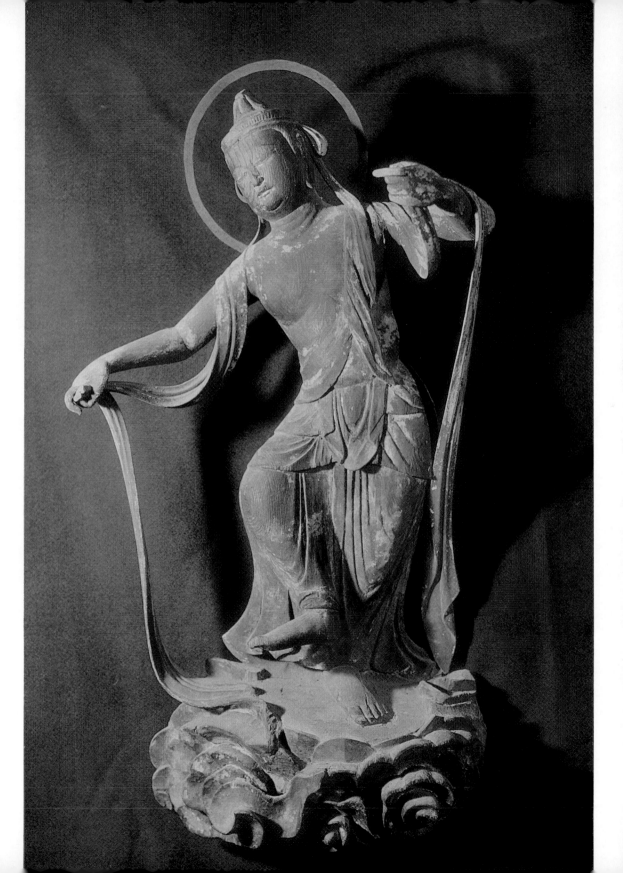

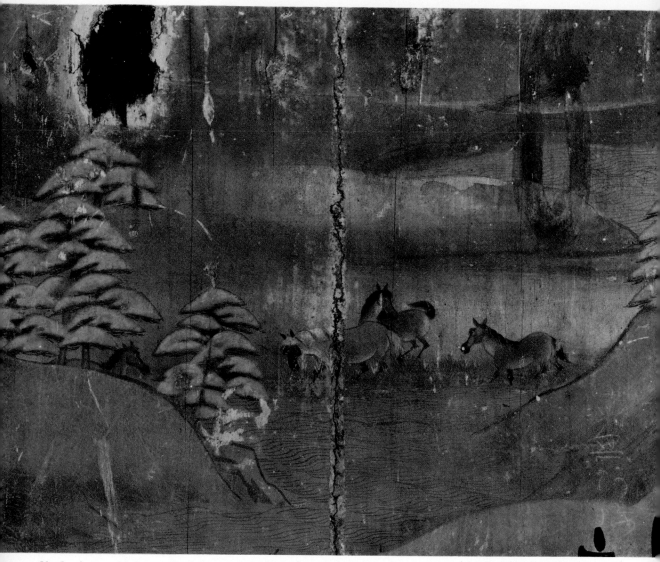

59. *Landscape with horses, detail from Phoenix Hall door painting of "middle class, upper rank" of rebirth. Colors on wood; length of figure of horse at right, 6.8 cm. 1053. Byodo-in, Uji, Kyoto Prefecture.*

60. *Adoring bodhisattva, detail from Phoenix Hall pillar painting. Colors on wood; height of figure, 18 cm. 1053. Byodo-in, Uji,* ▷
Kyoto Prefecture.

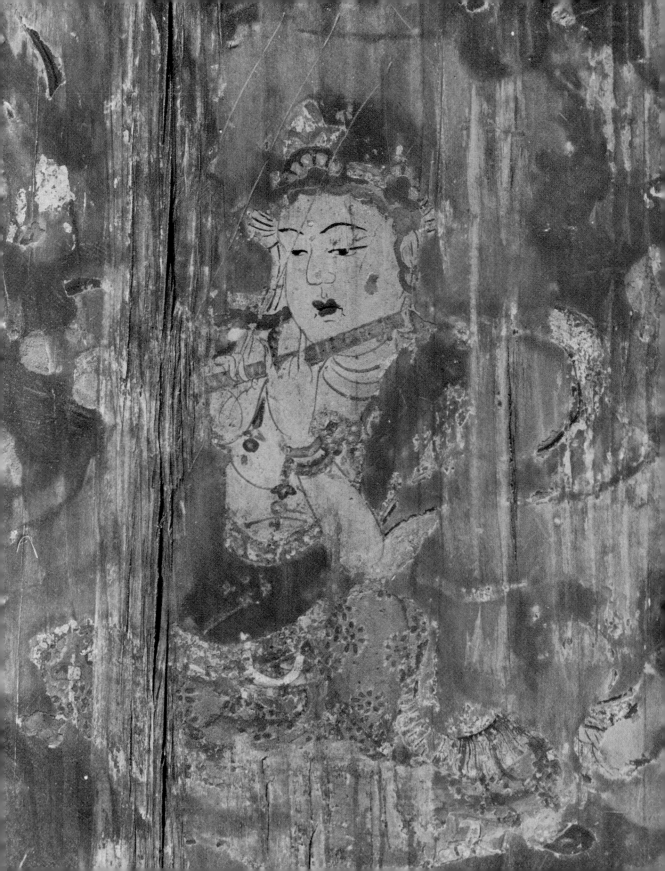

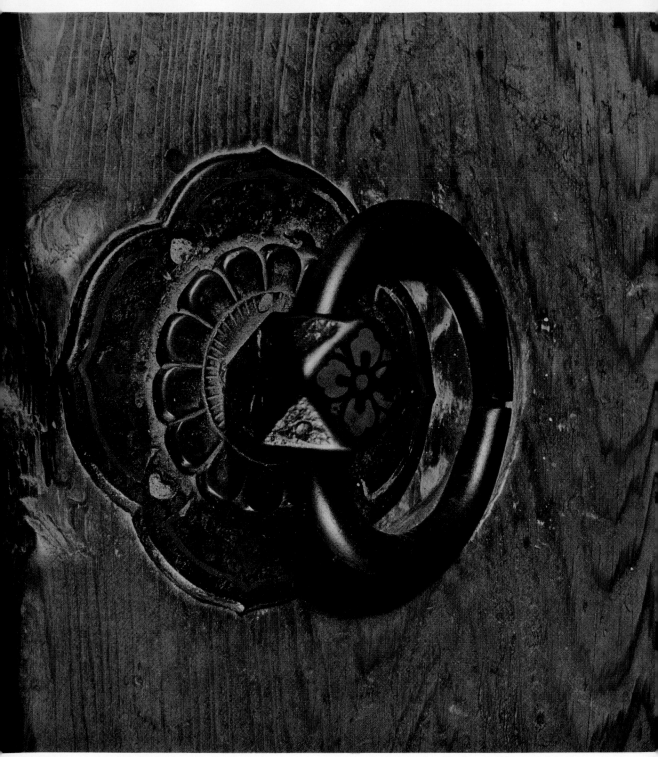

61. *Door pull of Phoenix Hall. Iron with copper inlay; diameter, 9 cm. 1053. Byodo-in, Uji, Kyoto Prefecture.*

62. Interior of north wing of Phoenix Hall. Interbeam span, 3.94 m. 1053. Byodo-in, Uji, Kyoto Prefecture.

sion). The doors showed the Eight Events in the Life of Shaka, while on the upper walls flew angels on clouds. The Godaido enshrined the Five Great Kings of Light: a twenty-*shaku* image of Fudo Myo-o (Acala) and *joroku* images of the other four.

The praises of the incomparable dignity and serenity of the images in the two halls were sung in prayers and incantations; and Jocho, the great sculptor who produced the works, achieved his desire to be awarded the rank of *hokkyo,* becoming the first carver of Buddhist images to gain a position in the Buddhist hierarchy. The title was purely honorary, however, for he did not actually serve in any hierarchic capacity, and his name was not entered in the official gazette of prelates.

The Yakushi hall faced west; its façade measured fifteen bays and was similar in style to the Amida hall. It enshrined *joroku* images of the Seven Mani-

festations of Yakushi, ten-*shaku* images of the bodhisattvas Nikko (Suryaprabha) and Gakko (Candraprabha), eight-*shaku* figures of the Twelve Godly Generals, and *joroku* representations of the Six Manifestations of Kannon. There were two paintings by Iimuro no En'en, grandson of Fujiwara no Koretada. One, on the *moya* pillars in front of the Yakushis, illustrated the Twelve Great Vows of Yakushi; the other, on the *moya* pillars in front of the Kannons, illustrated the so-called Kannon-bon, the twenty-fifth chapter of the *Lotus Sutra.* The Shaka hall was a thirteen-bay-wide structure with a cypress-bark roof, the center bays of which were made high enough to accommodate a *joroku* Shaka and six-*shaku* images of Bon Ten, Taishaku Ten, the Four Celestial Guardians, the Ten Great Disciples of Shaka, and the Eight Supernatural Guardians of Shaka, flanked by one hundred life-size

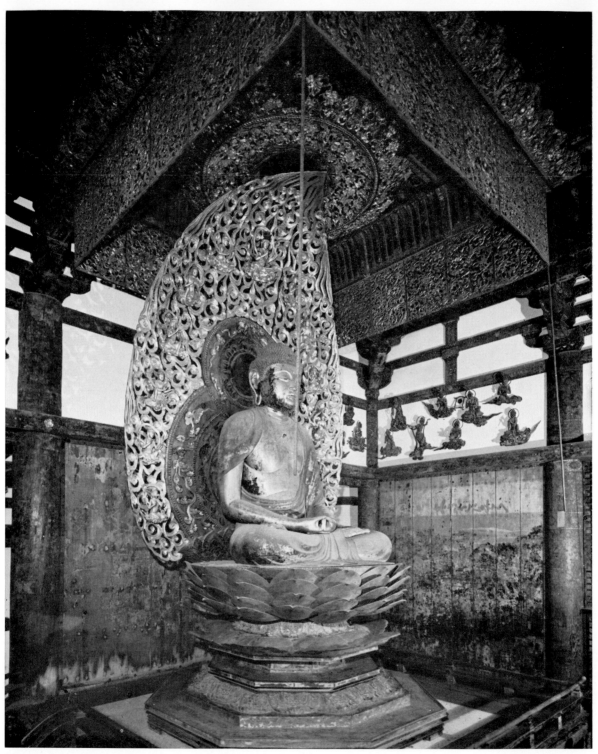

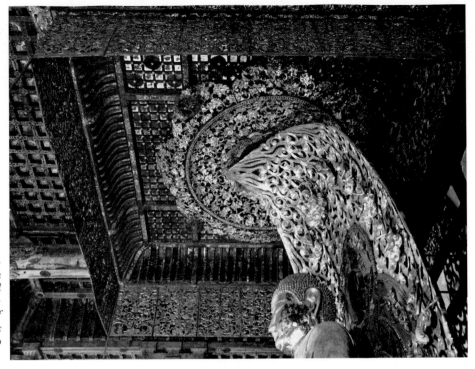

63. *Buddha Amida, by Jo-cho. Gold leaf and lacquer on wood; height of image, 295 cm. 1053. Phoenix Hall, Byodo-in, Uji, Kyoto Prefecture.*

64. *Canopy of Buddha Amida. Gold leaf and lacquer on wood with mother-of-pearl inlay; length, 487 cm.; width, 436 cm.; diameter of disk, 294 cm. 1053. Phoenix Hall, Byodo-in, Uji, Kyoto Prefecture.*

Shaka images. The paintings on the pillars illustrated the *Lotus Sutra*. The lecture hall, its façade seven bays wide, enshrined a twenty-six-*shaku* image of Dainichi; *joroku* figures of Shaka, Yakushi, the bodhisattvas Emmei (a manifestation of Fugen) and Fukukenjaku, Fudo Myo-o, and Daiitoku Myo-o (Yamantaka); and six-and-a-half-*shaku* figures of the Four Celestial Guardians.

When Michinaga took holy orders at Nara's To-dai-ji in the autumn of the year in which he renounced the world, he is reported to have been greatly moved by the splendor of the many Nara-period halls he saw and to have been determined to embellish his own temple to the same degree. However, the edifices and images that he actually completed were not replicas of the Nara-period works, and many show important departures. The Hojo-ji, though smaller than the gigantic Todai-ji, was still considerably larger than the majority of Heian temples. The practice of excavating a large

pond with an islet and of building artificial hillocks directly in front of buddha halls was not found in temples of Nara Buddhism but seems to have started in Heian times. It is recorded that in 963 Kuya raised a pagoda at the Shosui-ji on the west bank of the Kamo River in Kyoto; that in front of the pagoda a pond was dug, in which he floated barges having Chinese-style prows in the form of dragon heads and carrying copies of the *Dai Han-nya-kyo* (a collection of related *Hannya* sutras) transcribed in gold on indigo paper; and that he arranged performances of music played on stringed instruments to celebrate the *buddhadharma* (Buddhist law). This story indicates that gardens with ponds were being laid out in the precincts of Kyoto temples by the middle of the tenth century. When the pond was in front of an Amida hall, it could be argued that the pond was meant to symbolize the Pond of Ablution in the Pure Land, but other types of halls also had ponds, so that this explana-

65. *Mystic formulas inscribed on disk placed on lotus pedestal inside image of Buddha Amida. Ink on kaolin-finished wood; diameter of disk, 30.7 cm.; diameter of face, 29.2 cm. 1053. Phoenix Hall, Byodo-in, Uji, Kyoto Prefecture. (See also Figure 57.)*

66. *Lotus pedestal supporting disk bearing mystic formulas, placed inside image of Buddha Amida. Colors on wood; overall height, 19.1 cm.; diameter of disk, 30.7 cm. 1053. Phoenix Hall, Byodo-in, Uji, Kyoto Prefecture. (See also Figure 57.)*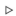

tion cannot be accepted without reservation. It is more likely that the style of providing a garden pond for a private mansion—the so-called *shinden* style, which was coming into vogue among the Kyoto aristocracy after its use in the Shinsen-en, the "forbidden garden" of the imperial court—simply found its way into temple architecture. In temples like the Hoko-in and Seson-ji, where residential quarters had been turned into buddha halls, the front pond is all the more likely to have existed from before the transformation.

THE FOUNDING OF THE BYODO-IN

The earlier Hojo-ji, the supreme monument of the Fujiwara regents, set the form of the so-called Fujiwara style in architecture, painting, and various associated handicrafts, and exerted an enormous influence on later generations. The first major temple complex constructed under that influence was the Byodo-in in Uji (Figs. 42, 49).

In 998, before founding the Jomyo-ji, Michinaga purchased a residence on the banks of the Uji River from the widow of Minister of the Left Minamoto no Shigenobu, Emperor Uda's (r. 887–97) grandson, who had died three years previously. Michinaga held the ceremonies of occupancy in the autumn of the following year but left this villa, then called Uji-in or Uji-dono, to his son Yorimichi, who used it for half a century as a place of recreation and refuge from the summer heat. Then in the third month of 1052, the year after the celebration of his sixtieth year, Yorimichi converted it into a Buddhist temple, naming it the Byodo-in, and held a ceremony to dedicate the residence as the temple's main hall. This structure faced east

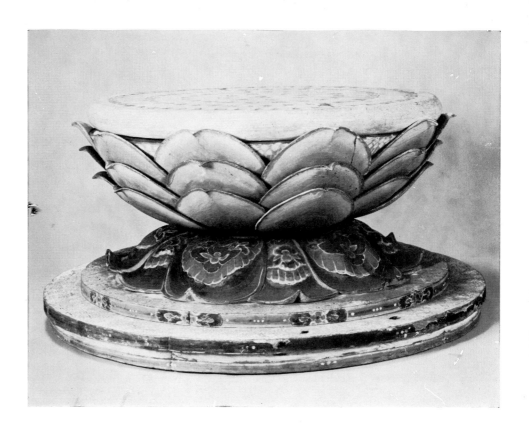

toward the Uji River and, like the Golden hall of the Hojo-ji, housed a statue of Dainichi as its principal object of worship. Among the flanking figures, the Yakushi, Shaka, and Daiitoku were the work of Jocho, but the Fudo Myo-o is said to have been by his father, Kosho.

One year later, in the third month of 1053, came the dedication of the Amida hall, now called the Ho-o-do, or Phoenix Hall (Figs. 19, 42, 43, 50). It enshrines a *joroku* Amida and, like the main hall, faces east. This image, on which work had begun about a year previously, was brought from Kyoto and set on the altar about one month before it was dedicated. The sculptor, Jocho, now raised to the rank of *hogen,* was rewarded by Yorimichi with a ceremonial court robe of pale green. The dedications of other halls followed: the lotus-meditation hall in 1056; the Taho pagoda in 1061 by the im-

perial consort Kanshi, Yorimichi's daughter, who enshrined there a group of five images of the Diamond World, including Dainichi; and the Godaido in 1066 by Yorimichi himself. The five images in the pagoda were carved by Kakujo, and the dedicatory inscription was in the hand of Minamoto no Kaneyuki, who was then director of the imperial craftsmen.

The visit by Emperor Goreizei (r. 1045–68) to the Byodo-in in 1067 was a most significant event in the history of this temple. A brocade canopy was set up over the pond to make a place of worship, while barges with dragon-head prows were launched upon the pond for musical performances. The sutra repository was already in existence at this time, and beginning in 1069 an annual recitation of the essence of the complete Buddhist canon was held in front of it. In 1070 Yorimichi built a palace

67. *Excerpt from the* Kan Muryoju-kyo *sutra inscribed after fashion of special writing card, from Phoenix Hall door painting of "lower class, upper rank" of rebirth. Colors on wood; height, 40.6 cm.; width, 32.8 cm. 1053. Byodo-in, Uji, Kyoto Prefecture.*

68. *Amida's Pure Land, detail from painting on front face of reredos of Amida image. Colors on wood; height, about 26 cm.; width, about 36 cm. Twelfth century. Phoenix Hall, Byodo-in, Uji, Kyoto Prefecture.* ▷

to the west of the Byodo-in; this may be the Uji Izumi-dono that his son Morozane repaired later. In 1073, in prayer for the alleviation of Yorimichi's illness, Minister of the Right Minamoto no Morofusa dedicated a Fudo hall in the southwest corner of the temple grounds. A Goma hall, to be used for an Esoteric Buddhist fire ritual, began to be constructed at Yorimichi's wish, but he died in the second month of 1074, so that the ceremonies marking the forty-ninth day of his death became the occasion for the hall's dedication. Thus it can be seen that the buildings of the Byodo-in were added gradually throughout the last twenty-odd years of Yorimichi's life.

The temple belongs to the Tendai sect, but the existence of a main hall, Taho pagoda, Godaido, Fudo hall, and Goma hall suggests a strong Shingon influence. Indeed, here is a clear indication of the comprehensive, eclectic character of Japanese Buddhism in the Heian period.

THE SOLEMNITY OF THE PHOENIX HALL

The Amida hall, or Phoenix Hall as it is popularly called, of the Byodo-in was dedicated one year later than the main hall, and whereas the main hall seems to be a mere remodeling of an existing residence, the Phoenix Hall exhibits an elaborate extravagance of style that can hardly have been achieved in one year of construction. In formal pilgrimages to temples the main hall was to be visited first and thus was accorded priority in terms of dignity; but the Byodo-in was in fact centered on the Phoenix Hall, which from Heian times was said to have re-created Amida's Pure Land in tangible form. The garden, too, was laid out with reference to the Phoenix

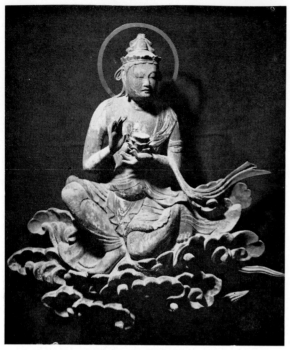

69. Cloud-supported adoring bodhisattva. Colors on wood; overall height, 64.4 cm. Eleventh century. Phoenix Hall, Byodo-in, Uji, Kyoto Prefecture.

Hall, with the main hall relegated to a subsidiary role. At the Hojo-ji, the Amida hall was built first and enjoyed ritual priority, while the overall layout of the complex emphasized the Golden hall, so that a nice balance was maintained between them. At the Byodo-in, by contrast, the Phoenix Hall predominated in terms of both ritual and location, demonstrating the development of Pure Land architecture.

Again, a lotus-meditation hall was built at the Byodo-in, but no *jogyo*-meditation hall. The significance of a *jogyo* hall might have been included in the Phoenix Hall, but the latter certainly does not have the form conventionally associated with *jogyo* halls. The Phoenix Hall is of a unique design, having two-story "wing extensions" to the right and left of the central structure and a "tail extension" (Fig. 17) to the rear, with towers rising from the roof at the ells of the wings. This design, derivative of the palaces depicted in several *jodohen,* drew from several sources: the towered corridor sur-

rounding the Great Audience Hall of the Official Compound at the Heian Imperial Palace; the area around the Shinkaden sanctuary to the west of the Palace Compound; the building and frontal pond of the Shinsen-en garden in Kyoto; and the winged buildings of the mansions of the nobility. However, the erection of buildings on an islet in a pond, and thus the development of a full-fledged garden architecture, represents a significant step forward.

Housed in the central structure of the hall is a gilded *joroku* statue of the seated Amida, his mudra in the meditative position (Figs. 16, 52, 63). His hairline is eight *shaku* above the base. (*Joroku,* or "sixteen *shaku,*" was halved when applied to seated images.) In the image's hollow interior is a beautiful lotus seat that retains its original brilliant coloring (Figs. 57, 66). On this pedestal rests a disk inscribed in Sanskrit with two mystical Amidist formulas—the minor formula in the center and the major formula around it (Fig. 65). Gen-

shin is said to have been particularly fond of reciting these formulas. The pedestal of the Amida image, with a flower-motif relief added to the calyx (Fig. 54), illustrates the fully developed art of lotus-seat design. The mandorla consists of two disks decorated with clouds and angels, but many of these are later restorations. Above the mandorla are a small circular canopy and a large rectangular one, replete with intricate decoration (Figs. 56, 64). The whole work, from base to canopy, has the rich glow of gold.

The altar is lacquered, with liberal use of mother-of-pearl in a stylized floral pattern. The railing, which was doubtless similarly decorated, is a later reconstruction. The pillars, bracketing, ceiling, and other woodwork are decorated in appealing colored designs (Figs. 55, 60), while the upper part of the surrounding walls bear fifty-two adoring bodhisattvas in wood, floating on clouds (Figs. 58, 69–71). On the front surface of the wooden reredos behind the buddha are depictions of potentates rendering veneration, while the Pure Land is shown diminished in the distance (Fig. 68). On the main and side doors and side wall-panels and on the back of the reredos are nine *raigo* pictures depicting Amida and the celestial host (Figs. 26, 37, 59); and on a small door in the rear is a scene of Witnessing the Sunset, one of the Sixteen Ways to Meditate while longing for rebirth in the Pure Land. All the scenes bear extracts from the *Kan Muryoju-kyo* inscribed on special writing cards.

The solemnity of the hall's interior is reminiscent of Michinaga's Hojo-ji: door paintings of the *kuhon raigo* and Amida's welcome to the nine categories of rebirth, with inscriptions from the scriptures, could also be seen in the Hojo-ji, while carvings similar to the cloud-riding bodhisattvas were found in its Golden hall. In looking for prototypes, we see that the first *kuhon jodohen* were on the walls of the East Compound *jogyo*-meditation hall of the Enryaku-ji, while the originals of the adoring bodhisattvas on the walls are to be found in the Jodo-in of the Nara-period nunnery Hokke-ji. The cylindrical base rafters under the eaves of the Phoenix Hall (Fig. 18) show a revival of the long-dormant Tempyo style used in the five-story pagoda of the

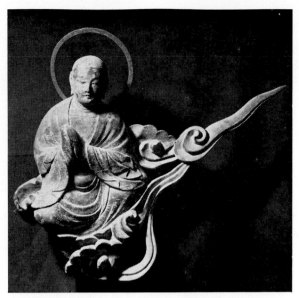

70. *Cloud-supported adoring monk. Colors on wood; overall height, 44.5 cm. Eleventh century. Phoenix Hall, Byodo-in, Uji, Kyoto Prefecture.*

Muro-ji in Nara Prefecture, while the elevation of the central portion of the lower eaves of the façade (Fig. 51) was no doubt inspired by a similar treatment of the original version of the Great Buddha Hall at the Todai-ji, which was still in existence when the Phoenix Hall was built.

Yorimichi carried out the reconstruction of the main portions of the fire-ravaged Kofuku-ji monastery in 1047–48. For the merit gained in carving the statues for this project, Jocho was raised from *hokkyo* to *hogen;* and the head of the government carpentry bureau, Nishiki no Kimimochi, his deputy Awata no Kiyotaka, and the foreman O no Yoshitada were all given court rank. The Buddhist painter and high priest Kyozen executed the pillar paintings in the Golden hall. The dedicatory inscription was in the hand of Governor of Ise Minamoto no Kaneyuki, whose father, Enkan, was a fourth-generation descendant of Emperor Yozei and was known as an outstanding calligrapher in Michinaga's time. The reconstruction of the Kofu-

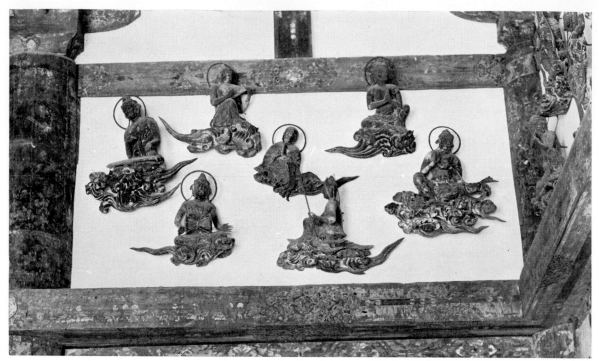

71. Cloud-supported adoring bodhisattvas on upper part of wall in central structure of Phoenix Hall. Colors on wood. 1053. Byodo-in, Uji, Kyoto Prefecture.

ku-ji was an excellent opportunity for builders and sculptors to come into contact with works of the period, and since the construction of the Byodo-in was begun almost immediately by what was probably a similar group of artisans, it was quite natural that the Phoenix Hall should show some influence of the Tempyo style. The bracketing on the pillars of the Phoenix Hall is much more carefully composed than that of the five-story pagoda of the Daigo-ji, providing a perfect example of the triple-

tier form. Heavy timbering was avoided for the lower members of the double-eaves system, and every effort was made to give an impression of lightness and slenderness by planing a great amount off the pillars, beams, brackets, purlins, and both tiers of the hip and eaves rafters. Here we see the clear break into the Fujiwara style, yet it is the retention of some elements of the Tempyo style that has set the Phoenix Hall so far above other structures of the same period.

CHAPTER THREE

Temples of the Retired Emperors

PURE LAND FAITH DURING THE EX-EMPERORS' RULE From the end of the eleventh century on, the Fujiwara regency was followed by a period of about one hundred years in which political power was exercised by three retired emperors—Shirakawa (r. 1072–86), Toba (r. 1107–23), and Goshirakawa (r. 1155–58)—who, after abdication, continued to rule from their headquarters in order to reassert imperial control over the nation. During this period the custom of amassing merit through dedicating large numbers of temples and images prevailed not only in Kyoto but throughout the whole country. But it was in the capital itself, and particularly at Shirakawa and Toba, locations in eastern and southern Kyoto, that building took place on a truly prodigious scale.

Inspired by Genshin's Ojo-in, Yokan, a high priest of the Sanron sect, which flourished at the Todai-ji, began to follow the precedent set by the Hall of Impermanence at the Jetavana monastery in the ancient Indian kingdom of Magadha. In 1097 he made a *joroku* Amida for the Yakuo-ji and there devoted himself to charitable works, opening a solarium for the treatment of the sick and providing food for the indigent. Coming under the influence of Tendai Pure Land doctrines, he followed the path of *shomyo nembutsu* (meditation while chanting Amida's name) and by the time of his death in 1111 had contributed greatly to the development of Pure Land doctrine in Japan through his authorship of the *Amida-kyo Yoki* (Essence of the Amida Sutra), *Ojo Juin* (Ten Superior Aspects of Rebirth), and other works, which the faithful of the time vied in copying.

The first half of the twelfth century saw the appearance of several notable priests: Ryonin in the Tendai sect, Chinkai in the Todai-ji Sanron sect, and in the Shingon sect Jippan of the Ono school and Kakuban of the Hirozawa school.

Ryonin (1072–1132), a monk attached to the East Compound *jogyo*-meditation hall of the Enryaku-ji, secluded himself in about 1097 in Ohara, northern Kyoto, to practice *jogyo* meditation. From his precept "The *nembutsu* I invoke flows to all beings, and the *nembutsu* of all beings permeates me" began the *yuzu* (permeation) *nembutsu*, and subsequently Ryonin founded the Yuzu Nembutsu sect. In 1109 he built the Raigo-in in Kyoto and began the study of Sanskrit chanting.

The monk Chinkai (d. 1152) lectured on the *Yuimakitsu-gyo* (Vimalakirti Sutra) in 1142 and wrote such works as the *Ketsujo-ojo Shu* (On Sure Rebirths) and the *Bodaishin Shu* (Earnest Wish for Enlightenment). He was a follower of Genshin and Yokan and was influenced by Shan-tao's (613–81)

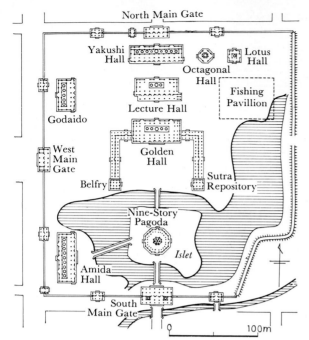

Labels within the image:
North Main Gate
Yakushi Hall
Octagonal Hall
Lotus Hall
Fishing Pavillion
Godaido
Lecture Hall
West Main Gate
Golden Hall
Belfry
Sutra Repository
Nine-Story Pagoda
Islet
Amida Hall
South Main Gate
0 100m

72. Restoration of Hossho-ji ground plan. The temple was origi-
nally completed in 1077 and was reconstructed after having
burned down in 1342, but it is no longer extant.

Commentary on the Kan Muryoju-kyo in making *shomyo* his standard observance.

Jippan (d. 1144) was a man of wide learning. He received training first in the Hosso (Consciousness Only) teachings at the Kofuku-ji and then went on to study other doctrines: Esoteric Shingon at the Daigo-ji, Tendai at Yokawa, and Ritsu (Rule) at the Toshodai-ji. He died at Mount Komyo in southern Kyoto. Still extant is his *Byochu Shugyo-ki* (Record of Spiritual Exercises in Sickness), which maintains an essentially Esoteric point of view and encourages use of *shomyo nembutsu*. This book also gives evidence of Shan-tao's influence.

Kakuban (1095–1143) was the priest who in 1132, under the patronage of the retired emperor Toba, built the Dai Dempo-in and the Mitsugon-in on Mount Koya. He was influenced by Jippan, wrote the *Ichigo Daiyo Himitsu-shu* (Compendium of Secrets of Life) and the *Amida Hishaku* (Exegesis of the Amida Sutra), and emphasized sudden en-

lightenment through direct perception of the mystical truth that "Amida *is* Dainichi," and "Reality *is* nirvana." It is worth noting that the Pure Land doctrines had made a strong impact even on the Shingon, a sect generally considered to deny their validity.

Genku (1132–1212), better known as Honen, studied at Kurodani on Mount Hiei and became a follower of the Pure Land doctrines that had developed from Chiko in the Nara period in a line through the Heian priests Ennin, Ryogen, Senkan, Genshin, Eikan, and Chinkai. He found particular edification in Genshin's *Ojo Yoshu* and in 1175 reached a higher plane of enlightenment involving total concentration on the *shomyo nembutsu*. In 1198 he produced the *Senjaku Hongan Nembutsu Shu* (Incantation of Amida's Forty-Eight Vows), criticizing, with Tao-ch'uo and T'an-luan (476–542), the other monastic orders and elements of Pure Land thought that emphasized grace through works. He totally discarded the concept of relying on the self ("salvation by works") and, adhering to Shan-tao, stressed the need to devote oneself to *shomyo nembutsu* with total faith in the saving power of Amida ("salvation by faith"), obtainable through the latter's original vow to abstain from entering nirvana until all sentient beings should attain enlightenment. Honen's establishment of the Jodo sect was a highly significant event in the development of Heian Pure Land doctrine, although the sect's influence was not felt during the times that form the purview of this book. We can, however, take a brief look at the characteristics of the temples and images created under the influence of Pure Land beliefs.

THE SIX "SHO" TEMPLES AT SHIRAKAWA

I would like to devote some time to the six related temples at Shirakawa on the eastern fringe of Kyoto: Hossho-ji, Sonsho-ji, Saisho-ji, Ensho-ji, Josho-ji, and another Ensho-ji. Often called the Six Sho Temples, because the second syllable of all their names is the same, these temples are typical of the first half of the period of rule by retired emperors.

The earliest, the Hossho-ji (Fig. 72), was founded

73. *Drawing believed to portray Hossho-ji Golden Hall, from copy of* Nenju Gyoji Emaki *(Picture Scroll of Annual Rites and Ceremonies). Colors on paper; height, 31.8 cm. A copy based on a twelfth-century original. Tanaka collection, Tokyo.*

by Emperor Shirakawa. Its grounds had been occupied since the time of Tadahira, well over one hundred years before, by the Fujiwara villa Shirakawa-dono and had been donated to the Imperial House by Minister of the Left Morozane, son of Yorimichi. The site, like that of the Hojo-ji, measured about 250 meters on a side; its construction required two and a half years. But the dedication in 1077 of the entire complex of buildings—comprising the Golden hall, lecture hall, Amida hall Godaido, and lotus hall, as well as the corridors, bellhouse, sutra repository, monks' quarters, and gates—inaugurated a temple whose grandeur far exceeded that of the Hojo-ji. In the southern half of the grounds was a large pond fed by the waters of the Shirakawa River, and in the middle of the pond an islet was constructed. The fishing pavilion Tsuri-dono on the northeast bank of the pond was without doubt the legacy of the Shirakawa-dono villa of the Fujiwara.

The Golden hall (Fig. 73) was "seven bays and four sides" and was furnished with double eaves. Enshrined in it were a double-*joroku* Dainichi, twenty-*shaku* images of the Four Buddhas of Dainichi's Womb World, nine-*shaku* figures of Bon Ten, Taishaku Ten, and the Four Celestial Guardians, and eight-*shaku* Binzuru (Pindola-bharadvaja), one of the Sixteen Arhats. The lecture hall, a "seven bays and four sides" building with double eaves on the south side, enshrined a twenty-*shaku* image of Shaka and *joroku* figures of Fugen and Monju. The Amida hall measured eleven bays excluding the aisles and enshrined nine *joroku* figures of Amida, ten-*shaku* images of the Eleven-headed Kannon and Seishi, and six-*shaku* figures of the Four Celestial Guardians. The Godaido was five bays wide excluding the aisles and enshrined a twenty-six-*shaku* image of Fudo Myo-o and *joroku* figures of the other four Great Kings of Light. The lotus hall, whose altar space measured only one bay, enshrined a Stupa of the Seven Treasures of Buddhism containing a copy of the *Lotus Sutra* written in gold. The South Main Gate was unusual in adopting a two-story configuration, five bays wide excluding the aisles. It enshrined twenty-*shaku* images of the Kongo Rikishi (Vajrapani), or Benevolent Kings.

Due to his meritorious service in building the Golden hall, Takashina no Tameie was made gov-

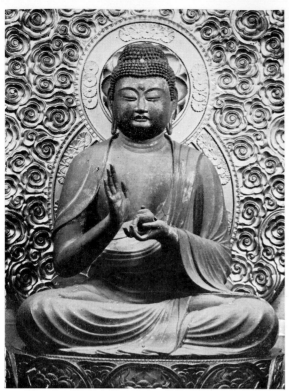

74. *Buddha Yakushi, believed to have belonged to Hossho-ji. Wood; height of image, 88.7 cm. Twelfth century. Saikyo-ji, Otsu, Shiga Prefecture.*

75 *(opposite page, left). Buddha Amida. Gold leaf and lacquer on wood; height of entire image (see Figure 88), 222.7 cm. Mid-twelfth century. Hokkongo-in, Kyoto.* ▷

76 *(opposite page, right). Buddha Amida. Gold leaf and lacquer on wood; height of image, 87.6 cm. Second half of twelfth century. Anrakuju-in, Kyoto.* ▷

lecture hall to participate in reading the essence of the complete canon effectively points up the desire of the Heian aristocracy to avoid preferring any one sect. At the Daijo-e, or Mahayana Convocation—which began at the Hossho-ji the year after its dedication and was held annually thereafter in the tenth month—monks of all sects were invited to participate in a series of ten sessions, lasting for a total of five days, on the *Kegon Sutra* and four related sutras. The Daijo-e was highly regarded as one of the Three Tendai Convocations. On the islet in front of the Golden hall was an octagonal nine-story pagoda completed in 1083 after a construction period of two years. Sutras written in gold were placed within the main pillar of the pagoda. Eight-*shaku* images of the Five Buddhas of Dainichi's Diamond World were placed in the four main directions of the pagoda's orientation, with other images in the other four directions. On the eight corner pillars were drawn pictures of buddhas in "moon circles," or disks. The Yakushi hall, dedicated at the same time, for topographical reasons was located to the north of the lecture hall. It measured nine bays excluding the aisles and enshrined *joroku* images of the Seven Manifestations of Yakushi and figures of Nikko and Gakko. In the neighboring octagonal hall was a three-*shaku* Aizen Myo-o (Ragaraja), or King of Love, in sandalwood.

In 1085 a *jogyo* hall was built for the deceased Fujiwara no Kenshi (d. 1084), who had been consort to Emperor Shirakawa. The solemn atmosphere of this hall was reminiscent of the Hojo-ji's Tohoku-in, which it resembled also in enshrining

ernor of Harima, and a number of other provincial governorships were dispensed to the patrons of the other halls. Ki no Nobutake, Fun'ya no Tameto, and Ki no Nobukata, supervisors of the Golden-hall construction, were all invested with court ranks, and the master sculptor Chosei, who created the buddhas in the Amida hall, was raised to the highest rank of *hoin*. Kakujo, the sculptor of the Golden-hall buddhas, died just before the dedication ceremony, but his assistant Injo was made *hokkyo,* as was Kakujo's son Kenkei, who made the images in the lecture hall.

The Golden hall and the Godaido contained images reflecting Esoteric beliefs, while the Amida hall (where *jogyo* meditation was carried on, thus eliminating the need for an independent *jogyo* hall) was, like the lotus hall, Tendai-oriented. And the fact that monks of all sects were invited to the

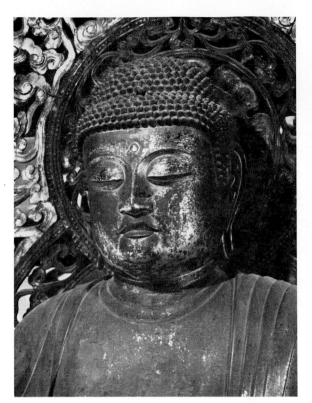 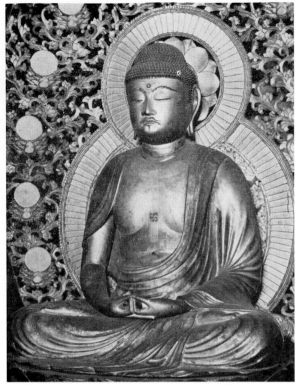

a life-size Amida and three-*shaku* statues of Kannon, Seishi, Jizo, and Ryuju and in having an attached residence. In 1109 the emperor Shirakawa, now retired and tonsured, dedicated a mandala hall, which had a one-bay-wide altar area and was located near the north gate. Enshrined in the hall were a Big Dipper Mandala in wood, an Ichiji Kinrin Butcho (personification of the True Word of Dainichi), and fifty-six other pieces: representations of the Seven Stars of the Big Dipper, the Nine Daylight Angels, the Twelve Signs of the Zodiac, and the Twenty-eight Constellations. In 1122 the retired emperor donated 263,000 half-*shaku* miniature stupas to the temple and had a small hall constructed for their enshrinement. Six years later he added 183,637 round stupas, large and small. In this he probably followed the Nara-period custom of one-million-stupa donations.

The structures of the Hossho-ji were subsequently destroyed through earthquake, fire, and civil disturbance. An Edo-period record notes simply that some ruins remained in the village of Okazaki. At present there remains in the Saikyo-ji in Otsu, Shiga Prefecture, only a seated figure of Yakushi (Fig. 74) that is said to have reposed in the Hossho-ji.

The second of the Sho temples, the Sonsho-ji, was dedicated in 1102 in the name of Emperor Horikawa (r. 1086–1107). From the beginning the temple complex included a Golden hall, lecture hall, ordination hall, Yakushi hall, mandala hall, Godaido, Kannon hall, and east and west pagodas. Three years later an enormous Amida hall was added. Measuring thirty-three bays excluding the aisles, it enshrined nine *joroku* figures of Amida, eight-*shaku* images of Kannon, Seishi, Jizo, and

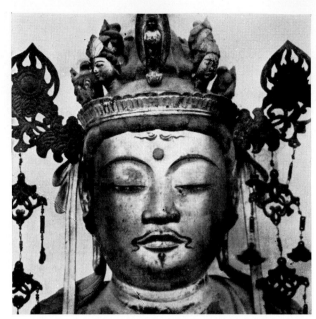

78. *Detail of Thousand-armed Kannon. Rengeo-in Main Hall (Sanjusangendo), Kyoto.*

77. *Thousand-armed Kannon. Gold leaf and lacquer on wood; height of image, 177 cm. 1164. Rengeo-in Main Hall (Sanjusangendo), Kyoto.*

Ryuju, and six-*shaku* images of the Four Celestial Guardians. Also added at this time were a Juntei hall and a lotus-meditation hall with an altar area measuring only one bay.

The Saisho-ji was dedicated in 1118 in the name of Emperor Toba, with Golden, Yakushi, and Godai halls, to which three pagodas were added later.

The Ensho-ji (円勝寺) was dedicated in 1128 at the behest of Emperor Toba's consort, Taikemmon'in (1101–45), a Fujiwara daughter whose given name was Shoshi (璋子)—not to be confused with the Shoshi (彰子) who had become consort to Emperor Ichijo. But the enshrinement of a life-size Dainichi in a three-story pagoda built by her in the temple precincts took place two years before the dedication of the Golden hall. The altar in the pagoda had a railing of red sandalwood richly in-

laid with mother-of-pearl, and a gilt-bronze peacock mirror was set on it. The four pillars of the pagoda were adorned with the Thirty-six Buddhas of Dainichi's Diamond World, while the doors depicted the Twelve Protectors of the Buddha. It is said that this decoration was an imitation of the grandeur of a hall at the Daigo-ji. This hall may well have been the Enko-in on Mount Daigo, dedicated in 1085 along with the Hossho-ji *jogyo*-meditation hall. The Golden hall of the Ensho-ji enshrined a twenty-*shaku* Dainichi, *joroku* images of his four attendant buddhas, and seven-*shaku* figures of the Four Celestial Guardians. In the eastern part of the precincts was the Godaido; and on the west, a nine-bay hall that may have been an Amida hall.

The Josho-ji, dedicated in 1139 in the name of Emperor Sutoku (r. 1123–41), comprised a Golden

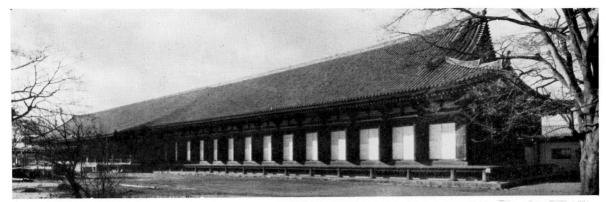

79. *Rengeo-in Main Hall (Sanjusangendo). Length of façade, 118.9 m. 1266. Kyoto.*

80. *Floor plan of Rengeo-in Main Hall (Sanjusangendo).*

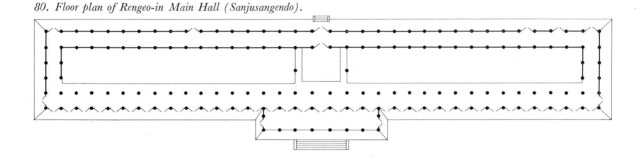

hall, corridors, a sutra repository, a bellhouse, a Kannon hall, and a gate.

The Ensho-ji (延勝寺) was dedicated in 1146 in the name of Emperor Konoe (r. 1141–55) and comprised a Golden hall, a bellhouse, a sutra repository, a pagoda, an Ichiji Kinrin hall, and a gate. After the emperor's death, his residence in the Konoe North Palace was moved to this temple in 1163 and was remodeled as a hall housing nine *joroku* Amidas.

The construction at Shirakawa of these six temples and of some dozen others occupied more than seventy years, from the reign of Emperor Shirakawa through the rule by Shirakawa and Toba from retirement down to the time of the Hogen (1156) and Heiji (1159) wars. This means that in the Shirakawa area a new temple was built on an average of every five years, and halls at the rate of one a year. Characteristic of this age was the fusion of religious and secular architecture, with halls of worship built within noblemen's palaces and imperial residences erected within temple precincts. The highly ranked Six Sho Temples in particular were designed to present an increasingly formalized solemnity, in a style that was centered on a Golden hall and a lecture hall—conventional since the Nara period—but one that was increasingly pervaded with images of Esoteric inspiration. Exceptionally complete examples, however, often included such elements of Pure Land architecture as a hall housing nine Amidas, and the temples built at imperial behest saw the bent for Pure Land architectural elements predominate. Thus we see that the Pure Land doctrine had already come to be most intimately interwoven with the spirit of the times.

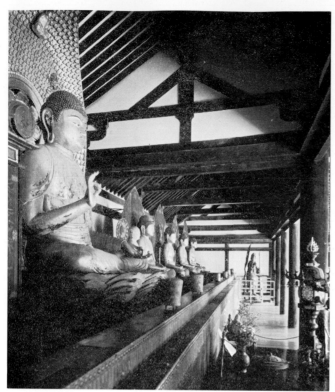

81. *Interior of Joruri-ji Main Hall. Intercolumniation (see Figure 91), 4.24 m. 1107. Kyoto Prefecture.*

82. *Interior of first story of Joruri-ji Three-Story Pagoda.* 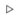 *Dimensions of first story (see Figure 89), 3.05 m. by 3.05 m. Twelfth century. Kyoto Prefecture.*

Besides the Ensho-ji at Shirakawa, Taikemmon'in also built the Hokkongo-in on the site of the vanished Ten'an-ji on the southern slopes of Narabigaoka, a hill that lies to the south of the Ninna-ji in the western suburbs of Kyoto. Until Josaimon'in succeeded her, Taikemmon'in raised large numbers of temples and images, but now only a single image of Amida remains (Figs. 75, 88).

THE TEMPLES IN THE TOBA DETACHED PALACE

The Toba Detached Palace was constructed by Emperor Shirakawa in 1086, the year of his abdication, at Toba in southern Kyoto. Immediately after abdication he withdrew to live in this palace, also called the Toba-dono, and this area remained of great importance during the period of rule by retired emperors.

The Toba Detached Palace originated as a villa donated to the emperor by Fujiwara no Suetsuna, governor of Bizen, to which Takashina no Yasunaka, governor of Sanuki, was ordered to add structures as imperial residences. Levies were raised from over sixty provinces, and the excavation of a pond and the building of hillocks proceeded rapidly. On an approximately square site of 100 hectares, the pond is said to have measured some 800 meters north to south and 600 meters east to west. This accounts for about half the total area, a circumstance no doubt due to the site's being marshy land by the Kamo River. Recent investigations have revealed the western bank of this ancient pond to the southwest of the Jonan Shrine. (See foldout opposite page 112.) Palace construction was rapid, with three villa complexes—the Minamidono, Kita-dono, and Higashi-dono (the South, North, and East villas)—completed in quick suc-

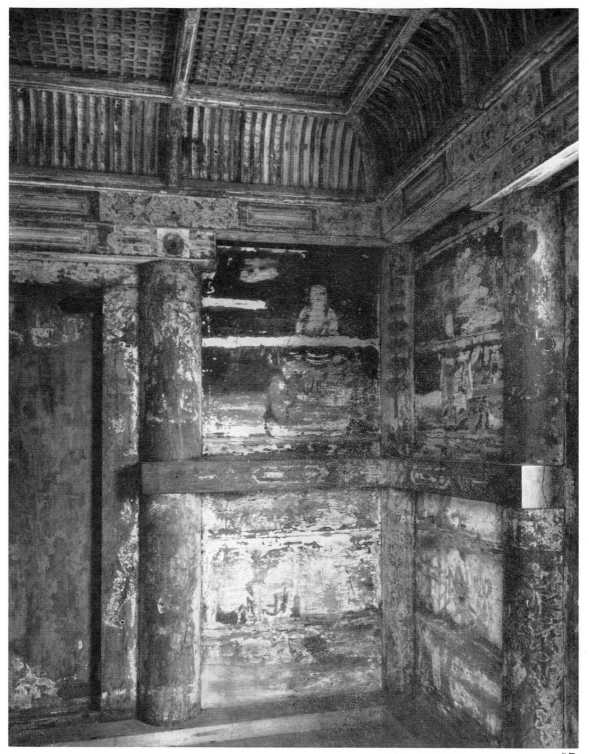

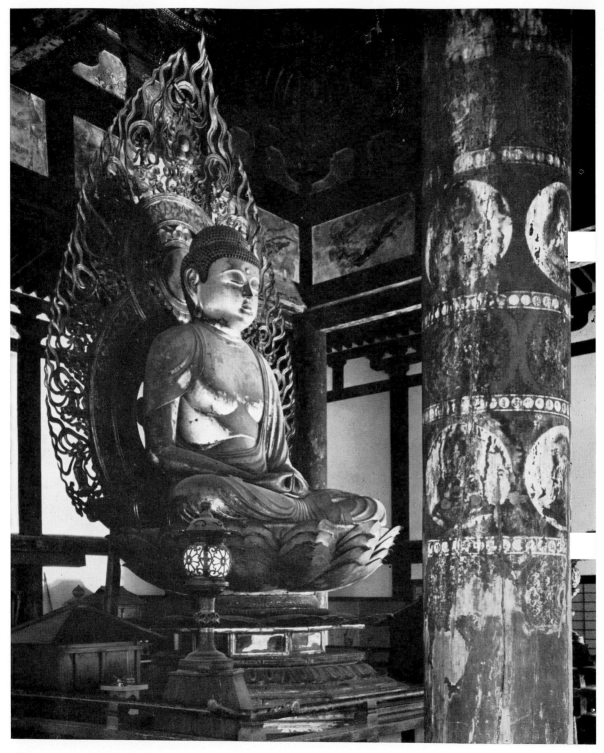

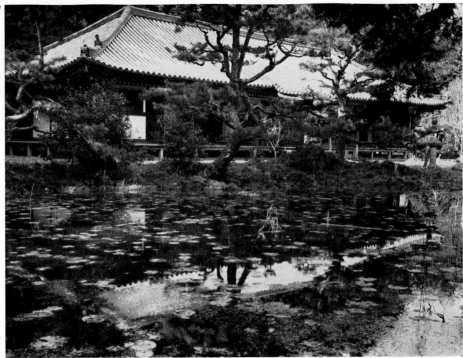

83. *Buddha Amida. Gold leaf and lacquer on wood; height of image, 278.8 cm. Second half of eleventh century. Hokai-ji Amida Hall, Kyoto. (See also Figure 93.)*

84. *Joruru-ji Main Hall. Length of façade, 25.3 m. 1107. Kyoto Prefecture. (See also Figure 91.)*

cession, and the Tanaka-dono somewhat later, after the retirement of Emperor Toba. In addition, the next fifty years saw the construction of a number of religious edifices—namely, the Shokongo-in, Jobodai-in, Shokomyo-in, Anrakuju-in, and Kongoshin-in.

The Shokongo-in, dedicated by the retired emperor Shirakawa in 1101, had as its principal object of veneration a *joroku* Amida, for which work the sculptor Ensei was raised from *hokkyo* to *hogen*. Myoshun was created *hokkyo* in recognition of his pillar paintings. The hall stood on the grounds of the Minami-dono, and the four pillars of the glass-ornamented altar bore mirrors decorated with incised figures of buddhas.

Shirakawa died in 1129 in the West Wing of the Sanjo Nishi-dono. This wing was subsequently removed to the Izumi-dono in the Toba Detached Palace, where, renamed the Jobodai-in, it enshrined nine images of Amida that had been made

while the retired emperor was still alive. In accordance with Shirakawa's last wishes, his ashes were moved in 1131 from the Koryu-ji to the three-story pagoda that he had built in the grounds of the Higashi-dono in 1109 using sandalwood and aloes. This pagoda is believed to have been located in the Jobodaiin-ryo, where Shirakawa's tomb now stands, and it is probable that the hall enshrining the nine Amidas was also in this vicinity. Shirakawa dedicated Taho pagodas to the detached palace in 1111 and 1112, the second apparently within the Higashi-dono grounds, and the retired emperor Toba dedicated a three-story pagoda at the Higashi-dono in 1139.

The Shokomyo-in in the precincts of the Kitadono, dedicated by Toba in 1136 after two years of construction, was a replica of the Phoenix Hall of the Byodo-in at Uji. Facing east overlooking a pond, the Shokomyo-in had only a one-bay altar space but was two stories tall. Besides the main

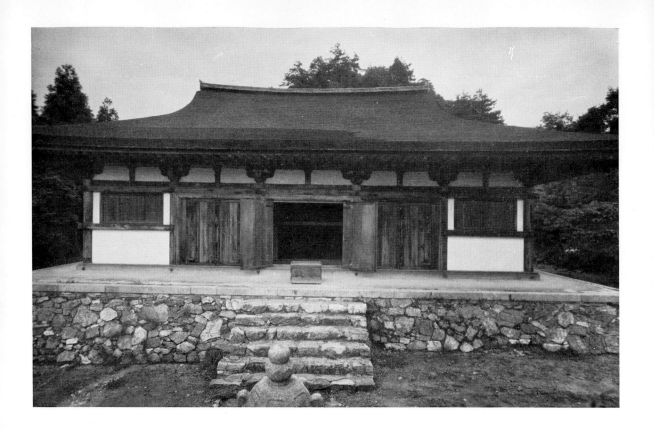

object of veneration, a *joroku* image of Amida, there were paintings showing divinities of Dainichi's Womb and Diamond worlds on the four pillars of the inner sanctuary, the rituals of Welcome to the Nine Categories of Rebirth on the ten door panels at the front and sides of the building, and the Twenty-five Bodhisattvas and the Nine Categories of Rebirth on either side of the reredos. There were 233 smaller figures on the ground floor, including two-and-a-half-*shaku* statues of Fugen and six other bodhisattvas and two-*shaku* images of bodhisattvas and devas set around the sanctuary; upstairs there were seven-and-a-half-*shaku* images of four attendant bodhisattvas—Kongoho, Ri, In, and Go—and thirty-two images of bodhisattvas playing music. The hall resembled the Phoenix Hall in having wings and towers on the sides, but differed in that there were four pillars in the inner

sanctuary and the upper part of the building was adorned inside and out with an almost excessive profusion of buddhas. A sutra repository, built at the same time, was modeled on that of the Byodo-in. The hall renowned as the Shokomyo-in Treasury until the early fourteenth century was probably this building.

In 1137 the retired emperor Toba dedicated a pagoda in a precinct within the Higashi-dono complex that he designated Anrakuju-in, and later, in 1147, he erected a hall housing nine Amidas to the south of the Anrakuju-in. A former regent, Fujiwara no Tadazane, built a Fudo hall—a one-bay altar area plus four aisles, facing north and built of unpainted wood—in the east garden of the Anrakuju-in. In it he enshrined a half-*joroku* image of Fudo Myo-o, two cherubs, and other statuary as tutelary deities of the Toba district. The north-

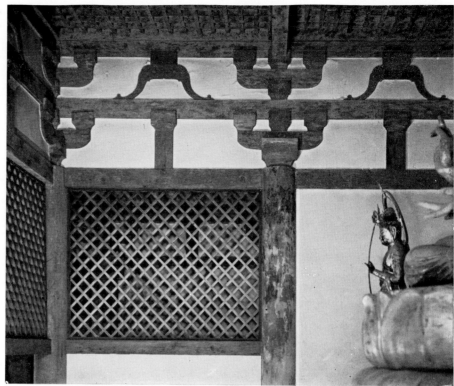

85. Daigo-ji Yakushi Hall. Length of façade, 13.94 m. 1124. Mount Daigo, Kyoto.

86. Interior of Daigo-ji Yakushi Hall. 1124. Mount Daigo, Kyoto.

facing Fudo hall that stands to the west of the present Anrakuju-in is its successor. The retired emperor died in the Anrakuju-in in 1156, and in accordance with his last wishes, his remains were interred in the 1137 pagoda. This tomb is the present Anrakujuin-ryo, but the pagoda crowning it has been lost. Toba intended that his consort, Bifukumon'in (1117–60), formerly Fujiwara no Tokushi, also be buried there, but after her death in 1160 her ashes were placed in the Kongobu-ji on Mount Koya. However, in 1163 the ashes of their son Emperor Konoe (r. 1141–55) were removed from the main hall of the Chisoku-in and placed under this pagoda. His relics now occupy the South Tomb of the Anrakuju-in, whose central edifice is a Taho pagoda reconstructed in 1606.

The last of the Toba temples was constructed on a site measuring 150 meters from east to west and 180 meters from north to south, situated to the north of the horse-riding ground and to the south of the raised-floor residence in the fields. Constructed in the center of the compound, complete with an artificial pond and hillocks, were a south-facing Shaka hall consisting of a three-bay core space and four aisles, a residence of the same size, a corridor running from east to west, fifteen or sixteen structures for retainers, and, southwest of the residence, an east-facing Amida hall, nine bays wide excluding the aisles, enshrining nine *joroku* statues of Amida. In 1154 this complex was named the Kongoshin-in.

The residence and Shaka hall, which were built by Tadazane in appreciation for his reappointment as governor of Harima, have been adjudged splendid and refined, while the Amida hall, which Narichika, governor of Sanuki, provided the emperor,

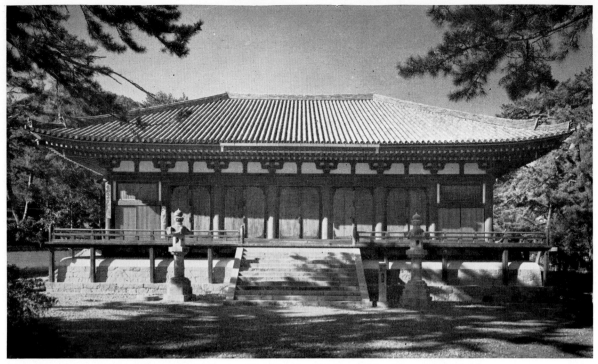

87. Taima-dera Main Hall (Mandala Hall). Length of façade, 21.03 m. 1161. Taima, Nara Prefecture.

has been considered coarse and vulgar. The Shaka triad was carved by *hoin* Kojo of the Nara school, while the nine Amidas were carved by *hoin* Ken'en; the door paintings were by Fujiwara no Takayoshi, and the pillar paintings by *hoin* Chijun. In 1157, in accordance with the wishes of the deceased Toba, an Amida hall was constructed in the Kongoshin-in for his mother, formerly Fujiwara no Shishi, by the order of Bifukumon'in, the widowed empress. This was the last temple constructed in the Toba region during the Heian period. Building at Shirakawa stopped at about the same time.

THE TEMPLES IN THE HOJUJI-DONO PALACE
The period of rule by the retired emperor Goshirakawa saw the rise of the Hojuji-dono palace, located in eastern Kyoto, and attention now shifted from Shirakawa and Toba. The temple called the Hoju-ji, originally built by Fujiwara no Tamemitsu, seems to have remained in disrepair after it was damaged by fire in 1032. In 1158, however, the Shojoko-in—a hall comprising a one-bay core and four aisles and dedicated to Kii no Sammi, wife of Shinzei (Minor Counselor Fujiwara no Michinori; died c. 1159), and enshrining a *joroku* Amida statue—was constructed to the northeast of the temple's main hall. This edifice, with its attendant palatial residence and connecting corridors, was judged to possess elegance and splendor, and it was from this time that the temple regained notice.

In the same year, to begin his rule as retired emperor, Goshirakawa abdicated in favor of the sixteen-year-old prince Morihito, who ascended the throne as Emperor Nijo (r. 1158–65). For his own residence, the retired emperor appropriated land

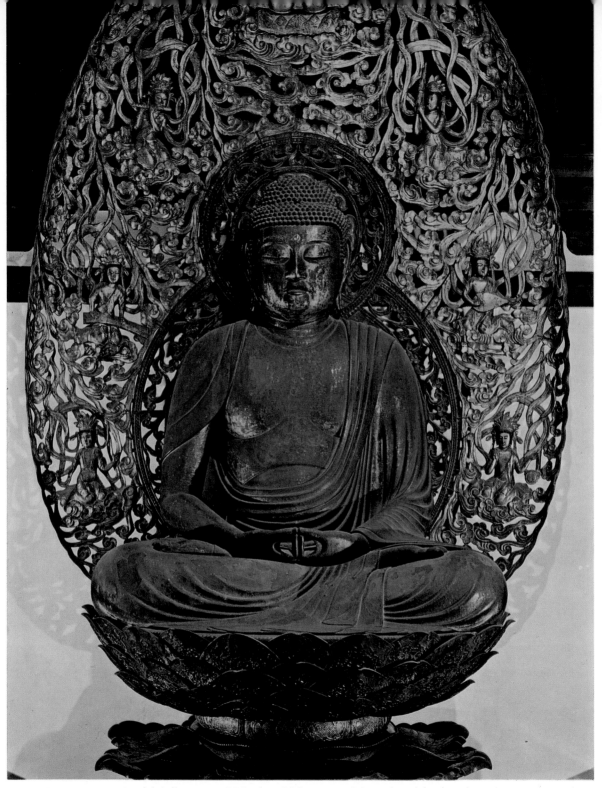

88. *Buddha Amida. Gold leaf and lacquer on wood; height of image, 222.7 cm. Mid-twelfth century. Hokkongo-in, Kyoto. (See also Figure 75.)*

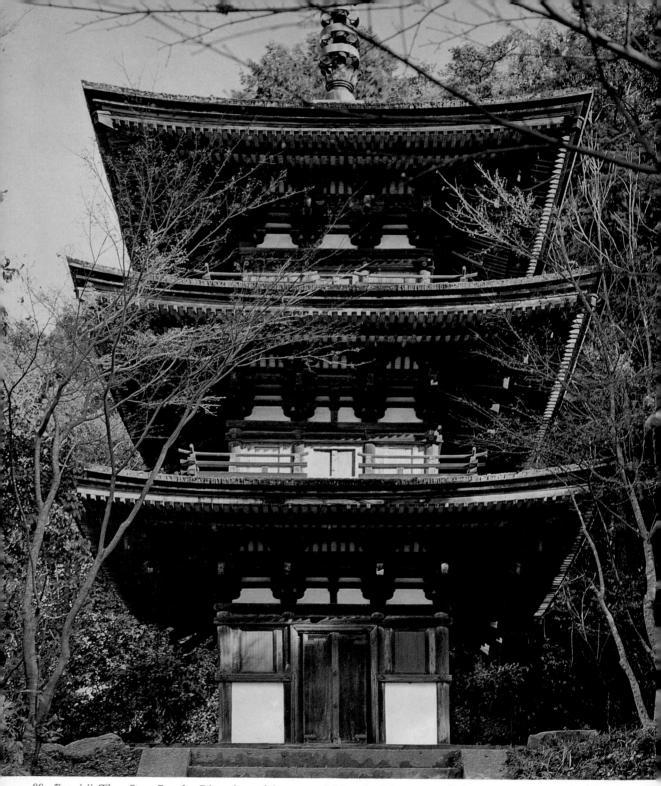

89. *Joruri-ji Three-Story Pagoda. Dimensions of first story, 3.05 m. by 3.05 m.; overall height, 16.08 m. Twelfth century. Kyoto Prefecture. (See also Figure 82.)*

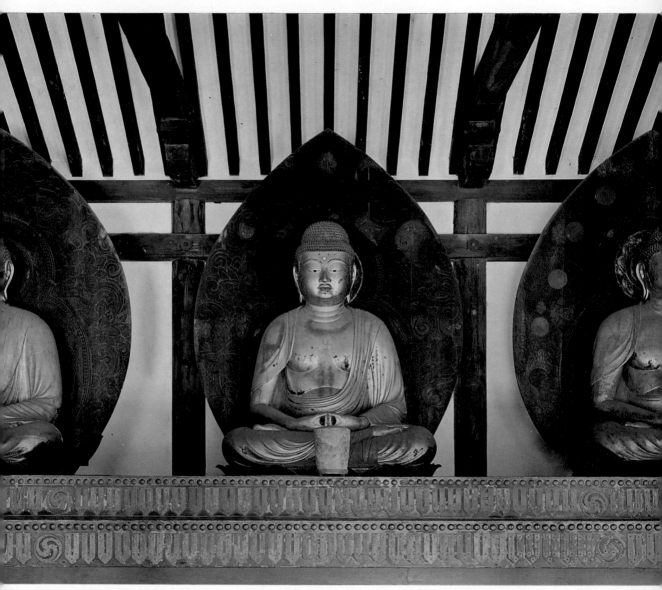

90. *Images of Buddha Amida. Gold leaf and lacquer on wood; height of images, 224 cm. 1107. Joruri-ji Main Hall, Kyoto Prefecture.*

91 (overleaf). *Interior of Joruri-ji Main Hall. Intercolumniation, 4.24 m. 1107. Kyoto Prefecture. (See also Figure 84.)* ▷

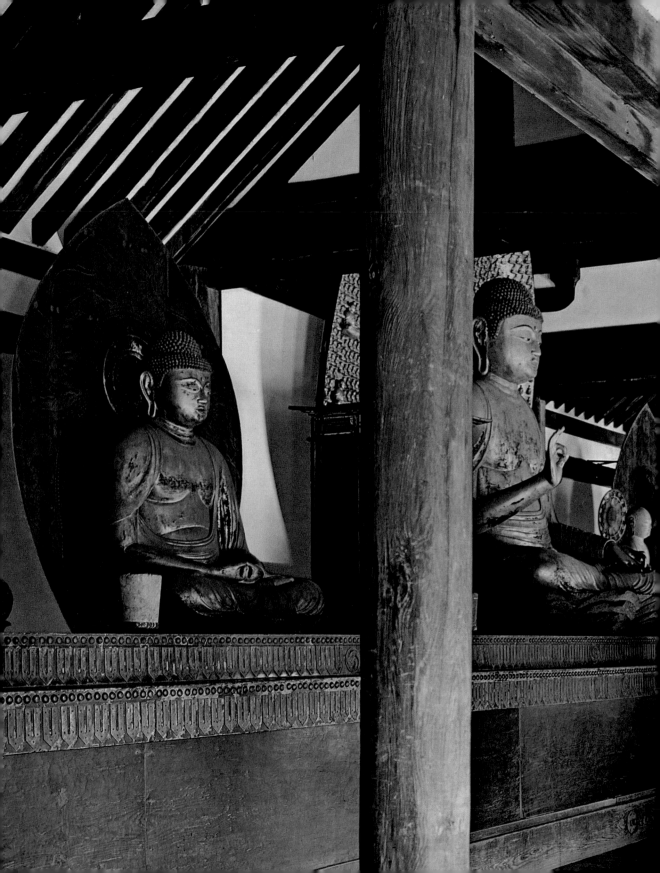

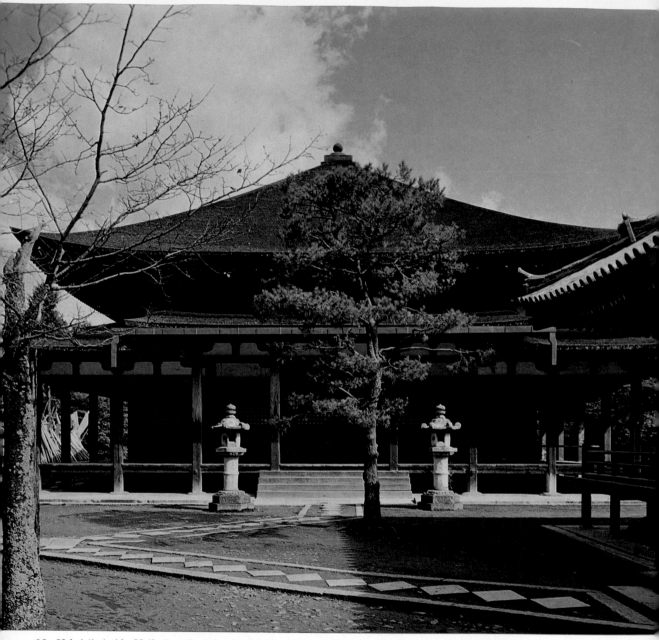

92. Hokai-ji Amida Hall. Length of façade, 18.48 m. Late twelfth or early thirteenth century. Kyoto.

93. Buddha Amida. Gold leaf and lacquer on wood; height of image, 278.8 cm. Second half of eleventh century. Hokai-ji Amida ▷ Hall, Kyoto. (See also Figure 83.)

94 (overleaf). Amida triad. Gold leaf and lacquer on wood; heights of images: Amida, 230 cm.; attendants (see Figure 24), ▷ 128.8 cm. 1148. Sanzen-in Main Hall, Kyoto.

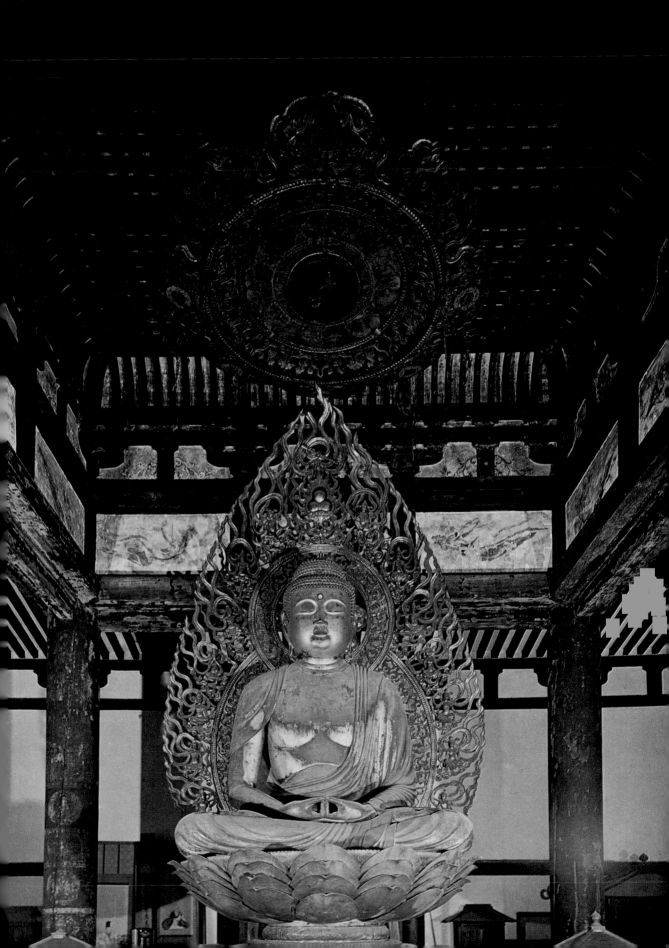

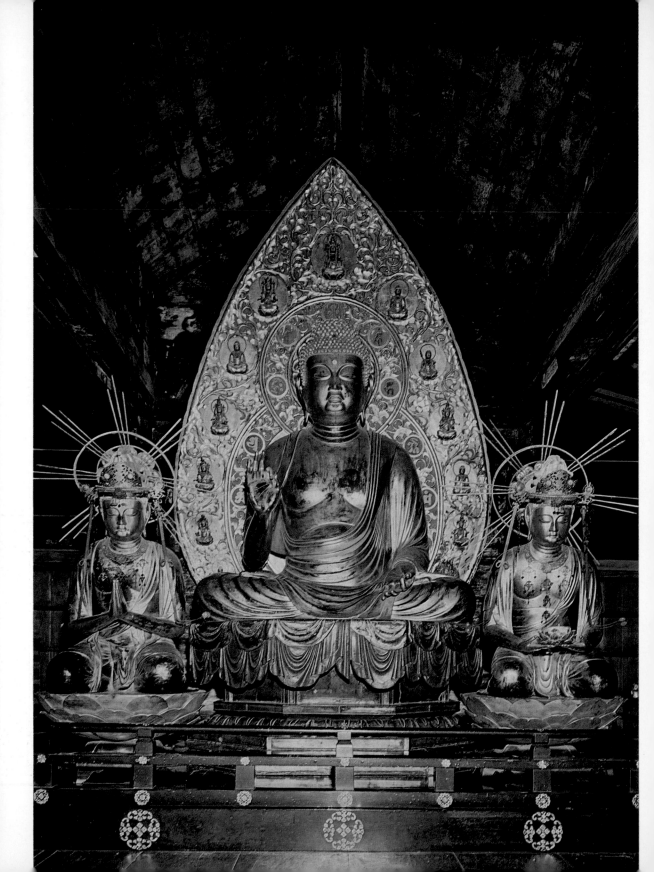

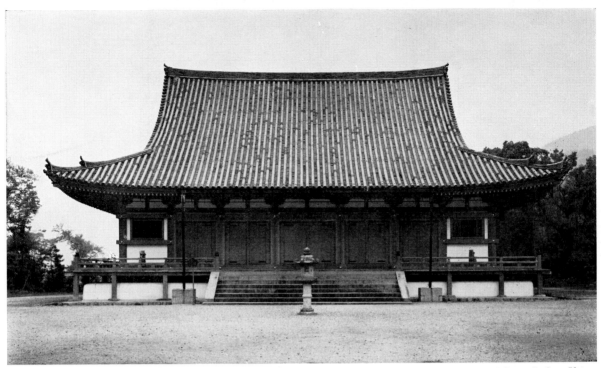

95. *Daigo-ji Golden Hall. Length of façade, 20.8 m. Late twelfth century. Mount Daigo, Kyoto.*

on the east bank of the Kamo River extending some 450 meters from north to south and 350 meters from east to west, and on it constructed the Hojuji-dono palace. This project necessitated razing more than eighty existing buildings of various sizes and incurred a good deal of public resentment; nevertheless the ceremony of occupancy was held in 1161. In the southern part of the compound was the Minami-dono (South Villa), also called the Hojuji-dono villa, while in the northern part was the Kita-dono (North Villa), also called the Shichijo-dono. Both had gates to their west, and in addition there were two-story gates to the south and west of the Kita-dono and to the northwest of the Minami-dono.

In the eastern grounds of the Minami-dono was a Fudo hall dedicated in 1167, as well as a confessional in which services were held to console the spirits of the deceased, especially those of the imperial lineage. The Kosenju-do, nine bays with aisles on only three sides, enshrined one thousand and one figures of the Thousand-armed Kannon (Sahasra Bhuja) and his followers, the Twenty-eight Protectors of Buddhism. The hall was dedicated in 1176 and is said to have been located atop the hill in the southeastern grounds of the Hojuji-dono palace; it may well have been in the Minami-dono villa. Of the buddha halls of the Kita-dono, the Nembutsudo, dedicated in 1177, is well known as a replica of that of the Shitenno-ji in Osaka.

In contrast with these small buddha halls within the villas, in 1164 the retired emperor Goshirakawa dedicated the main hall of the Rengeo-in as a full-scale temple in itself. Lying west of the Minami-dono and facing east, it was thirty-three bays long excluding the aisles and enshrined a *joroku* central image and one thousand life-size representations of the Thousand-armed Kannon, as

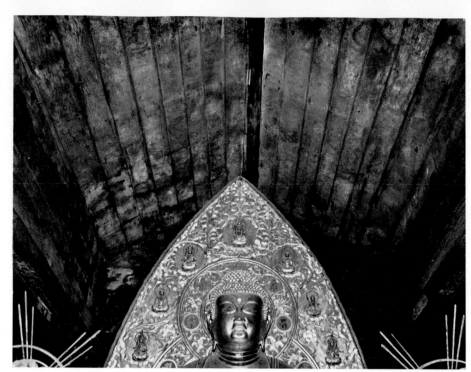

96. Ceiling of Sanzen-in Main Hall. C. 1148. Kyoto. (See also Figure 94.)

97. Sanzen-in Main Hall. ▷ Length of façade, 8.21 m. C. 1148. Kyoto.

well as images of the Twenty-eight Protectors of Buddhism. The images are said to have been made by Kokei and Unkei, father and son from the Shichijo, or Nara, school of Buddhist sculpture, and by sculptors from the Madenokoji and Shichijo Omiya workshops in Kyoto. Gyokei, a high priest of the Shingon sect, is reputed to have put the finishing touches to the central figure himself. Besides the imperial residence built on the central five bays of the veranda in the front of the hall, there was another imperial residence to the south of this building. The treasure repository, north of the hall, was no less famous than those of the Byodo-in and the Shokomyo-in at Toba for the excellence of the works it contained.

Besides the main hall, the precincts of the Rengeo-in contained a Fudo hall. Also built under the aegis of Goshirakawa were a Shinto shrine to the northwest of the main hall, in 1175; a five-story pagoda to its southeast, in 1177; and a Big Dipper hall in 1183. And in 1193, to commemorate the first anniversary of Goshirakawa's death, an Amida hall was dedicated in the southwest grounds of the Rengeo-in, enshrining a *joroku* Amida triad and a Fudo Myo-o made by the sculptor Inson during the ex-emperor's lifetime.

The Rengeo-in was consumed in the great Kyoto fire of 1249, but it is said that the head of the central image, 156 of the other thousand figures of the Thousand-armed Kannon, and the Twenty-eight Protectors were saved. The main hall was reconstructed between 1251 and 1253, and the sculptor Tankei (1173–1256) produced the main image and replaced the lost figures of Kannon. The dedication ceremony was held in 1266. This is the existing Rengeo-in Main Hall, or, as it is better known, the Sanjusangendo (Hall of Thirty-Three Bays; Figs. 79, 80). The hall appears to be

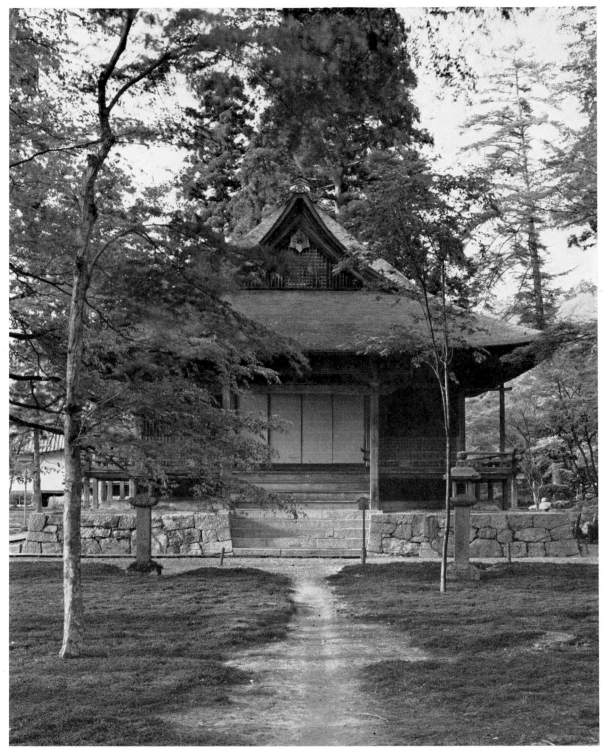

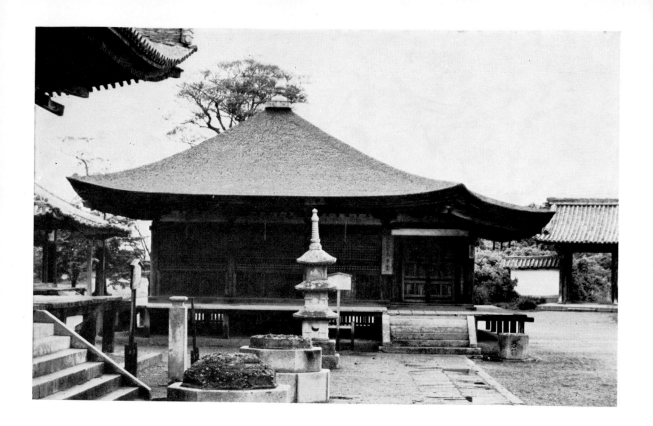

faithful to the original in location, floor plan, and construction. It is believed that of the thousand smaller images of Kannon, 125 are those made for the original dedication of 1164 (Figs. 77, 78).

The Saishoko-in, in the southern precincts of the Hojuji-dono palace, was dedicated in 1173 at the behest of Kenshummon'in (1142–76), formerly Taira no Jishi and then a concubine of Goshirakawa. Paintings by Tokiwa Mitsunaga within the residential quarters of this hall and on sliding doors in the corridors to the left and right illustrated the twenty-eight chapters of the *Lotus Sutra*. Others of his works in the lady's residence showed scenes of her visits to Mount Koya, to the Hirano Shrine in Kyoto, and to the Hie Shrine in Otsu. The faces of her attendant ministers and their subordinates in these paintings were by the hand of Fujiwara no Takanobu (1142–1205).

The hall faced east over a large pond. The fact that it had two-story wings on both sides suggests the influence of such edifices as the Byodo-in and the Shokomyo-in at Toba. The wall panels were apparently gilded. Before the year was out, the south wing of the hall was made the lady's private chapel and a Lotus Mandala (a scene of Shaka expounding the *Lotus Sutra*) was made for display there. Construction of a pagoda was belatedly begun at the end of 1178.

In 1174 Goshirakawa undertook the construction of a lotus hall to the east of the Rengeo-in to serve as his tomb, but when Kenshummon'in predeceased him in 1176, another lotus hall was hurriedly built beside the first to inter her remains. When Goshirakawa died in 1192, his remains were interred in the earlier hall, the present Hoju-ji Lotus Hall Tomb.

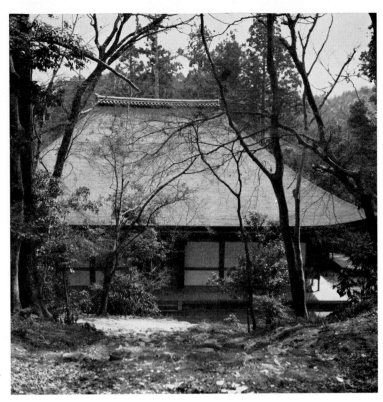

◁ *98. Kakurin-ji Taishido. Length of façade, 6.39 m. 1112. Kakogawa, Hyogo Prefecture.*

99. Ishiyama-dera Main Hall. Length of façade, 21.21 m. 1096. Otsu, Shiga Prefecture.

THE LEGACY OF THE TWELFTH CENTURY

Of all the buildings that graced the city of Kyoto during the rule of the retired emperors, only the three-story pagoda that was moved to the Joruri-ji, outside the city, remains. Its delicate detail well reveals the characteristics of the architectural style of the ancient capital (Figs. 82, 89).

The main hall of the Joruri-ji (Figs. 81, 84, 91) is the only surviving example of a type of building popular at that time: a hall enshrining nine Amidas. Examples of larger, seven-bay edifices are the lecture hall of the Koryu-ji in Kyoto (Fig. 154), the mandala hall of the Taima-dera in Nara Prefecture (Fig. 87), the main hall of the Ishiyama-dera in Otsu, Shiga Prefecture (Fig. 99), and the Golden hall of the Daigo-ji in Kyoto (Fig. 95). The Golden hall of the Taima-dera (Fig. 155) and the

Yakushi hall of the Daigoji (Fig. 85) are examples of five-bay buildings. Three-bay halls with square floor plans in northern Japan are represented by the Konjikido of the Chuson-ji (Fig. 103), but in Kyoto and its vicinity and in Shikoku we see three-bay halls with their depth increased to provide a greater prayer area, as exemplified by the main hall of the Sanzen-in in Kyoto (Fig. 97) and the Taishido (Fig. 98) and *jogyo*-meditation hall (Fig. 156) of the Kakurin-ji in Hyogo Prefecture. The Hokai-ji Amida Hall (Fig. 92) is an example of the five-bay square form with double eaves.

Additional examples of pagodas include the three-story pagoda of the Ichijo-ji in Hyogo Prefecture, built in 1171, and the Taho pagoda of the Kongo-ji in Osaka Prefecture, built about the same time or shortly before. The latter building, however, shows evidence of sixteenth-century restoration.

Penetration of Pure Land Art into the Northern Provinces

THE EXTENT TO WHICH Buddhism spread beyond the capital in Heian times is perhaps best attested by the fact that large numbers of Buddhist images from that period are still extant in all areas of Japan. And since the existence of images would lead one to expect temples and chapels to house them, we may suppose that temple construction was also carried out throughout Japan in the Heian period, although such edifices are extremely rare today except in Kyoto and its surrounding districts.

THE RISE OF FUJIWARA NO KIYOHIRA In 1015, the year before Fujiwara no Yorimichi renamed as Byodo-in the villa in Uji that he had inherited from his father, a rebellion known as the Earlier Nine Years' War broke out in the wild reaches of northeastern Japan. The House of Abè had long been chiefs of the six semiautonomous Ezo (perhaps Ainu) districts along the Kitakami River that now form the western half of Iwate Prefecture. Under Abè no Yoritoki (d. 1057) the Abès, headquartered in the Koromogawa fort, gained in strength and began to raid outside their six territories into the country south of the Koromogawa. As a result, the central authorities appointed Minamoto no Yoriyoshi (988–1075) governor of Mutsu (the eastern half of northern Honshu) and dispatched him to suppress the Abès. In 1057 Yoritoki was defeated, but his two sons, Sadato (1019–62) and Muneto, remained strong. In 1062 Kiyohara no Takenori, a powerful warrior from the province of Dewa (the western half of northern Honshu), came to the assistance of Minamoto no Yoriyoshi and reduced the Koromogawa fort, along with Komatsu, Torinomi, and other Abè strongholds. Eventually Sadato and his brother-in-law Fujiwara no Tsunekiyo were defeated in the fall of the Kuriyagawa fort (located at present-day Morioka) and Muneto surrendered, bringing the rebellion to an end. This Tsunekiyo is thought to have been of a powerful family in Watari, a district located on the southern coast of present-day Miyagi Prefecture. His son was Fujiwara no Kiyohira, who was to found the Chuson-ji temple in Hiraizumi.

In 1063, for their success in suppressing the Earlier Nine Years' War, Yoriyoshi was made governor of Iyo and his son Yoshiie (1041–1108) governor of Dewa. Kiyohara no Takenori was given the singular honor of being created marshal of frontier

100. *Beginning of document dedicated on completion of Chuson-ji complex. Ink on paper; height, 33 cm. 1329. A copy by Fujiwara no Sukekata. Daichoju-in, Chuson-ji, Hiraizumi, Iwate Prefecture.*

defense, indeed an exceptional case for a person not dispatched from the central government. He assumed control not only of his original holdings in Dewa but also of the six remote districts of the Abè family and seems to have made the Koromogawa fort his headquarters. The family's power increased during the time of Takenori's son Takesada and grandson Sanehira, but family quarrels led in 1083 to the Later Three Years' War. Minamoto no Yoshiie, then governor of Mutsu, intervened and, on the sudden death of Sanehira, parceled out the latter's domains, the southern three of the districts to Kiyohira and the northern three to Kiyohira's maternal half brother Iehira, who was a paternal half brother of Sanehira. (Because of this relationship Kiyohira, a Fujiwara, was also considered a member of the Kiyohara clan.) When Kiyohira fell out with his brother, Yoshiie took his side and in 1087, strengthened by the arrival from Kyoto of his own brother Yoshimitsu (d. 1127), took the Kanezawa fort in Dewa and defeated Iehira and his clansmen. This brought about the downfall of the Kiyohara clan and ended the rebellion.

As a result Kiyohira took over from the Kiyoharas, assuming control over the domains in Mutsu and Dewa that the Kiyoharas had gained from the Abès. Kiyohira's original headquarters at the Toyota fort, thought to have been located at Iwayado in the present city of Esashi, Iwate Prefecture, was enclosed by the mountains on the east bank of the Kitakami River and suffered from inconvenient transport and communications facilities. Thus sometime between 1087 and 1096, with the rebellion safely behind him, Kiyohira, with an eye to future growth, chose as his base Hiraizumi, to the south of the Koromogawa. The new site shared its rear border with this traditional stronghold of the Abès and offered much greater space on the flats on either bank of the Kitakami, as well as ample hilly areas.

In 1091 Kiyohira presented Regent Morozane with two horses. This was his first effort to approach the Fujiwara regents, and through the deeding of

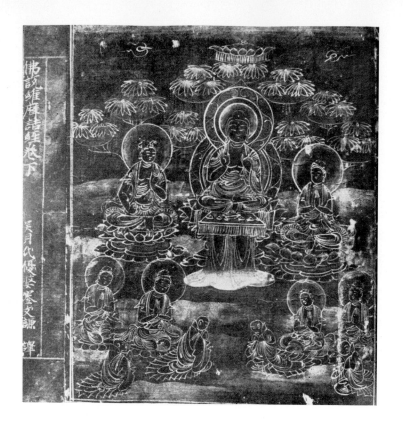

manorial estates, he was apparently able to forge a relationship with the Fujiwara family in Kyoto, for he was appointed commandant of the six remote districts, further consolidating his power and authority. Kiyohira's move to Hiraizumi had taken place at the beginning of the period of rule by the retired emperors, and the wave of building temples and dedicating Buddhist images that swept the capital also spread to Hiraizumi. The time had come for the introduction of Pure Land doctrinal elements, which were becoming as popular among the warriors as among the courtiers.

Minamoto no Yoriyoshi, who figured in the Earlier Nine Years' War, in later years became a patron of temple building and sculpture and an ardent reciter of *nembutsu* incantations, and finally renounced the world. His son Yoshimitsu from his earliest years made it a practice to read the *Lotus Sutra* and make myriad repetitions of the *nembutsu* every day. Such was his devotion that he donated to the Onjo-ji in Otsu a *joroku* Amida statue and a hall to house it. In 1127, the year before Kiyohira's death, the devout Yoshimitsu died holding the multicolored threads connected to the main image of the temple. He had also sent his eldest son into the priesthood. Kiyohira must have become well acquainted with Yoshimitsu in the course of the Later Three Years' War, so it is by no means unlikely that he had many opportunities to be influenced by the Pure Land doctrines of the capital.

KIYOHIRA AND THE CHUSON-JI

The information that Kiyohira founded the Chuson-ji immediately upon assuming control of the six former Abè districts is contained in a chronicle of the Kamakura shogunate, *Azuma Ka-*

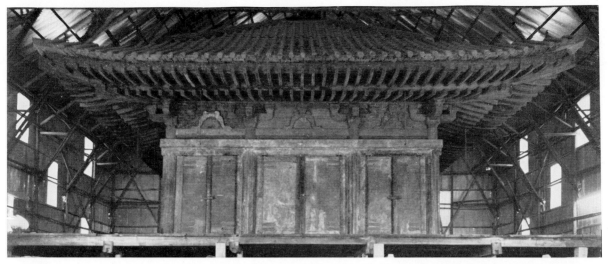

103. *Konjikido. Length of façade, 5.5 m. 1124. Konjiki-in, Chuson-ji, Hiraizumi, Iwate Prefecture.*

◁ *101 (opposite page, left). Frontispiece to scroll 2 of* Yuimakitsu-gyo *(Vimalakirti Sutra), in the Complete Buddhist Canon. Gold and silver illumination on indigo paper; width of scroll, 25 cm. 1117–26. Daichoju-in, Chuson-ji, Hiraizumi, Iwate Prefecture.*

◁ *102 (opposite page, right). Wayside shrine with buddha figure, detail from* Mandala of Pagodas in The Ten Worlds Based on the "Konkomyo Saisho-o-gyo" Sutra. *Twelfth century. Daichoju-in, Chuson-ji, Hiraizumi, Iwate Prefecture.*

gami (Mirror of the Eastland; 1180–1266), which mentions a petition, submitted in 1189 by the clergy of the Chuson-ji to Minamoto no Yoritomo (1147–99), the military champion who was to become shogun three years later.

The chronicle refers to the petition as recording that wayside shrines (Fig. 102) were set up at intervals of about a hundred meters along the road from the Shirakawa Barrier, a checkpoint at the southern border of the province of Mutsu, to Sotogahama in the north—a distance of over twenty days' journey. Each shrine was decorated in gold with a figure of Amida. We are also told that a pagoda was erected atop a mountain in the center of the province. We cannot be sure that this hub was in the Chuson-ji, but there was at its center a subtemple called the Taho-ji with halls enshrining a Shaka and Taho on the left and right, between

which ran a road with a barrier at which traffic north and south over the hill could be monitored. Another petition from the monks of the Chuson-ji, dated 1334, calls this structure the Saisho-in and indicates that it was completed in 1105. Doubtful as the dating may be, we can nonetheless see that from the beginning Kiyohira's vision was of grand proportions.

His next work was the construction of a large two-story hall, which he called the Daichoju-in. Its main image was a "thirty *shaku*" (perhaps thirty-two *shaku,* or double *joroku*) figure of Amida flanked by nine *joroku* Amidas. The same petition states that this hall was built in 1107, but as in the case of the Taho-ji, this cannot be confirmed. Other buildings included a Shaka hall, enshrining more than a hundred images of Shaka, and a Both Worlds hall, housing wooden images of various

CHUSON-JI · *109*

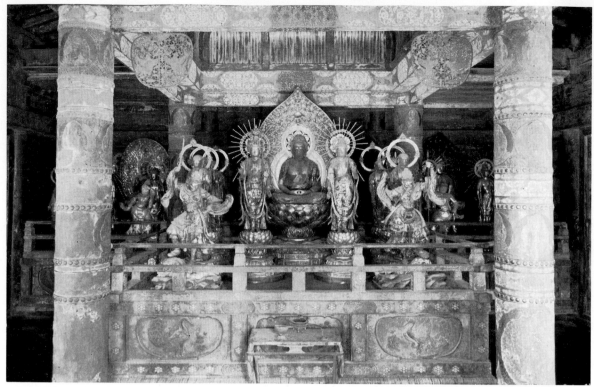

104, 105. Interior of Konjikido. 1124. Konjiki-in, Chuson-ji, Hiraizumi, Iwate Prefecture. (See also Figures 21, 117, 120.)

deities from the mandala of both the Diamond and the Womb worlds of Dainichi, but their dates are not known. A recommendation to build tutelary Shinto shrines for the Chuson-ji, the Hie Shrine in the north and the Hakusan Shrine in the south, is also reported in the *Azuma Kagami*.

In the petition the Golden hall is recorded as having been built in 1108, enshrining three half-*joroku* figures of Shaka as the main objects of worship instead of the full-*joroku* figures we would expect, and also containing one hundred small Shaka images and images of the Four Celestial Guardians. Thus there seems to be confusion between the Shaka hall and the Golden hall. We must treat with equal caution the statements in the petition concerning the contents and the date of the Golden hall, for a date of 1108 would mean that almost two decades had passed before the grand dedication, surely an unnaturally long period.

The construction in 1122 of a hall measuring twenty-five *shaku* square is known from an extant ridgepole plaque, and since the present sutra repository is only slightly larger than this, the plaque could belong to it, assuming that the repository remains its original size. However, buildings of this size were common. The description equally fits the remains traditionally accepted as those of the "lesser sutra repository," and no doubt many others too, so that no flat statement can be made. We do know from an inscription on the ridgepole of the inner roof, however, that the framework of the Konjikido (Fig. 103) was built in 1124.

The grand dedication ceremony of the Chuson-ji took place on the twentieth day of the third

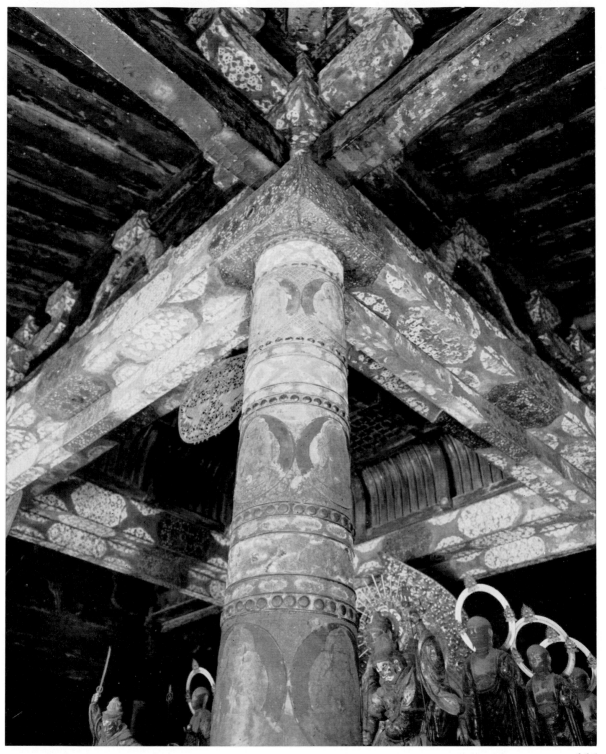

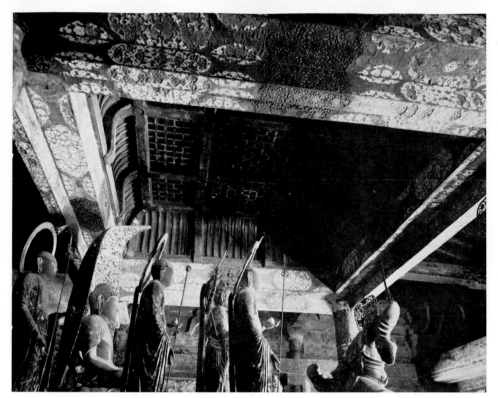

106. *Ceiling of Konjikido. 1124. Konjiki-in, Chuson-ji, Hiraizumi, Iwate Prefecture. (See also Figure 20.)*

month of 1126. It is said that Fujiwara no Atsumitsu, magistrate of the Right Capital (the western half of Kyoto), was the author of the dedicatory document, with the calligraphy by Junior Prosecutor Fujiwara no Tomotaka written in Kyoto (Fig. 100). The document states that the objective of founding the temple was the peace and prosperity of the nation and expresses the hope that the souls of the victims of the Earlier Nine Years' and Later Three Years' wars, both friend and foe, might be led to the Pure Land. It gives thanks for the clan's more than thirty years of control over the provinces of Dewa and Mutsu as chief of the subjugated Ezo tribes and prays for the long life of the retired emperor Shirakawa, Emperor Sutoku, and the previous emperor Toba and his consort Taikemmon'in. It glorifies the temple as having been designated one "built at the behest of the court" and notes that it was hope for Kiyohira's personal rebirth in the Pure Land that prompted the foundation.

According to this document the principal hall, which was later called the Golden Hall, had a three-bay altar space and four aisles, was roofed in cypress bark, and was flanked by twenty-two-bay wings to the right and left. Ritual decorations and utensils included thirty-two multicolored silk banners and two thirty-*shaku*-long banners of light and dark colors. The main object of worship was a *joroku* Shaka triad, beautifully set off by ceiling and canopy. There were three three-story pagodas, each adorned with twelve drapelike sheets of gilt bronze and enshrining Dainichi, Shaka, Yakushi, and Miroku triads. The sutra repository, a two-story tile-

parts represent the present commercial and
reas. The labels in *italics* and the lines in brown
original structures and topography.

ba Detached Palace

Toba
Bridge

Tanaka Villa

East Villa

Jobodai-in

Kongoshin-in

Tomb of
Emp. Toba

Anrakuju-in

Tomb of Emp.
Shirakawa

Fudo-in

Izumi-dono

Tomb of
Emp. Konoe

Jonan Shrine

Riding Ground

Islet

Kamo River

0 300m

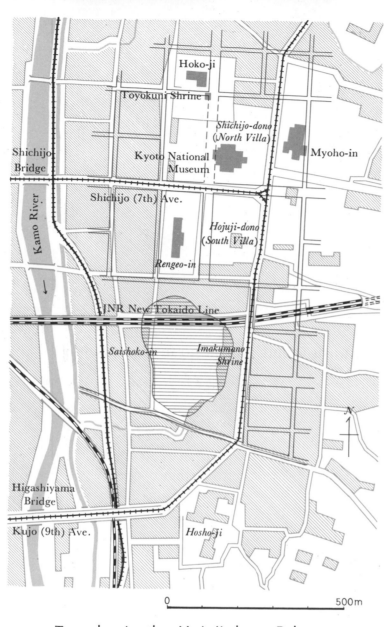

Hoko-ji

Toyokuni Shrine

*Shichijo-dono
(North Villa)*

Kyoto National
Museum

Myoho-in

Shichijo
Bridge

Shichijo (7th) Ave.

*Hojuji-dono
(South Villa)*

Rengeo-in

Kamo River

JNR New Tokaido Line

Saishoko-in

*Imakumano
Shrine*

Higashiyama
Bridge

Kujo (9th) Ave.

Hosho-ji

0 500m

Temples in the Hojuji-dono Palace

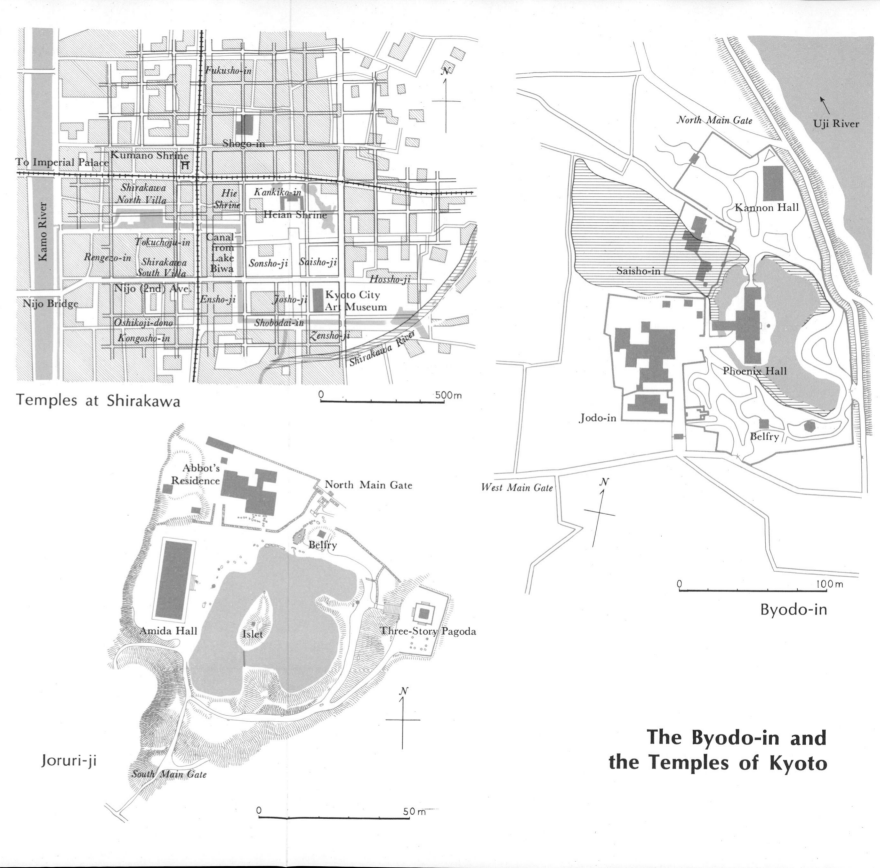

Fukusho-in

Shogo-in

To Imperial Palace

Kumano Shrine

*Shirakawa
North Villa*

*Hie
Shrine*

Kankika-in

Heian Shrine

Kamo River

Rengezo-in

Tokuchoju-in

Canal
from
Lake
Biwa

Sonsho-ji

Saisho-ji

*Shirakawa
South Villa*

Hossho-ji

Nijo (2nd) Ave.

Kyoto City
Art Museum

Oshikoji-dono

Ensho-ji

Josho-ji

Nijo Bridge

Kongosho-in

Shobodai-in

Zensho-ji

Shirakawa River

Temples at Shirakawa

0 500m

Abbot's
Residence

North Main Gate

Belfry

Amida Hall

Islet

Three-Story Pagoda

N

Joruri-ji

South Main Gate

0 50 m

North Main Gate

Uji River

Kannon Hall

Saisho-in

Jodo-in

Phoenix Hall

West Main Gate

Belfry

N

0 100 m

Byodo-in

**The Byodo-in and
the Temples of Kyoto**

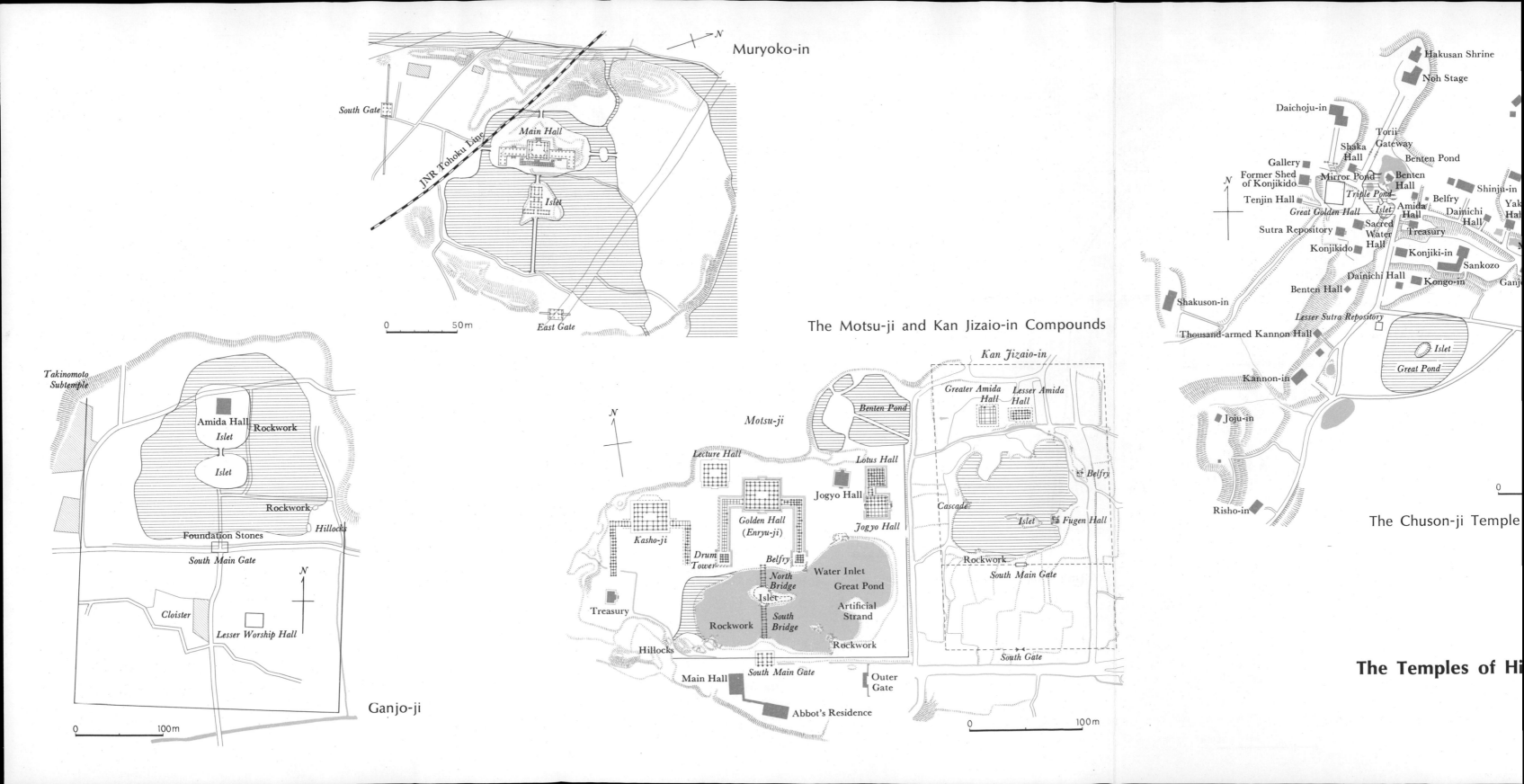

Muryoko-in

South Gate

JNR Tohoku Line

Main Hall

Islet

0 50m

East Gate

The Motsu-ji and Kan Jizaio-in Compounds

Takinomoto Subtemple

Amida Hall Rockwork
Islet

Islet

Rockwork

Foundation Stones *Hillocks*

South Main Gate

N

Cloister

Lesser Worship Hall

0 100m

Ganjo-ji

N

Motsu-ji

Benten Pond

Lecture Hall

Lotus Hall

Jogyo Hall

Golden Hall (Enryu-ji)

Jogyo Hall

Kasho-ji

Drum Tower *Belfry*

North Bridge Water Inlet

Islet Great Pond

Treasury *South Bridge* Artificial Strand

Rockwork Rockwork

Hillocks

Main Hall *South Main Gate* Outer Gate

Abbot's Residence

Kan Jizaio-in

Greater Amida Hall *Lesser Amida Hall*

Belfry

Cascade

Islet *Fugen Hall*

Rockwork

South Main Gate

South Gate

0 100m

Hakusan Shrine

Noh Stage

Daichoju-in

Torii Gateway

Shaka Hall Benten Pond

Gallery Benten Hall

Former Shed of Konjikido Mirror Pond Shinju-in

N *Triple Pond*

Tenjin Hall Belfry Yak Hall

Great Golden Hall *Islet* Amida Hall Dainichi Hall

Sutra Repository Sacred Water Hall Treasury

Konjikido Konjiki-in

Dainichi Hall Sankozo

Benten Hall Kongo-in Ganj

Lesser Sutra Repository

Shakuson-in

Islet

Thousand-armed Kannon Hall *Great Pond*

Kannon-in

Joju-in

The Chuson-ji Temple

Risho-in

0

The Temples of Hi

107. Floral openwork of kalavinkas (mythical birds). Gilt bronze; height, 28.5 cm.; width, 32.8 cm. Twelfth century. Konjikido, Konjiki-in, Chuson-ji, Hiraizumi, Iwate Prefecture.

roofed structure, held a copy of the complete canon written in gold and silver on indigo paper and enshrined a life-size image of Monju. Opposite the repository was a two-story bellhouse in which a 600-catty (300-kilogram) bronze bell was hung. Reference is also made to three main gates, three earthen walls, as well as a twenty-one-bay arched bridge and a ten-bay oblique bridge, both of which spanned the newly excavated pond. Two decorated boats with dragon-head prows were also made for the provision of musical accompaniment at ceremonies, for which purpose musical instruments and thirty-eight dance costumes were prepared. The document continues that hillocks were built up on high ground to the north and a pond was dug on a flat to the south, and that the mountains and streams to the cast and west created a most favored location for this monastery.

Several buildings—including the Taho-ji subtemple, the two-story hall Daichoju-in, the Shaka hall, and the Both Worlds hall—are not mentioned in the dedicatory document, probably because some were already antiquated and others were not yet

built. Exclusion of the Konjikido, whose framework was completed in 1124, has been put down to a number of causes, such as the intention to use it as a mausoleum, but it is more likely that the interior was still unfinished at the time of the grand dedication ceremony.

Not all the structures in the Chuson-ji mentioned in the *Azuma Kagami* were completed under the rule of Kiyohira; some must have been added under his successors, Motohira and Hidehira. This is indicated by a reference to the existence of three altars in the Konjikido and to a "complete canon from Sung"—the latter probably referring to the block-printed set of sutras from the K'aiyuan-ssu temple of Southern Sung that is still the property of the Chuson-ji. Since the latest printing date found in the Chuson-ji set is 1148, it may have been imported before the series was completed in 1172 —that is, during the rule of Motohira. From this printed work a copy in gold on indigo paper was made under Motohira and Hidehira. Both sets of the canon may have been placed in another, specially constructed sutra repository, or they may

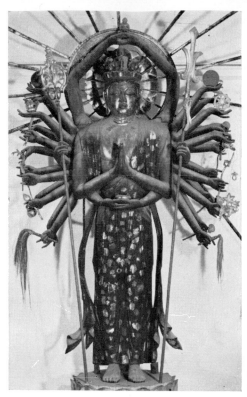

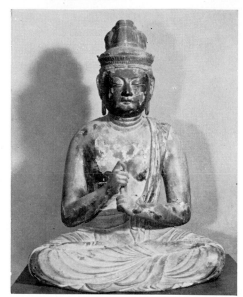

109. Buddha Dainichi. Gold leaf and lacquer on wood; height of image, 56.5 cm. Twelfth century. Ruriko-in, Chuson-ji, Hiraizumi, Iwate Prefecture.

108. Thousand-armed Kannon. Gold leaf and lacquer on wood; height of image, 174 cm. Twelfth century. Kannon-in, Chuson-ji, Hiraizumi, Iwate Prefecture.

have joined the first set in gold and silver, kept in the original repository.

At any rate, by the time of Hidehira the temple complex of Chuson-ji boasted over forty ceremonial halls and dormitories for more than three hundred monks. It appears that the Shaka hall was modeled after the Hojo-ji Shaka Hall in Kyoto, which also enshrined one hundred and one images of Shaka, while precursors of the wood-sculptured figures from the Mandala of Both Worlds are to be found in the octagonal hall of the Enichi-ji, reputedly founded by Kobo Daishi (774–835), at Aizu in Fukushima Prefecture and in a temple built by Seien in Tottori Prefecture. Examples of reliefs of the Mandala of Both Worlds in wood are to be found in the Myo-o-in of the Kongobu-ji on Mount Koya and in the Jizo-in at Uji.

When Kiyohira arranged for Chuson-ji to be designated as a temple "built at the behest of the court," he had in mind specifically its use for worship by the retired emperor Toba. The Eshin-in, constructed in the Yokawa Compound of the Enryaku-ji by Regent Fujiwara no Kaneie (929–90), had been made a designated temple on the request of the priest Kakuun, who was well acquainted with Genshin. We are told that in the fire of 1081 at the Onjo-ji, fifteen designated halls were razed. All this indicates that at this time subtemples or even subsidiary halls within a temple were commonly so designated. Thus we see how Kiyohira, who had had contacts with the family of the regent, strove to raise the standing of the Chuson-ji.

MOTOHIRA AND THE MOTSU-JI

The death of Fujiwara no Kiyohira in 1128 ushered in the rule of his son Motohira, who, as the court-appointed commandant of Dewa,

110. *Pond in front of now vanished Motsu-ji Golden Hall. East-west breadth of pond, about 180 m. Twelfth century. Hiraizumi, Iwate Prefecture.*

succeeded to a domain comprising all of northern Honshu as far south as the Shinobu county in what is now northern Fukushima Prefecture. Giving expression to the power and wealth he had garnered from these lands, Motohira built the Motsu-ji at the foot of the hills south of the Chuson-ji.

On the subject of the Motsu-ji, the *Azuma Kagami* notes that the Golden hall, known as the Enryu-ji, had woodwork of red and other kinds of sandalwood inlaid with gold and silver and was decorated with countless gems intermixed with various colors. The main image, a *joroku* Yakushi by Unkei, was the first example of the use of jewels for eyes and was accompanied by statues of the Twelve Godly Generals. Other buildings included a lecture hall, a *jogyo*-meditation hall, a two-story gate, a bellhouse, and a sutra repository. The name tablet of the temple was written by Regent Fujiwara no Tadamichi (1097–1164), and Buddhist inscriptions on cards in

the various buildings by Imperial Adviser Fujiwara no Norinaga. The history also notes that the main image, Kichijo Ten (Srimahadevi), of the Kichijo-do was a copy of that in the Fudaraku-ji in northern Kyoto, and that, since there was said to be an oracle that the image possessed life, a *joroku* image of Kannon was made to hide the main image in its hollow interior. The Senjudo contained statues of the Thousand-armed Kannon and his attendants, the Twenty-eight Protectors of Buddhism, inlaid with gold and silver. Two shrines were erected, to east and west, for the temple's tutelary Shinto deities. The Kasho-ji, a subtemple in the Motsu-ji complex that was under construction at the time of Motohira's death in 1157, was later finished by Hidehira. It enshrined a *joroku* figure of Yakushi, and paintings inspired by the twenty-eight chapters of the *Lotus Sutra* adorned the four walls and three doors.

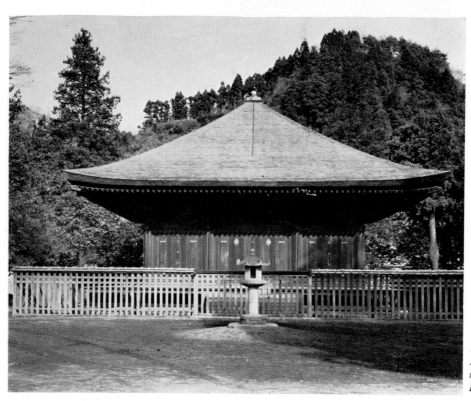

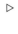

112. Interior of Ganjo-ji ▷ Amida Hall. 1160. Shiramizu, Iwaki, Fukushima Prefecture.

The statement in the *Azuma Kagami* that the petition of 1189 attributed the Enryu-ji main image to "a certain Unkei," probably referring to the famous Nara sculptor Unkei, is doubtful. Like the attribution of the Chuson-ji Konjikido statuary to Jocho, this claim is unacceptable because of chronological discrepancies. The great Unkei, who died in 1223, could only have been a small child, if indeed he had even been born, at the time that the Enryu-ji was dedicated. It is said that the sculptor who created the Enryu-ji image was rewarded by Motohira with fabulous riches, and that the retired emperor Toba was at first loath to allow the departure of the image from Kyoto. These tales were probably invented to make fun of Motohira as a country bumpkin unversed in metropolitan ways.

The story that Regent Tadamichi wrote the name tablet for Motohira's hall appears in the *Koji-dan* (Discussion of Ancient Matters), by Minamoto no Akikane, and seems to have been widely accepted. The Enryu-ji was apparently dedicated before Tadamichi's death in 1164. Imperial Adviser Norinaga, reputed to be the calligrapher of the inscriptions on cards in the hall, was exiled to Hitachi (present-day Ibaraki Prefecture) for his part in the Hogen War of 1156; pardoned, he returned to Kyoto in 1162 and died later on Mount Koya. This further bolsters the suggestion that the Motsu-ji monastery was founded in Motohira's declining years, say, in 1155 or just before, or about thirty years after the Chuson-ji. The Motsu-ji was also a designated temple for worship by the retired emperor Toba.

The Kan Jizaio-in, named after an appellation of Amida, lies a short distance east of the Motsu-ji and, according to the *Azuma Kagami,* was founded

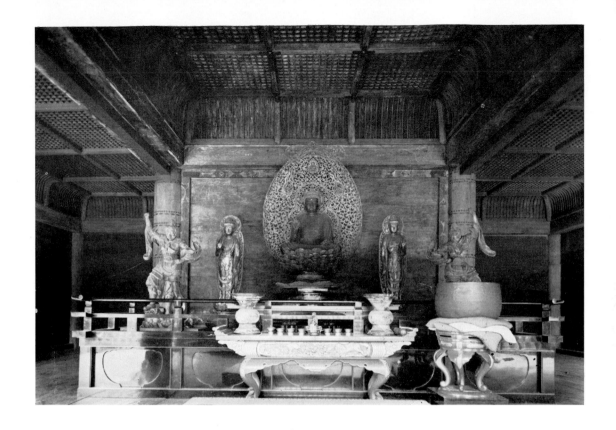

by Motohira's wife, "a daughter of Abè no Muneto." This lady may indeed have been of the Abè clan, but, as was early pointed out in the *Hiraizumi Zakki* (Hiraizumi Miscellany), Muneto's daughter would have been some thirty years Motohira's senior, making the alliance highly improbable.

In the main hall, called the Amida Hall, the altar was decorated in silver, with burnished gold on the railing, and paintings of holy sites in Kyoto adorned the four walls. Nearby the same lady founded a smaller Amida hall, with card inscriptions on sliding panels reputedly by Norinaga. The *Azuma Kagami* and those parts of the *Chuson-ji Kyozo Monjo* (Records of the Chuson-ji Sutra Repository) that seem to be no later than the late Kamakura or Muromachi period, though undated, agree that the main Amida hall was three bays wide excluding the aisles, faced south, and enshrined an Amida triad set upon a silver-decorated altar fifteen *shaku* wide. The railings were of "mirror-polished" (burnished) gold, and in the inner sanctuary the latticed ceiling was decorated with gold leaf, while its four pillars were also extremely costly. Paintings on the four walls depicted various religious gatherings and festivals, as well as the Byodo-in at Uji and scenes of Saga and Kiyomizu in Kyoto. The rear face of the reredos showed a scene where Amida, still training, forsakes his kingship to turn to the Buddha Se Jizaio and to join the priesthood as Dharmakara. The scene was accompanied by a card bearing a verse from the *Daihodo Daijikkyo* (Collection of Mahayana Sutras), also quoted in the *Ojo Yoshu,* to the effect that "on dying, my wife and children, my rare treasures, and my kingship, I will not take with me; but the Buddhist doctrine and the spirit of almsgiving, I will not forgo—they

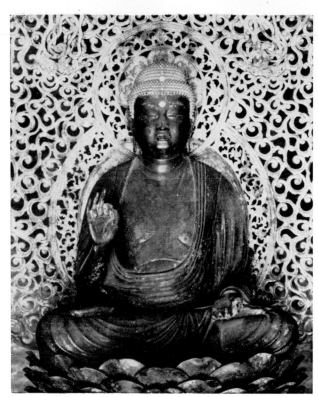

113. Buddha Amida. Gold leaf and lacquer on wood; height of image, 85 cm. 1160. Ganjo-ji Amida Hall, Shiramizu, Iwaki, Fukushima Prefecture.

114 (opposite page, left). Buddha Amida. Gold leaf and lacquer on wood; height of image, 52.2 cm. Twelfth century. Jion-ji, Yamagata Prefecture. ▷

115 (opposite page, right). Buddha Amida. Gold leaf and lacquer on wood; height of image, 273 cm. Twelfth century. Kozo-ji Amida Hall, Takakura, Miyagi Prefecture. ▷

shall be my companions in the future life as well as in this." The front surface of the reredos was decorated with a thousand gems, and the upper part of the wall with angels in flight. The ceremonial veil was of T'ang origin.

The smaller Amida hall also faced south, contained card inscriptions in Norinaga's hand, and was decorated with mirrors that Motohira's wife had used.

The Motsu-ji, including the Kan Jizaio-in, was every bit as grand in scale as the Chuson-ji, comprising as it did more than forty buddha halls and dormitories for over five hundred monks.

HIDEHIRA AND THE MURYOKO-IN

The rule of Hidehira, the third of the line, spanned a thirty-year period, from 1157 through 1187. Made marshal of frontier defense, he was later appointed governor of Mutsu and was finally invested with the fifth court rank, an honor that had eluded his father and grandfather. The *Azuma Kagami* tells us that Hidehira's official residence, the Hiraizumi-no-tachi, was on the east side of the Konjikido, and in the compound's southeastern corner was the Kyara Palace, where he normally lived. The Hiraizumi-no-tachi, probably the traditional residence of his predecessors, was on the west bank of the Kitakami River, that is, south of the present Takadachi palace site. Directly to the west of the Kyara Palace, Hidehira founded the Muryoko-in, which was also called Niimido (New Hall). It enshrined a *joroku* Amida. Its four walls and doors were decorated with scenes based on the *Kan Muryoju-kyo* and were also embellished with paintings of Hidehira's own hunting exploits. There was also a three-story pagoda.

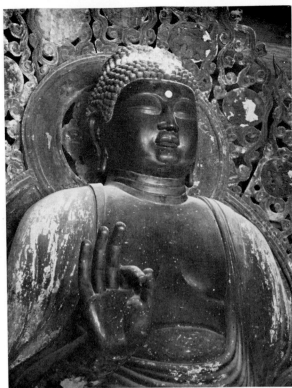

The tradition that the themes of decoration in this temple were based on those in the Byodo-in at Uji was confirmed some years ago when excavations revealed traces similar to the plan of the Phoenix Hall, with its central structure and wings to the right and left. The temple is named for the Buddha Muryoko, another appellation of Amida.

THERE IS AN EXTANT MAP purporting to show the city of Hiraizumi in Hidehira's day, but it represents Edo-period speculation and is not to be trusted in matters of detail. We are forced to rely on accounts in the *Azuma Kagami* and on observation of the present topography. But we can say that the religious structures were located primarily on hills to the northwest, the residences of the ruling family on the flat land toward the Kitakami River, and the districts housing the common people in the south. There were a number of Shinto shrines tutelary to Hiraizumi as a whole: the general shrine in the center, Hie and Hakusan shrines to the east, Gion and Oji shrines to the south, Kitano Tenjin and Kimpusen shrines to the west, and Ima Kumano and Inari shrines in the north. Some are still in existence, giving an indication of the area over which Hiraizumi used to spread. In this installation of the same types of shrines that had strong cults in the capital we can discern the intention to nurture metropolitan culture in every field, and from this we can form an appreciation of the nature of the Hiraizumi culture. It was in 1160 that the retired emperor Goshirakawa established the Ima Kumano and Ima Hie shrines near the Hojuji-dono palace in Kyoto. Assuming that Hiraizumi practice was modeled on this, Hiraizumi's tutelary shrines must have been founded under Hidehira.

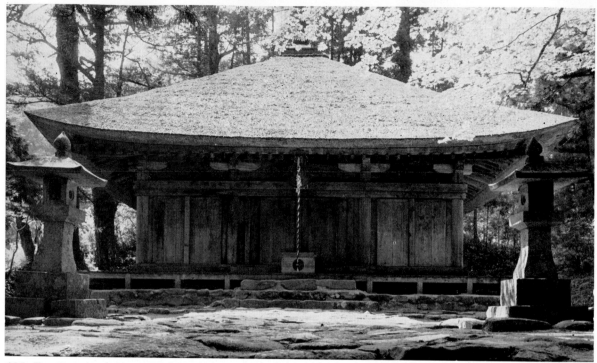

116. Kozo-ji Amida Hall. Length of façade, 9.3 m. 1176. Takakura, Miyagi Prefecture.

The palatial residential buildings in Hiraizumi were totally destroyed in Minamoto no Yoritomo's expeditions against the Fujiwara in 1189, but the grandeur of the temples of the three lords was largely unimpaired. Subsequently the Kamakura shogunate, the military government for which Yoritomo won imperial recognition in 1192, also made efforts to preserve the temples of Hiraizumi, but the loss of their powerful benefactors left them unable to recover from the trials by fire that were visited on the Motsu-ji in 1226 and on the Chuson-ji in 1337. At the present time only the foundations remain of most of the buildings, but by rare good fortune they decayed without any later renova-

tion, so that the remains reflect the twelfth-century ground plans with unusual fidelity. It is the recognition of this priceless advantage that has spurred continued archaeological investigations of Hiraizumi in recent years.

Two important edifices from the districts to the south of Hiraizumi have come down from Hidehira's day: the Amida halls of the Ganjo-ji in Shiramizu, Fukushima Prefecture (Fig. 111), and of the Kozo-ji in Miyagi Prefecture (Fig. 116). The buddhas of the Ganjo-ji hall (Figs. 112, 113) are similar to those of the Konjikido, and it is worth noting that in several respects they appear to be the work of sculptors of the same school.

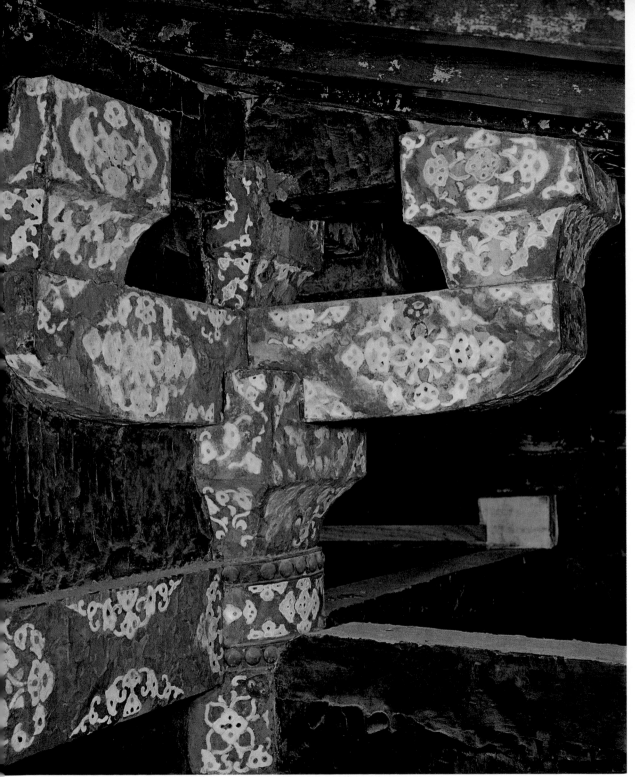

117. *Bracketing of Konjikido. Lacquer on wood with mother-of-pearl inlay; height of base block, 21 cm. 1124. Konjiki-in, Chuson-ji, Hiraizumi, Iwate Prefecture.*

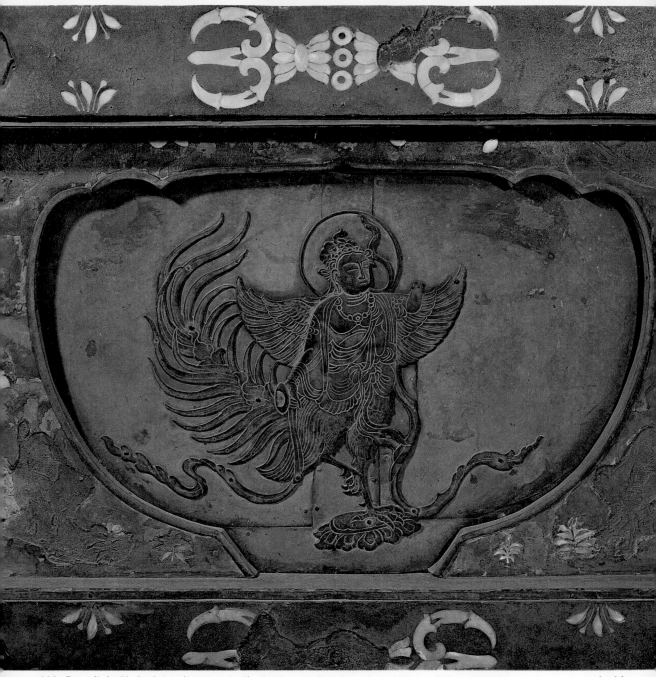

118. Bas-relief of kalavinka *(mythical bird)*, *detail from altar decoration of Chuson-ji Sutra Repository. Lacquer on wood with mother-of-pearl inlay; height of oval recess, 32.5 cm. Twelfth century. Daichoju-in, Chuson-ji, Hiraizumi, Iwate Prefecture.*

119. *Konjikido pillar painting of bodhisattva. Lacquer on wood with mother-of-pearl inlay and gold-dust embedding; diameter* ▷
of pillar, 27.5 cm. 1124. Konjiki-in, Chuson-ji, Hiraizumi, Iwate Prefecture.

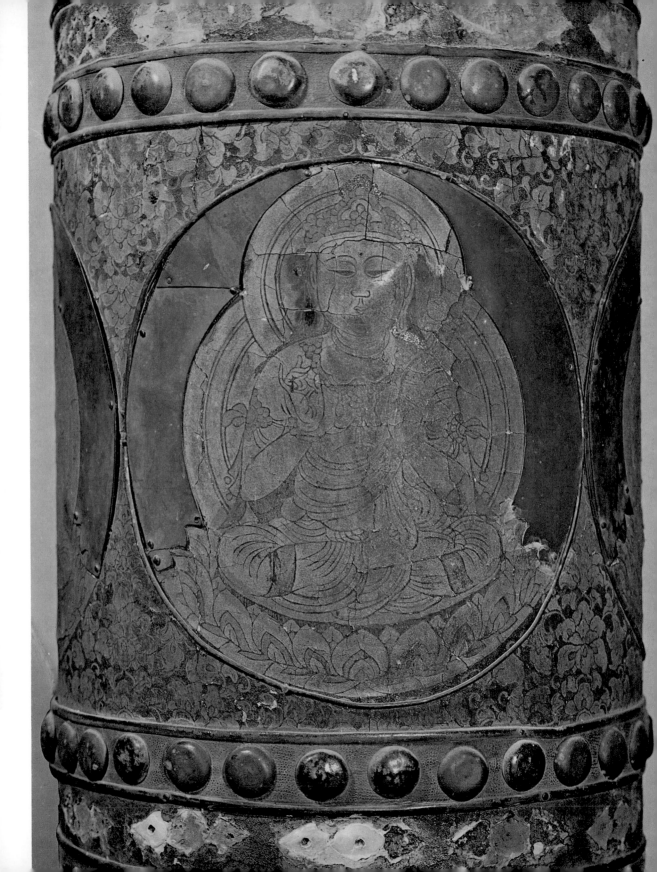

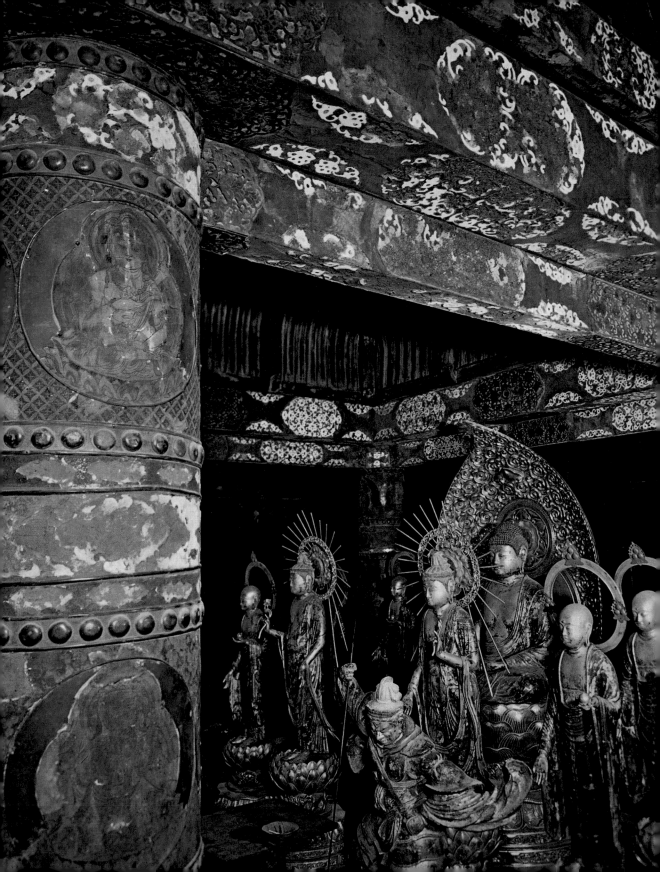

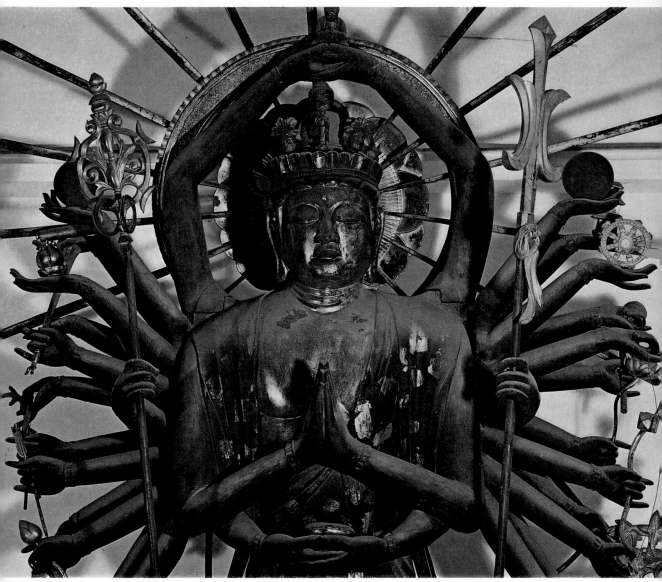

121. *Thousand-armed Kannon. Gold leaf and lacquer on wood; height of image, 174 cm. Twelfth century. Kannon-in, Chuson-ji, Hiraizumi, Iwate Prefecture.*

◁ 120. *Interior of Konjikido. 1124. Konjiki-in, Chuson-ji, Hiraizumi, Iwate Prefecture.*

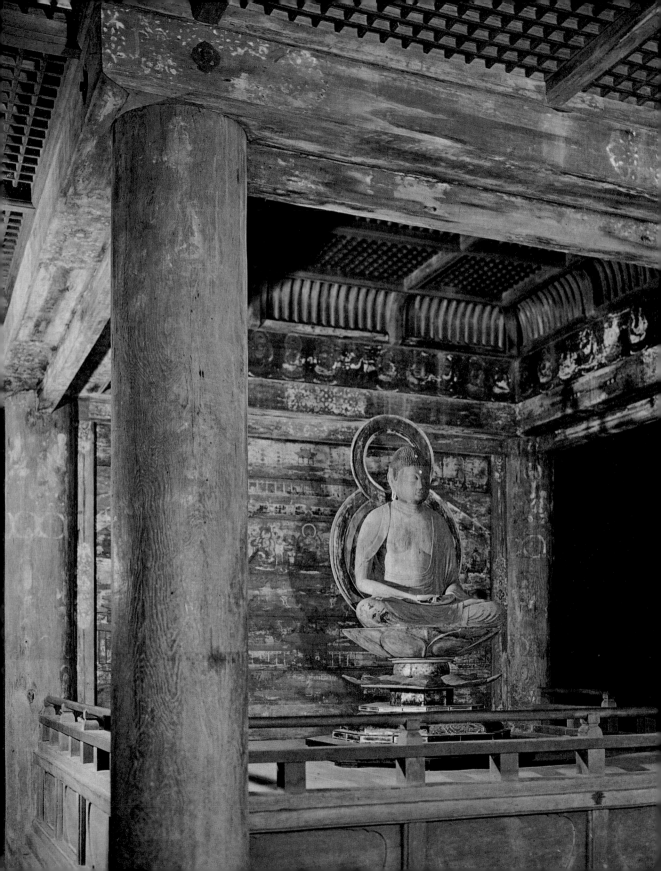

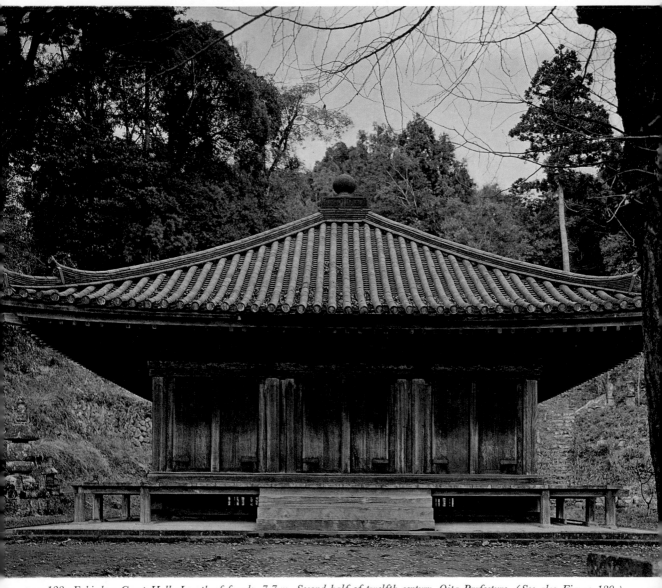

123. Fuki-dera Great Hall. Length of façade, 7.7 m. Second half of twelfth century. Oita Prefecture. (See also Figure 130.)

◁ *122. Interior of Fuki-dera Great Hall. Second half of twelfth century. Oita Prefecture. (See also Figure 129.)*

*124 (overleaf). Nageiredo. Length of façade, 5.44 m. Second half of eleventh century. Oku-no-in (Innermost Precinct), Sambutsu- ▷
ji, Mount Mitoku, Tottori Prefecture. (See also Figure 127.)*

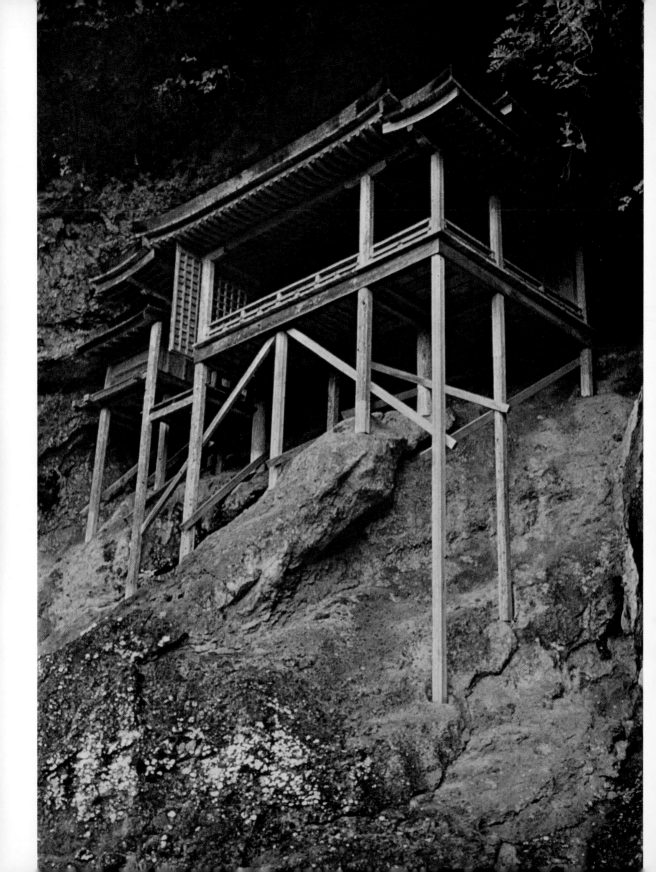

CHAPTER FIVE

—•—

Penetration of Pure Land Art
into
Western Japan

WESTERN HONSHU Beyond the Misasa hot-spring resort in Tottori Prefecture is located the Tendai-sect temple Sambutsu-ji. Its Nageiredo hall is the only Heian-period Buddhist structure in the western area of the Japan Sea coast. Among various relics that are said to have been excavated in the 1780s is the "divine mirror," etched with various figures from the Central Realm of the Mandala of Dainichi's Womb World. The mirror bears a date corresponding to 996, attesting to the temple's great age. Passing behind the main hall, which is set at the foot of a hill, and crossing a bridge over a gorge, one climbs a steep hill via a narrow winding way and approaches first the Monju hall, and somewhat higher the Jizo hall, both set on a rocky ridge overlooking the Japan Sea to the northwest. Passing the bell-house, one surmounts a large rock known as Uma-no-se (Horse's Back), and passes the sutra repository of a former tutelary shrine and a Kannon hall built into a cavern. Finally, rounding an outcropping of rock, one looks up suddenly to the striking beauty of the innermost sanctuary (Figs. 124, 127), known as the Nageiredo ("Thrown-in Hall") from its appearance in the hollow of the north-facing rock face into which it is built. It is a hard climb of well more than eight hundred meters from the main hall.

The Nageiredo has one bay in the façade and two bays at the rear. The sloping roof forms overhanging eaves on the north and west sides, complemented by a lowered roof in the northwest corner. These roofs of varying heights and the tall pillars rising from the rock face combine to provide great structural beauty despite the hall's modest dimensions. Inside is a low altar, on which stand the main image of Zao Gongen, a Benevolent King–like figure well over one meter high (Fig. 125). To its left and right, and below the altar, are six more figures of the same deity (Fig. 126), testimony to the spread of the cult of ascetic training on Mount Kimpusen. The ridgepole plaque made during the the repairs of 1375 indicates that this hall was built as the tutelary shrine of the temple. Since it was protected in its rock cavern, it is in a good state of preservation, and many structural details are in pristine condition. This, together with an analysis of the style of the images, suggests that the hall's construction may safely be placed around the second half of the eleventh century. The Aizendo,

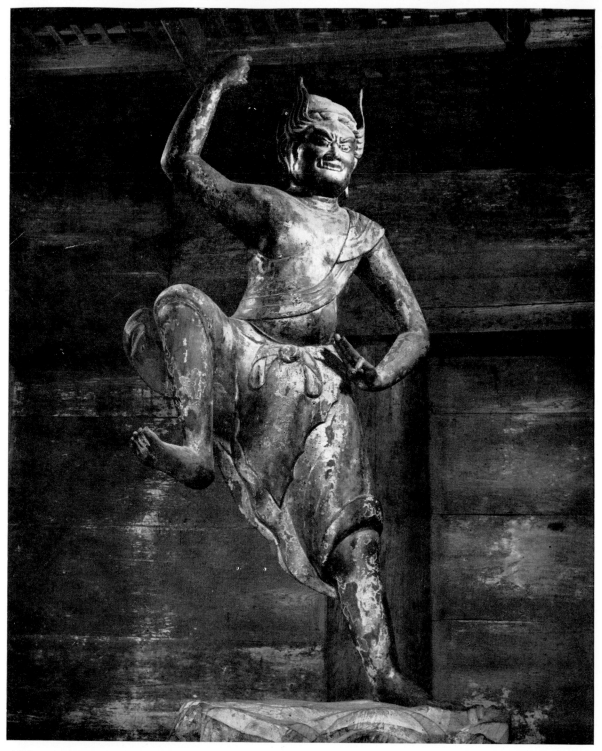

125. *Zao Gongen. Gold leaf and lacquer on wood; height of image, 114 cm. Late eleventh or early twelfth century. Nageiredo, Oku-no-in (Innermost Precinct), Sambutsu-ji, Mount Mitoku, Tottori Prefecture.*

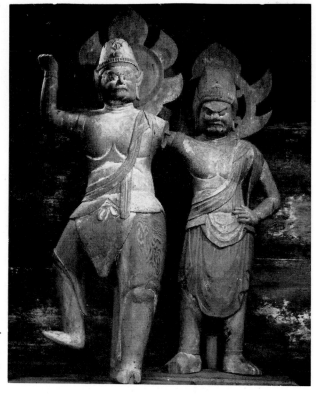

126. *Zao Gongen. Gold leaf and lacquer on wood; height of image at left, 102 cm. Late eleventh or early twelfth century. Nageiredo, Oku-no-in (Innermost Precinct), Sambutsu-ji, Mount Mitoku, Tottori Prefecture.*

a small one-bay-square annex to the east, probably also dates from the same time.

THE ROKUGOSAN TEMPLES OF NORTH KYUSHU

Of the many temples that flourished in Rokugo (the Six Districts) on the Kunisaki Peninsula (Fig. 160), Oita Prefecture, during the period of government by retired emperors, the Amida hall (called the Great Hall) of the Fuki-dera (Figs. 123, 130) is the sole survivor.

As the southwest terminus of Inland Sea trade routes, the Kunisaki Peninsula had had contacts with Chinese and Korean culture even before the Nara period and was subjected to early Buddhist influence. Legend has it that Usa Hachiman, a Shinto deity with particularly close Buddhist connections, appeared in the Nara period and, making skillful use of opportunities presented by the rebellion of Fujiwara no Hirotsugu (c. 710–40) and by the great event of the installation of the Great Buddha at the Todai-ji in Nara, attracted the interest and patronage of the court and came into possession of vast land holdings for his sanctuary, the Usa Hachiman Shrine. The Miroku-ji, the tutelary temple of the shrine, was founded beside it in 738, and excavations in later years have confirmed that in the front garden of the temple's Golden hall stood two three-story pagodas, one to the east and one to the west.

We are told that the first abbot of the Miroku-ji was Horen, who according to the *Shoku Nihongi*

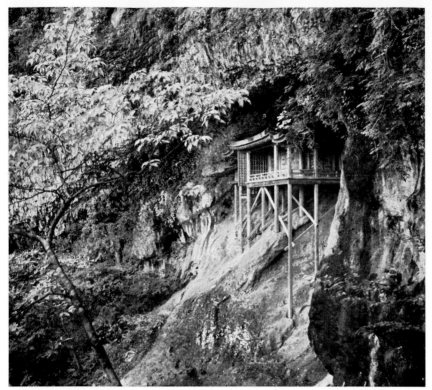

127. *Nageiredo. Length of façade (see Figure 124), 5.44 m. Second half of eleventh century. Oku-no-in (Innermost Precinct), Sambutsu-ji, Mount Mitoku, Tottori Prefecture.*

(Chronicles of Japan Continued; 797) belonged to the ruling clan of Usa and was acclaimed for his efforts in the early eighth century to alleviate the sufferings of the people through medicine. According to the *Genryaku-Bunji Ki* (Chronicles of the Genryaku and Bunji Eras [1185–90]), he was succeeded as chief priest by Kegon, Kakuman, and Taino; and all four of them, so the *Hachiman Usa-gu Gotaku-sen-shu* (Collection of Usa Hachiman Shrine Oracles) records, were fellow practitioners with the Bodhisattva Nimmon, considered to have been an incarnation of Hachiman. These five practiced Buddhist disciplines for some seventy years on the Umakimine, a peak now known as Omotoyama, which is the traditional site of the original Usa Hachiman Shrine and lies some six kilometers

southeast of the present shrine. Then some time after 724, Nimmon (Hachiman) moved to Mount Ogura, where he did reverence to Miroku, that is to say, founded the Miroku-ji. Horen did like reverence at Yamamoto, dedicating a monastery to the Bodhisattva Kokuzo (Akasagarbha), as did Kegon to Nyoirin (Cintamanicakra) at Kunise, Kakuman to Yakuo at Kunawa, and Taino to Yakushi in Rokugo. In addition, Nimmon founded the Ryozen-ji.

In the Heian period, the collection of oracles continues, Nogyo, also of the Usa clan, spent thirty-one years practicing religious disciplines in Rokugo. It is said that while he was praying in a cave at Tsubado for insight into which route Nimmon had taken, the bodhisattva appeared to him, showed

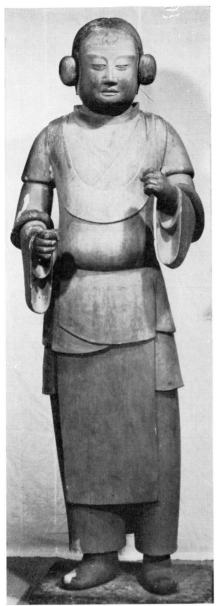

128. Taro Ten. Colors on wood; height of image, 160.5 cm. 1130. Choan-ji, Oita Prefecture.

him two routes to take for training, and enjoined him to travel about the three eastern districts—Aki, Musashi, and Tsumori—and the three western districts—Imi, Kunawa, and Tashibu—that made up the Rokugo and to serve as future guardian of the area. It is highly unlikely that Nimmon and most of the other priests mentioned here were historical figures, but the story is interesting as an explanation of the origin of the Rokugosan, or Rokugo temples, pointing up the close connections existing between them and the Usa Hachiman Shrine.

The colophon to an edition of the *Lotus Sutra* incised on a copper plaque, dated 1141 and belonging to the Choan-ji in Bungo Takada, Oita Prefecture, indicates that the temples concentrated in the six districts were already referred to collectively as the Rokugosan around the middle of the twelfth century. The images of Taro Ten (Fig. 128)—the Shinto incarnation of Fudo Myo-o—and his two attendant cherubs, now located in the Choan-ji, used to be worshiped in the temple's tutelary shrine as its "god-body." According to an inscription in the interior of the Taro Ten, these statues were carved in 1130, indicating that the Choan-ji must have been completed before that date.

Most of the Rokugo temples lie in the present six districts of Kunawa, Tashibu, Aki, Musashi, Kunisaki, and Imi in Kunisaki County, but some spill over into other jurisdictions at the neck of the peninsula (Fig. 160). The temples lying in the valleys radiating from volcanic Mount Futago were referred to in a list of 1228 as "the temples, branch temples, sacred caves, buddhas, and [Shinto] deities in the Rokugo Manzan valleys," and since then the name Rokugo Manzan ("Myriad Temples of Rokugo") has been widely used. It is said that Nimmon was once active in these temples, and that the cave shrines visited by pilgrims totaled more than one hundred. In many of the temples worship of the Six Tutelary Bodhisattvas was common, and in praying to Hachiman Shinto chants were combined with sutra readings, showing the deep connection between the Rokugosan and the Usa Shrine. Given the fact that six Shinto gods—Ise, Atsuta, Kamo, Hachiman, Sanno, and Kashima—were revered at the West Compound of the Enrya-

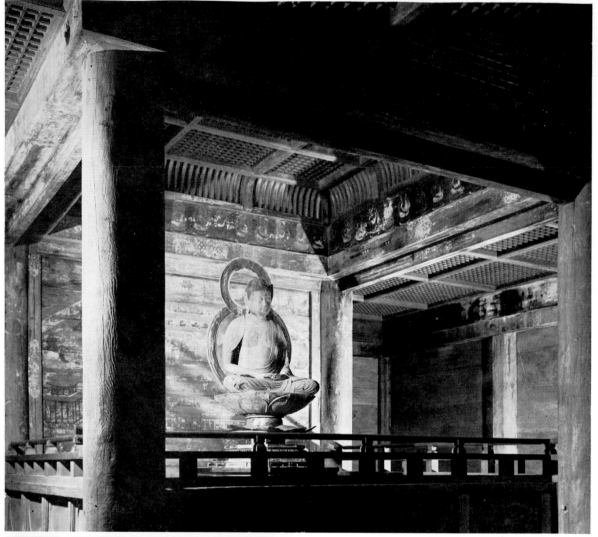

129 (above). Interior of Fuki-dera Great Hall. Second half of twelfth century. Oita Prefecture. (See also Figure 122.)

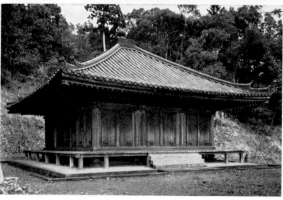

130. Fuki-dera Great Hall. Length of façade (see Figure 123), 7.7 m. Second half of twelfth century. Oita Prefecture.

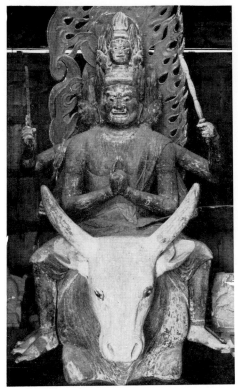

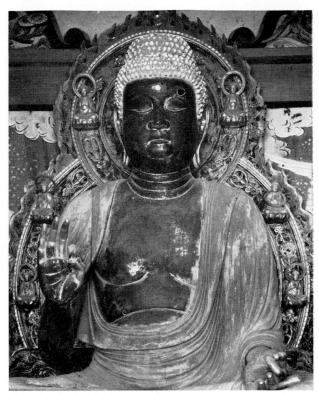

131. *Daiitoku Myo-o. Colors on wood; height of image, 129 cm. Twelfth century. Maki Great Hall. Oita Prefecture.*

132. *Buddha Amida. Height of image, 215.8 cm. Twelfth century. Maki Great Hall, Oita Prefecture.*

ku-ji, it seems reasonable to suppose that the same was true here.

THE ROKUGOSAN AND THE PURE LAND DOCTRINE

The connection of the Tendai sect with the Usa area stems from the time of Saicho (767–822), the founder of the Enryaku-ji, who in fulfillment of a vow made on his voyage to T'ang China undertook in the spring of 814, as part of religious observances in Kyushu, to deliver a lecture on the *Lotus Sutra* at the Miroku-ji, which enshrined Hachiman. In 818 Saicho vowed to build pagodas in every province from Kanto in the east to northern Kyushu in the west to provide protection for the nation. The Miroku-ji in Usa was selected as the site of the pagoda for Buzen Province. Saicho intended to enshrine in it one thousand copies of the *Lotus Sutra*. In the 890s, however, when two hundred had been laboriously written out, they were destroyed by fire. Thus it was impossible to complete the project, and instead a Taho pagoda enshrining one thousand copies of the sutra was built at the temple annexed to the Hakozaki Shrine near Fukuoka. Thus, though Saicho's plan was not carried out, it is worth noting that he showed an interest in the Miroku-ji, for it was apparently from this temple that Tendai Bud-

dhism spread into this region. The affiliation of the temples of the Rokugo is further clarified by a Kamakura-period reference to its being under the Mudo-ji, a Tendai temple.

In 987, two years after completing his *Ojo Yoshu,* Genshin went on a pilgrimage to sacred sites in Kyushu, and at Dazaifu, in present-day Fukuoka Prefecture, he met Chai Yin, a Chinese monk. And around the year 1000, the Chinese merchant Chou Wen-te visited Japan and sent a letter to Genshin in care of a local official. These events show that the Tendai Pure Land doctrines of Genshin had influenced northern Kyushu, and we may take it for granted that Pure Land teachings became popular in the temples of the Rokugo at about this time.

TEMPLES NEAR THE ROKUGOSAN

The Great Hall of the Fuki-dera (Figs. 123, 130), located in the Tashibu parish of the Usa Hachiman Shrine, was founded under the influence of these Pure Land teachings. A ridgepole plaque dated 1353 refers to "the Amida hall of Fuki village, Hayami County." In the Edo period it was called either the Lecture Hall or the Great Hall. Thus the present appellation is relatively new. Since the Fuki-dera appears in an 1168 list of the twenty-eight major Rokugo temples, it may be presumed to be at least that old, but we do not know if the Great Hall itself is of equal age. The hall was based on a three-bay-square plan, in the manner of a *jogyo*-meditation hall, but what would normally be extended eaves in the front are instead

◁ *133. Ryugan-ji Chapel. Length of façade, 6.85 m. 1286. Oku-no-in (Innermost Precinct), Ryugan-ji, Oita Prefecture.*

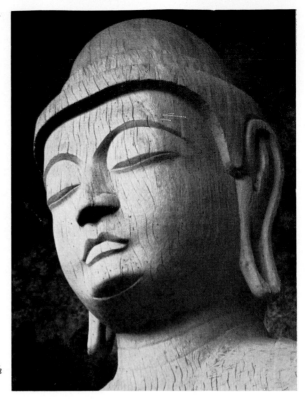

134. Buddha Yakushi. Wood; height of image, 306 cm. Twelfth century. Ryugan-ji, Oita Prefecture.

built into the roof, thus increasing the depth of the building to allow a larger worshipers' area. The front pillars of the altar (Figs. 122, 129) are not arranged to align right and left with the wall pillars, and the conventional open-timbered roof over the aisles around the altar is replaced by a ceiling. This type of interior is more characteristic of Kamakura-period architecture, so that this hall, a highly advanced variant of a *jogyo* hall, cannot be any earlier than the very end of the twelfth century.

The Great Hall of Maki, located in Tashibu about four kilometers southwest of the Fuki-dera and traditionally held to have been built at the same time and from the same stand of yew, is said to be the remains of the Denjo-ji, one of the major Rokugo temples. The temple precincts are now much reduced, and the main hall is new, but enshrined in it are the original images of the seated Amida (Fig. 132) and the Four Celestial Guardians in the center, with a standing Fudo Myo-o and two cherubs in the bay to the left and a figure of Daii-toku Myo-o (Fig. 131) in the right bay. The three main images are large, and all show the tranquillity characteristic of the first half of the twelfth century. The size of the images suggests that this monastery originally had a main hall and Godaido far grander than the Fuki-dera Great Hall.

Moving southward up the Yakkan River, past the Usa Shrine, to a point where the river curves to the west and the land rises somewhat, we come to the Ryugan-ji in the town of Innai, in the south-

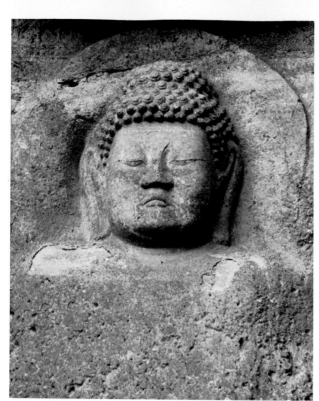

135. Buddha Dainichi, one of the carved-rock buddhas at Kumano. Height of image, 673 cm. Late twelfth century. Taizo-ji, Oita Prefecture.

136. Furuzono group of carved-rock buddhas. Colors on stone; height of head of Buddha Dainichi (foreground), 66.7 cm. Twelfth century. Usuki, Oita Prefecture.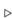

western corner of the original Usa county. In the hills about two hundred meters to the rear of the new main hall is a cave containing a wooden altar on which rest three seated *joroku* images in wood: Amida in the center, with Yakushi (Fig. 134) on the right and Fudo on the left. All may be assigned to the twelfth century. The original chapel in the front was probably contemporary with the images, but inscriptions on the beams of the present structure (Fig. 133) indicate that it was rebuilt in 1286. Three bays by two in plan, the hall has a plank floor built out over the drop from the cave mouth; the simple sloping roof is shingled with wood. A considerable gap between this roof and the cave face permits a lambent illumination of the upper portions of the images, providing a sense of illusion in the dim

surroundings. This combination of Amida, Yakushi, and Fudo is the same as that enshrined by Imperial Adviser Fujiwara no Tametaka in a hall in his mansion in 1130, so the *Goshui Ojo-den* (More Japanese Tales of Rebirth) tells us, and some connection is likely.

The carved-rock buddhas located to the southeast of Kunisaki Peninsula, made largely in the twelfth century, necessitated a considerable expenditure of labor. A number of noteworthy monuments still remain, and together with the temples and sculptures in the Rokugo districts, they show that the scale of religious work in this area was fully comparable to that of the three generations of the Fujiwara at Hiraizumi on the remote northeastern frontier of the nation.

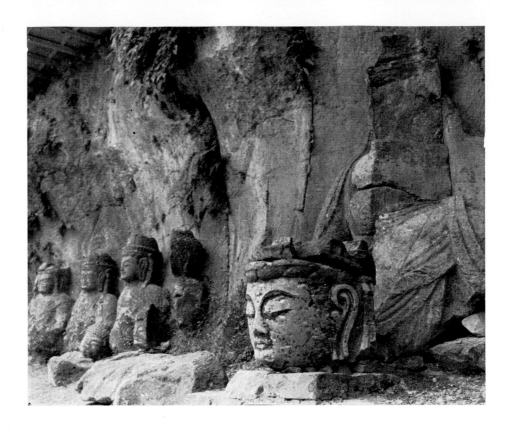

The best examples of rock sculpture are the stone buddhas of Usuki, carved in large semicircular niches in a rock face on the right bank of the Usuki River near the old site of the Mangetsu-ji. The niches are now open to the elements, but holes for roof beams, visible in the upper part of the rock face, indicate that chapels used to stand in front of the niches. In front of the Furuzono group of carved buddhas (Fig. 136), whose niche is the largest at Usuki, foundation stones can still be seen, testifying to the existence of a very imposing chapel. The images and the chapel of the Ryugan-ji, in the same cultural zone as those of Usuki, are therefore seen to preserve the early methods of sheltering stone buddhas, the methods that were prevalent in eastern Oita Prefecture.

CHAPTER SIX

The World of the Mandala

The following three chapters are devoted to the discussion of specific works of art connected with Pure Land thought. For the sake of fuller treatment, I have purposely included here some works that have already been mentioned in the previous chapters, at the expense of unavoidable repetition.

SOME EARLY MANDALAS The present Chiko Mandala, in the Gokurakubo quarters of the Gango-ji in Nara, is a copy. The *Kakuzen Sho* (Compendium of Kakuzen) records that the original, which belonged to the Gango-ji and was shown to the retired emperor Goshirakawa sometime between 1186 and 1192 by its chief priest Hangen, was painted on wood and measured about thirty centimeters in length and somewhat more in breadth. Another account in the book, to the effect that the mandala was a representation of the miniature Pure Land that "the Buddha created in the palm of his hand," confirms the tradition that the original was a small wood-panel painting, and it is probable that the sketch shown in the *Kakuzen Sho* (Fig. 137) reflects its composition. A copy of this mandala on wood, painted around the end of the twelfth century, exists in the Gokurakubo of the Gango-ji; it is set into the reredos of a shrine housing the statue of Amida, the main object of worship. Austere and of the most precise technique, this outstanding work is notable for the close attention paid to the

expression on the face of the central figure, Amida (Fig. 7); but its size, roughly two meters square, is excessive for a Pure Land "in the palm of the hand." In all probability the copy was enlarged and embellished from its earlier model to make it more suitable for devotional purposes. But even the original cannot be traced to the time of Chiko by anything more than tradition; there is no way to determine how much it precedes the first references to it at the end of the tenth century. There is a theory that the two monks shown represent Chiko and Raiko, but all one can say is that this is also a possibility.

The Taima Mandala was enshrined in the Taima-dera in Nara Prefecture, where it was hung in an elongated hexagonal shrine built in the West Hall. In 1217, in the Kempo era, a copy was made —now called the Kempo Mandala—and hung on the front wall of the shrine, while the damaged and faded original was affixed to its rear panel. Since the thirteenth century many copies, large and small, have been made and distributed; the copy in Kyoto's Zenrin-ji was painted just prior to 1230. The Taima-dera made a new copy, the Bunki Mandala, in 1502, reportedly because the Kempo Mandala had been lost to the ravages of war, and made another in 1678–79. At about the same time, the original was removed from the rear panel of the shrine by applying a paper overlay, wetting it, and then letting it dry. The reverse image on the paper was then transferred to silk,

indistinct portions were painstakingly painted in, and a scroll bar was attached.

Thus the character of the single original is now shared by three pieces. The silk scroll, called the Tapestry Mandala, is considered the true Taima Mandala, while the fragmentary indentations and traces of pigment that remain on the rear panel of the shrine are called the Rear Panel Mandala. Both of these are kept at the Taima-dera. The paper applied in the lifting process, which bears a reversed impression of the work, is called the Paper Print Mandala and is now the property of the Saiko-ji at Kiyomizu in Kyoto. The work now hung in the shrine in the Taima-dera Mandala Hall (Fig. 138) is the Bunki copy.

Structurally the Taima Mandala may be classified as a complex *jodohen* depicting the import of the *Kan Muryoju-kyo*. The main scene shows Amida's Pure Land, with the symmetry characteristic of the height of T'ang style. Before a background of fantastic temples and other buildings appear a platform, lotus pond, and stage with the dominant figure of Amida, his hands at chest level, attended by Kannon and Seishi, accompanied by a host of buddhas, bodhisattvas, and reborn beings, and sheltered by a canopy and the seven types of "treasure trees." The left-hand border shows eleven scenes from the story of Prince Ajatasatru and his mother Lady Vedehi, for whom the Buddha preached what was to become the *Kan Muryoju-kyo;* on the right are shown thirteen of Amida's Sixteen Ways to Meditate. The lower border consists of nine scenes representing the remaining three of the Sixteen Ways, thus making it probably the oldest Japanese example of a *kuhon raigo* (welcome to the nine categories of rebirth) representation. In texts and copies made since the Kamakura period, an inscription with the date 763 appears in the lower center, but its phraseology is of a later period than this, and it is impossible to discover whether the original had any inscription.

The Shokai Mandala, kept in the lotus-meditation hall of Nara's Chosho-ji, is a *jodohen* made by Shokai, a priest of the Kofuku-ji who resided and practiced lotus meditation at the temple around 989. An epithet with the date 996, appearing at

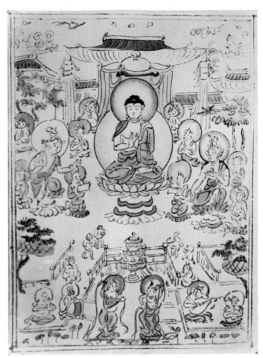

137. *Chiko Mandala, a copy included in* Kakuzen Sho *(Compendium of Kakuzen).*

the bottom of the mandala and quoted in the Gokoku-ji version of the *Shoji Engi-shu* (Collected Legends of Various Temples), describes the work as "woven from lotus fiber," indicating that the original was, like the Taima Mandala, a tapestry. Later lotus flowers appeared from the fiber, it is said, and were copied as an addition to the outer border. The original was destroyed, probably in the fire of 1459, so that only copies are extant. The composition is extremely involved, but an examination of the central scene shows the influence of the Taima Mandala, with the main figure of Amida making the same mudra. Its individuality comes from the sixteen lotuses along the border. Each flower bears one of the verses representing the Sixteen Ways to Meditate, doubtless a modification of the Sixteen Ways depicted on the right and lower borders of the Taima Mandala. A copy of the

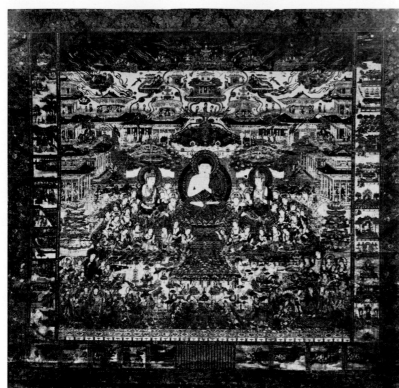

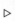

139 (opposite page, left). Small buddha triad behind celestial host, detail from left panel of triptych (see Figure 13) showing raigo of Buddha Amida and celestial host. Colors on silk; dimensions of this panel: height, 210 cm.; width, 105.2 cm. First half of twelfth century. Yushi Hachimanko Juhakka-in, Kongobu-ji, Mount Koya, Wakayama Prefecture.

140 (opposite page, right). Small buddha triad behind celestial host, detail from Phoenix Hall door painting of "lower class, upper rank" of rebirth. Colors on wood; height of central figure, about 4 cm.; dimensions of entire painting: height, 75 cm.; width, 97.5 cm. 1053. Phoenix Hall, Byodo-in, Uji, Kyoto Prefecture.

138. Bunki copy of Taima Mandala. Colors on silk; height, 374 cm.; width, 382 cm. 1502. Taima-dera, Taima, Nara Prefecture.

Shokai Mandala from the seventeenth century belonging to the Jokaku-ji in Sendai is similar, while the one originally in the Gokuraku-ji in Nara, now government property in the safekeeping of the Cultural Properties Protection Commission, is a copy dating from the second half of the twelfth century and lacks the lotus border.

RAIGO PICTURES OF THE HEIAN PERIOD

In the triptych *Amida Triad and Cherub* (Fig. 12) in the Hokke-ji in Nara, the central figure of Amida (Fig. 34) is, like the mid-ninth-century statue of Amida in the lecture hall of Kyoto's Koryu-ji, seated full face forming the mudra with hands in front of the chest; from the fact that clouds are shown under the lotus seat, the work is considered to be a *raigo* representation.

The panel on the left shows the two bodhisattvas Kannon (Fig. 14) and Seishi in half and full profile, respectively, kneeling (Kannon with the left leg raised) as in the door painting of the Byodo-in Phoenix Hall (Fig. 37), while the guiding cherub is standing looking back. All three figures, supported on clouds, show a degree of motion that contrasts with the static posture of the central figure. There are some differences among the panels in both coloring and brushwork, so that the side panels are usually dated later, around the first half of the twelfth century.

The triptych *Amida and the Celestial Host* at the Yushi Hachimanko Juhakka-in in Wakayama Prefecture (Figs. 13, 36) was originally at the Anraku Valley in the Yokawa Compound of the Enryaku-ji, whence it was stolen in the course of pillaging by the military leader Oda Nobunaga (1534–82).

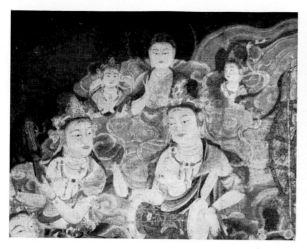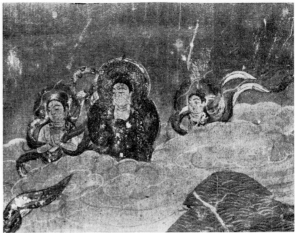

Later recovered, it was repaired in 1587 and enshrined at Mount Koya.

The cloud-supported bodhisattvas of the celestial host number twenty-nine excluding what appear to be another buddha and his two attendants to the rear (Fig. 139). The fact that, as with the sculptured-wood adoring bodhisattvas on clouds in the Phoenix Hall, the number is not restricted to twenty-five indicates that the work is of an early style. The triad formation, with the central figure facing directly front and figures of Kannon (Fig. 15) and Seishi to the left and right below, is also an older element. The presence of three monks directly behind the main figure and the importance of the position they occupy among the host bring to mind the *raigo* portrayals conceived by Genshin and lends credence to the Edo-period tradition that this work is by him. It may be that it is a somewhat embellished copy made around the first half of the twelfth century on the basis of a work dating from Genshin's time.

The *raigo* door paintings of the Byodo-in Phoenix Hall were painted around 1053. Each picture shows a scene of Amida's *raigo* drawn on a small scale against a grand panorama of nature (Fig. 37). Three rays of light from the shining curl between the eyebrows of the buddha illuminate the supplicants in their homes. These works show variety in the postures and positioning of the figures comprising the host, and in terms of the overall feeling of animation also exhibit great superiority to the one at the Yushi Hachimanko Juhakka-in, although they share some characteristics, such as the appearance of a group of monks near Amida in some panels and the addition of a small triad behind the host in one (Fig. 140). This small triad is shown on the door painting of the "lower class, upper rank" of rebirth, and according to the *Kan Muryoju-kyo* the buddha in this triad is the genuine Amida, who, with his two attendants and other bodhisattvas, has made himself manifest at the forefront of the host to welcome supplicants. The portrayals of the "middle class, middle rank" and "lower class, middle rank" of rebirth on the left and right walls of the Phoenix Hall were executed later, apparently around the turn of the thirteenth century, and would naturally have been patterned after the door paintings. Indeed the appearance of sixteen and nineteen, rather than twenty-five, bodhisattvas in the celestial host and the presence of four monks among them and the small triad behind show the earlier style. The position of Amida's left hand, resting in his lap in the *gosho* (or *raigo*) mudra, however, differs from that in the style of the *raigo* in the Kombu-in in Nara Prefecture (Fig. 35).

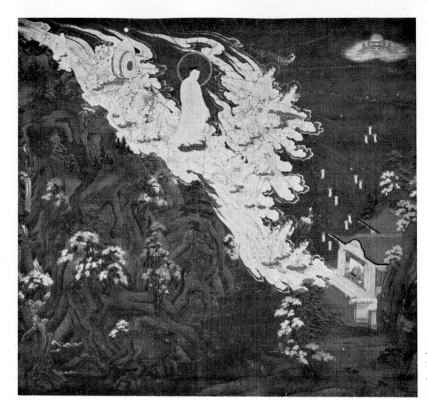

141. *Buddha Amida and the Twenty-five Bodhisattvas, one of the "fast-moving* raigo." *Colors on silk; height, 145.1 cm.; width, 154.5 cm. Thirteenth century. Chion-in, Kyoto.*

According to the *Kan Muryoju-kyo,* the "middle class, lower rank" of rebirth involves no *raigo* of Amida and bodhisattvas, while the manifest Amida and bodhisattvas do appear in the "lower class, upper rank" and "lower class, middle rank"; in the "lower class, lower rank" only a golden lotus appears in the form of the sun. Thus there is no necessity for Amida and the celestial host to be portrayed in every panel of the nine categories of rebirth. The appearance of the sun in the "lower class, lower rank" in later copies of the Taima Mandala shows faithful attention to the sutra's account.

The Amida *raigo* paintings belonging to the Shin-ren-sha temple in Kanazawa, Ishikawa Prefecture, and to the Hase-dera in Nara Prefecture, along with the *raigo* picture of Amida and the Twenty-five Bodhisattvas at the Kombu-in, all dating from around the second half of the twelfth century, show Amida seated with his mudra in the *gosho* position. In the Hase-dera work there are seven bodhisattvas of the celestial host. They increase in the Kombu-in work to twenty-five, the number that was popular during the Kamakura period. In contrast to the standing figures characteristic of the Kamakura period, however, all these works feature seated figures.

The Heike Nokyo *raigo* pictures appear in a collection of sutras copied by Taira clan members and dedicated to the Itsukushima Shrine in Hiroshima in 1164 by Taira no Kiyomori (1118–81). The frontispiece to the "Medicine King" chapter of the *Lotus Sutra* (Fig. 25) appears to reflect the scriptural declaration that female believers maintaining this chapter would, when departing their earthly lives and entering the world of peace and

happiness, be surrounded by Amida and a great host of bodhisattvas and would be reborn on pedestals within lotus flowers. In treatment it is an *ashide-e*, a style of painting in which pictorial and inscriptional elements are mixed. At the lower right a noblewoman is shown on the bank of a lotus pond, accompanied by the inscription "If this woman, by maintaining this chapter, ends her life . . ." In the background in the upper left Amida, supported on clouds, illuminates the woman with the light emitted from his forehead; beside him is a lotus seat upon which supplicants would be seated. Flanking this is the inscription ". . . she will immediately be reborn in the world of peace and happiness." This is a rare variety of *raigo* picture, admixing decorative and sportive elements, and exemplifies the works inspired by the *Lotus,* rather than the *Kan Muryoju,* sutra.

RAIGO PICTURES OF THE KAMAKURA PERIOD

Raigo paintings of the Kamakura period are found in profusion throughout Japan in a variety of types. The Amida triad in the Rengezammai-in of the Kongobu-ji shows an early type of symmetrical *raigo,* with the central figure in the "preaching mudra" (both hands in front of the chest, with a finger of one hand touching a finger of the other). In the *raigo* picture of Amida and the Twenty-five Bodhisattvas in the An'yo-ji in Fukui, the central figure poses with his hands joined in front of his body, the middle finger and thumb touching. The attendant host faces forward, with little sense of motion. Since most of the bodhisattvas are shown seated, older elements are present; but standing figures of Kannon and Seishi show newer influences. The *raigo* depiction of Amida and the Twenty-five Bodhisattvas in Kyoto's Chion-in (Fig. 141) is called a "fast-moving *raigo*" from the fact that Amida and the host of bodhisattvas supported by a streamlined cloud formation seem to be swooping down from upper left to the home of a supplicant at the lower right. Consistent with this speed, the main figure is not sitting at his ease as in Heian-period works but is standing erect making the *gosho* mudra. The items carried by the

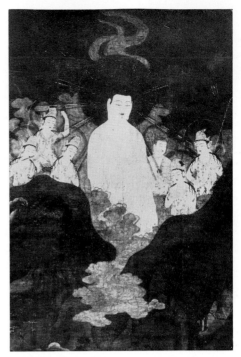

142. Buddha Amida over mountains. Colors on silk; height, 120.6 cm.; width, 80.3 cm. Thirteenth century. Collection of Seiichi Ueno, Hyogo Prefecture.

Twenty-five Bodhisattvas are virtually the same as those mentioned in the *Nijugo Bosatsu Wasan* (Hymn to the Twenty-five Bodhisattvas), which is thought to have been composed by Genshin. Some scholars feel that the hymn dates from after the middle of the Kamakura period, thereby limiting the period during which this *raigo* portrayal could have been made.

Another type of *raigo* picture appearing during the Kamakura period is the *yamagoshi,* or "over-the-mountains," *raigo,* which portrays Amida coming from beyond western mountains to welcome supplicants. In the example from Kyoto's Zenrin-ji (Fig. 28), the upper torso of Amida can be seen above the mountains; to his hands, held in front of his chest, are attached multicolored threads leading to the hands of supplicants. In the foreground to the left and right appear Kannon and Seishi

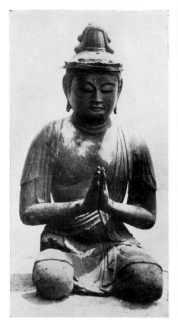
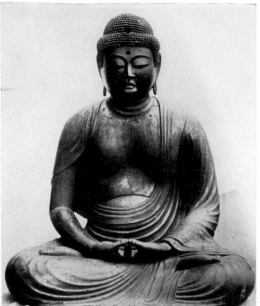
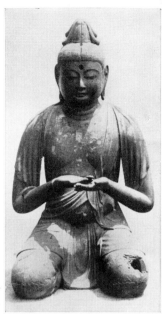

143. Amida triad. Gold leaf and lacquer on wood; heights: Amida (center), 138.8 cm.; Kannon (right), 79.8 cm.; Seishi (left), 81 cm. Second half of twelfth century. Hoan-ji, Ehime Prefecture.

in a symmetrical arrangement, an indication of earlier stylistic influence. In the example from Kyoto's Konkaikomyo-ji (Fig. 27) both Kannon and Seishi, like the main figure, are withdrawn beyond the mountains. The work in the collection of Seiichi Ueno of Hyogo Prefecture (Fig. 142) shows a standing Amida posed at a slight angle with the upper body visible beyond the mountains, with three bodhisattvas each to right and left, thus honoring the tradition of symmetry while maintaining considerable freedom in positioning the figures. It may be that this work was patterned after the Konkaikomyo-ji work, with some alterations to make it less formal.

RAIGO PORTRAYALS IN WOOD

The wooden *raigo* statuary group in the Soku-jo-in of the Sennyu-ji in Kyoto (Figs. 30, 38), consisting of a *joroku* Amida and the Twenty-five Bodhisattvas, is said to have been housed originally in a certain Fushimi-dera

temple, which was first built at Momoyama in southern Kyoto, on the northern bank of the Uji River, but was moved to Okamedani, also in southern Kyoto, by Toyotomi Hideyoshi in a bid to construct a castle on the site of the temple. The main figure and eleven bodhisattvas are in the original wood, while fourteen bodhisattvas are later replacements. Although some hold that the original did not have the usual complement of twenty-five bodhisattvas, by the fifteenth century the convention had been honored. The fact that the main figure poses with a mudra in the meditative position, like the main statue of the Byodo-in Phoenix Hall, is an early stylistic element; the Kannon figure, one of the originals, is seated and holds a lotus seat, as in the door paintings in the Phoenix Hall and the works at the Kongobu-ji.

The Amida triad statuary in the main hall of the Sanzen-in at Ohara, Kyoto (Fig. 94), dated 1148, fully adheres to convention, the main figure posed with the *gosho* mudra and the two attend-

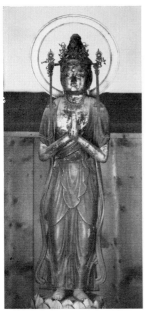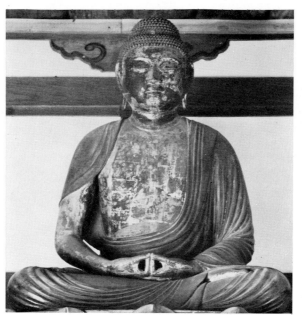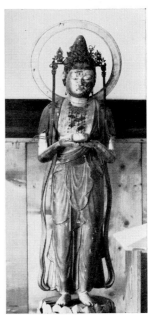

144. *Amida triad. Gold leaf and lacquer on wood; heights: Amida (center), 115 cm.; Kannon (right), 107.5 cm.; Seishi (left), 107.5 cm. Second half of twelfth century. Shobodai-ji, Kanagawa Prefecture.*

ant bodhisattvas seated (Fig. 24)—Kannon holding a lotus pedestal and Seishi with palms together.

The welcoming Amida triad at the Seisui-ji in Yasugi, Shimane Prefecture, is from around the end of the twelfth century.

The Amida triad of the Hoan-ji in Yawatahama, Ehime Prefecture (Figs. 143), is also of the welcoming type but is of early style in that the main figure is in the meditative posture. Taken together with the figures of Jizo and Ryuju, now at the Cho-on-ji in Uwajima, Ehime Prefecture, this work would form a complete Amida pentad of the Tendai type. The whole set is said to have been created for the Chuko-ji, a temple built on Taira lands near the Hoan-ji by Taira no Tadamitsu (whose personal name consists of characters that can also be pronounced Chuko) at the behest of the retired emperor Goshirakawa.

The Amida triad of the Shobodai-ji in Yokohama (Figs. 144), thought to date from around 1175,

has the central figure in the meditative posture, but the attendants are standing in welcome in the new "fast-moving *raigo*" form.

The two attendants in the Amida triad of Osaka's Shitenno-ji (Fig. 29) have one leg raised behind them as if running, showing more pronounced characteristics of the "fast-moving *raigo*." Since both the central and attendant figures show a mixture of old and new styles, the dating of this work is no easy task. But because we know that the temple had a meditation hall and a Gokuraku (Amida's Paradise) hall around the middle of the twelfth century, we may take it that these figures were in some way connected with them.

The Pure Land hall of the Jodo-ji, built in 1192 by Shunjobo Chogen (d. 1206) in Hyogo Prefecture, still enshrines the original imposing figures of a cloud-supported *joroku* standing Amida and attendants. This work leaves the observer overpowered with awe.

By the late sixteenth century "over-the-moun-

145 (left). Kannon mask used in mukaeko. Colors on wood; height, 24 cm. 1102. Horyu-ji, Ikaruga, Nara Prefecture.

146 (right). Bodhisattva mask used in mukaeko. Colors on wood; height, 39 cm. Thirteenth century. Jodo-ji, Hyogo Precture.

tains" *raigo* like the work in Kyoto's Chugen-ji came to be executed in wood, and we can see sculpture followed suit in the course taken by two-dimensional pictures.

THE WELCOME SERVICE AND THE MASKS USED

A *mukaeko* (pageant of Amida's welcome) was begun by Genshin at the Kedai-in hall in the Yokawa Compound of the Enryaku-ji as an annual event celebrating the ritual of Amida's *raigo* with a procession symbolic of the celestial host of bodhisattvas accompained by instrumental music, singing, and chanting. It was said that all who witnessed the service became choked with emotion, prostrated themselves in prayer, and joined the spiritual bond that would lead them to rebirth in the Pure Land. In due time, around 1018, such a pageant was also held in Kyoto, on the occasion of the lectures on the *Lotus Sutra* at the Rokuharamitsu-ji and the Urin-in. In Tango (present-day Kyoto Prefecture), under the governorship of either Oe no Takachika (d. 1046) or Oe no Kiyosada, an imposing *mukaeko* was held, probably officiated by Genshin's disciple

Kan'in, with musicians brought in from Kyoto. At the *mukaeko* first conducted in 1111 or earlier by the priest Yokan at the Yoshida-dera in eastern Kyoto, twenty sets of bodhisattva costumes were in use; and at the *mukaeko* begun around 1195 by Chogen at the Raigo and other halls of a temple at Watanabe, in present-day Osaka, the paraphernalia used included costumes for thirty celestial cherubs and twenty-eight bodhisattvas, along with bells, drums, and other musical instruments.

The main element of these pageants was the procession of the celestial host of bodhisattvas, for which masks were used from the beginning. Horyu-ji's Kannon mask carved for "raigo services" by Zozen in 1102 (Fig. 145) is one example. Chogen carved a standing Amida *raigo* sculpture for the Jodo-ji in Hyogo Prefecture, in addition to the triad in the Pure Land hall, for the express purpose of *mukaeko,* which he began in 1200. A number of the masks used in this and later pageants are preserved at the temple (Fig. 146). Similar masks are also found at the Kibitsu Shrine in Okayama Prefecture and in the Ishite-ji in Ehime Prefecture.

Kyoto Temples:
Predecessors and Successors

EARLY TEMPLES OF THE FUJIWARA The Gokuraku-ji, built by Regent Fujiwara no Mototsune (836–91), is a good example of the temples constructed around the end of the ninth century by the Fujiwara, the all-powerful family of the Heian period. The temple declined in the late sixteenth century but is believed to have been located in what is now Fukakusa Gokurakuji-cho, Fushimi Ward, in the southeast environs of Kyoto. It is said that although the main hall held an Amida made before Mototsune's death in 891, the hall itself was built around 899 by his son Minister of the Left Tokihira (871–909). Thus it is probable that the temple, as completed, more properly belongs to the early tenth century, but little is known of its buildings.

In 928 or a little earlier, another son, Regent Tadahira (880–949), built the Hosho-ji on the east bank of the Kamo River near the present Tofuku-ji. The main hall enshrined a statue of Dainichi. The temple was also furnished with a south hall, bellhouse, and gate, to which a Godaido was later added. In 945, in order to practice lotus meditation, Tadahira's sister Onshi, consort of Emperor Daigo, dedicated a Taho pagoda enshrining statues of Fugen and the Six Manifestations of Kannon, but there was still no sign of Pure Land decoration. The small standing statue of the Thousand-

armed Kannon (Fig. 147) in the present Hosho-ji, a small hall in Higashiyama Ward, Kyoto, is somewhat over one meter in height and has its major portion carved from a single piece of wood. This work is thought to go back to the founding of the Hosho-ji and thus may well be a survivor of the six Kannons of the 945 Taho pagoda.

Shifting the emphasis, I should now like to turn to a discussion of Tonomine in Nara Prefecture, the site of the mausoleum of an early Fujiwara. It is said that with the entry into Tonomine of Zoga (917–1003), who like Genshin was a disciple of Ryogen, the Tonomine-dera temple joined the Tendai sect. Lotus meditation had been practiced at the temple since 896, using its Golden hall; but in 946, the year after Zoga's arrival, a lotus-meditation hall was built at the behest of Emperor Murakami (r. 946–67). In 963 *jogyo* meditation was begun in the Hounbo of this temple by the priest Nyokaku, a disciple of Zoga and the eighth son (secular name, Takamitsu) of Fujiwara no Morosuke, and in 970 a *jogyo*-meditation hall was built by Minister of the Right (later Regent) Fujiwara no Koretada, Morosuke's eldest son. Thus halls for both types of meditation were completed at Tonomine only a dozen or so years after lotus and *jogyo* halls were built in the Yokawa Compound of the Enryaku-ji.

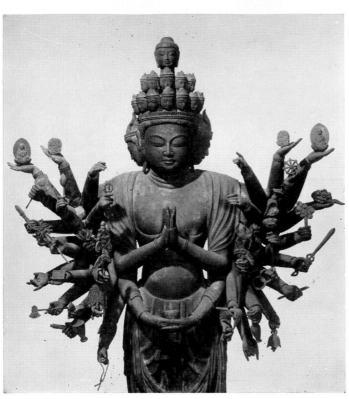

147. *Thousand-armed Kannon. Wood; height of image, 109.7 cm. Tenth century. Hosho-ji, Kyoto.*

148. *Genealogy of sculptors of Buddhist images in* ▷ *the Jocho school.*

At the Hoju-ji, founded to the east of the Kamo River in 988 by Minister of the Left Fujiwara no Tamemitsu, ninth son of Morosuke, the dedication of the main hall was accompanied by that of a lotus-meditation hall, enshrining a statue of Fugen, and of a *jogyo*-meditation hall, enshrining an Amida with four of the celestial host. Then in 990, Regent Kaneie (929–90), Morosuke's third son, converted his mansion Nijo Kyogoku-no-tei into a temple, the Hoko-in, but he died the same year. In 992 his son Regent Michitaka (953–95) built a hall, the Shakuzen-ji, within the temple precincts and the following year dedicated a lotus-meditation hall.

Koretada's grandson Imperial Adviser Yukinari (972–1027), upon the death in 995 of his maternal grandfather Minamoto no Yasumitsu, came into possession of their ancestral mansion and converted it into a temple called the Seson-ji (also Momozono-dera). He made the residential quarters the temple's main hall and commissioned Kosho to sculpt figures of Dainichi, Fugen, and the Eleven-headed Kannon, which he enshrined there, performing the dedication in 1001. The *Suisaki,* records of aristocratic court life written some eighty years later, relates that the pictures on the sliding partitions of the Seson-ji were by tradition considered to be the work of Kose no Hirotaka. It would seem, however, that in the process of conversion into a temple little alteration of the mansion was made.

THE AFTERLIFE OF THE HOJO-JI In its first major cataclysm, the fire of 1058, the Hojo-ji (Fig. 41) lost its Golden hall, Amida hall, lecture hall, Shaka hall, Godaido, Jis-

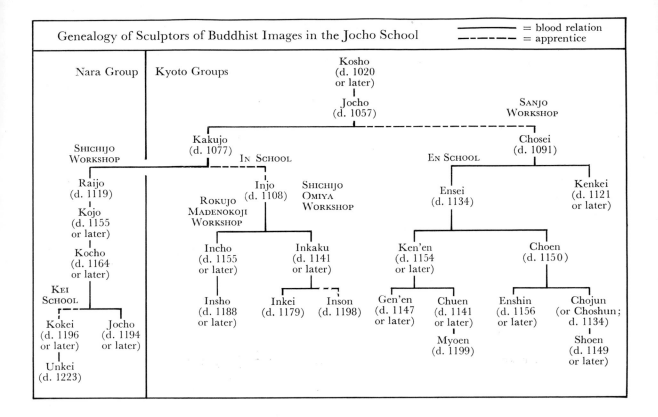

Genealogy of Sculptors of Buddhist Images in the Jocho School

———— = blood relation
------- = apprentice

Nara Group Kyoto Groups

Kosho
(d. 1020
or later)

Jocho
(d. 1057)

SANJO
WORKSHOP

Kakujo
(d. 1077)

IN SCHOOL

EN SCHOOL

Chosei
(d. 1091)

SHICHIJO
WORKSHOP

Raijo
(d. 1119)

Kojo
(d. 1155
or later)

Kocho
(d. 1164
or later)

Injo
(d. 1108)

SHICHIJO
OMIYA
WORKSHOP

ROKUJO
MADENOKOJI
WORKSHOP

Ensei
(d. 1134)

Kenkei
(d. 1121
or later)

Incho
(d. 1155
or later)

Inkaku
(d. 1141
or later)

Ken'en
(d. 1154
or later)

Choen
(d. 1150)

KEI
SCHOOL

Kokei
(d. 1196
or later)

Jocho
(d. 1194
or later)

Insho
(d. 1188
or later)

Inkei
(d. 1179)

Inson
(d. 1198)

Gen'en
(d. 1147
or later)

Chuen
(d. 1141
or later)

Enshin
(d. 1156
or later)

Chojun
(or Choshun;
d. 1134)

Unkei
(d. 1223)

Myoen
(d. 1199)

Shoen
(d. 1149
or later)

saido, octagonal hall, Tohoku-in, Saihoku-in, ordination hall, both lotus halls, pagoda, monks' quarters, bellhouse, sutra repository, south pavilion, and treasure repository, as well as several dozen buddhas of the *joroku* size or larger, a hundred images of Shaka, a hundred of Kannon, and many other works. The fact that the reconstruction the next year commenced with the Amida hall and the Godaido suggests that the temple gave the Amida hall priority over the Golden hall. Since the sculptor Jocho had died the year before the fire, it was his son Kakujo who made the images for the two halls. Two years later the Tohoku-in, whose building and buddhas had been considered to be of incomparable sublimity, was restored. The statuary for the Golden hall, Yakushi hall, and Kannon hall,

restored in 1065, were the work of Jocho's disciple Chosei, who was honored with the rank of *hokkyo* in recognition of his achievement. In 1068 the temple saw the dedication of 120 *joroku* buddha paintings, and for creating them Kyozen became the first painter of Buddhist images to gain the title *hokkyo*.

In 1079 east and west three-story pagodas, the new lecture hall, the Jissaido, and the lotus-meditation hall were dedicated. The two pagodas, copied after that of the Yakushi-ji, with double eaves on each story, enshrined statues of the Eight Events in the Life of Shaka and had pillar paintings illustrating the *Threefold Lotus Sutra,* including the opening and closing sutras. The Jissaido enshrined *joroku* images of Dainichi, Amida, Yakushi, Shaka, Fugen, Seishi, Jizo, Joko, Kannon, and

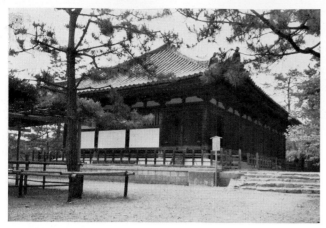

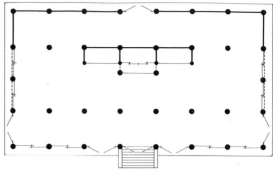

149, 150. Byodo-in Kannon Hall (left) and its floor plan (above). Length of façade, 19.09 m. Thirteenth century. Uji, Kyoto Prefecture.

Yakuo. The lecture hall contained pillar paintings of the Lotus Mandala (a scene of Shaka preaching the *Lotus Sutra*) and, on the doors, representations of the Sixteen Arhats, Tamon Ten, Jikoku Ten, the Ten Devils, Kariteimo (a female deity who used to devour the babies of others but repented her sin when the Buddha hid one of her own children), and other deities of Indian origin. The lotus-meditation hall had scenes from the Lotus Mandala on its four pillars and pictures illustrating the *Lotus Sutra* on its four door panels.

After the start of the Kamakura period one after another of the temple's buildings was destroyed. In 1331 the Amida hall, reconstructed in 1059, burned down, and only vestiges of the temple remained. The *Ama no Mogusa,* records of cloister life compiled in 1420, tells us that due to changes in the course of the Kamo River, the site was inundated around the beginning of the fifteenth century, but it is not known if this account can be trusted. At any rate, the location corresponds to the area north of present-day Kojinguchi in Kyoto's Kamigyo Ward.

The sculptures of the major temples of Kyoto and Nara during this period were largely the work of Jocho and others of his school. In his *Rekidai Daibusshi-fu* (History of Great Buddhist Sculptors), written in 1856, the philologist Kurokawa Haru-mura (1798–1866) collated the relevant material and produced a genealogical table that has since been widely used. Figure 148 incorporates revisions proposed by the late Takeshi Kobayashi (1903–69), formerly director of Nara National Research Institute of Cultural Properties.

Ensei, Injo, and Kokei, along with their followers, are conveniently termed the En, In, and Kei schools. The main workshops in the Kamakura period and later were the Sanjo (Chosei school), Shichijo Omiya (Injo-Inkaku school), and Rokujo Madenokoji (Incho school) in Kyoto, and in Nara the Shichijo (Raijo school). Jocho of the Nara school asserted that the only legitimate line was the one running to himself; but as each sculptor must have had his own interpretation, it is impossible to establish legitimacy with any certainty. (See foldout opposite page 153.)

BYODO-IN AFTER YORIMICHI

After the Byodo-in was made into a temple, besides the structures for religious use and dormitories for monks there were residential areas both within and outside the precincts where Yorimichi lived in seclusion. These were grouped under the name Uji-dono. On Yorimichi's death this complex passed to his daughter Kanshi, who had been made consort to Emperor Goreizei be-

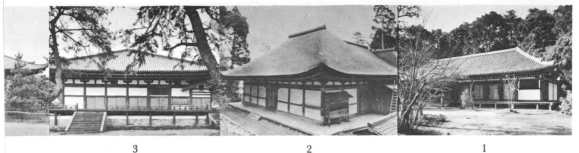

3 2 1

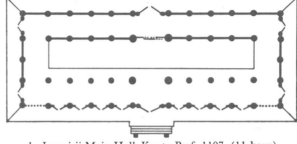

1. Joruri-ji Main Hall, Kyoto Pref. 1107. (11 bays)

2. Ishiyama-dera Main Hall, Otsu, Shiga Pref. 1096. (restoration of original plan, 7 bays)

. Taima-dera Main Hall, Nara Pref. 1161. (7 bays)

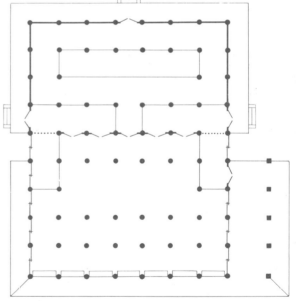

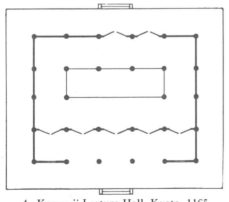

7 bays)

4. Koryu-ji Lecture Hall, Kyoto. 1165. (5 bays; originally 7 bays)

Extant Structures of Heian Buddhist Architecture

13 12 11

1160 • 1180 • 1200 • 1220 •

Amida, Butsudo-ji, Mie Pref. 1172.

Dainichi, Enjo-ji, Nara. 1176.

1150
Choen

1154
Ken'en

ku

1155
Kojo

1155
Incho
1156
Enshin

huen

1149
Shoen

47
Gen'en

1149
1198
Inson

1164
Kocho

1164
1196
Kokei

1164
1223
Unkei

1166
1199
Myoen

1167 1179
Inkei

1175 1188
Insho

1185 1194
Jocho

Amida, Sanzen-in, Kyoto. 1148.

Amida, Chogaku-ji, Nara Pref. 1151.

Amida, Ganjo-ji, Iwaki, Fukushima Pref. 1160.

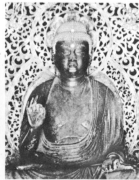

fore the latter's death in 1068. In 1089 Kanshi dedicated the Hojo-in in Uji, together with images carved by Jocho's disciple Chosei. Morozane's grandson Regent Tadazane built a villa, the Fuke-dono, to the north of the Byodo-in in 1114.

In the autumn of 1118, on the occasion of a service dedicated to various buddhas and held by Kanshi in the Amida hall, the pond in front of the building was set with imitation lotus blossoms and water birds, and the banks were adorned with imitation cherry trees, autumn leaves, and cranes and wagtails. A small pavilion in front of the pond was reserved for the former empress consort, and a shed for court ministers and a stand for an orchestra were set up nearby. Probably a stage was also erected over the water. The small pavilion referred to here would be the small structure that Yorimichi is said to have had built in front of the Amida hall across the lake, comparable to the *nenzudokoro* (place of invocation) in the Hojo-ji Amida hall except for its placement outside the hall.

An octagonal Aizen hall was dedicated in 1126. Contemporary reports indicate that at the time of visits by the retired emperor Toba in 1132 and 1134, a "confessional" and a "chapel" (probably the buildings later called the East and West Nem-butsudo) were already in existence near the main hall. A villa called the Ogawa-dono was situated to the northwest of the Byodo-in at this time. In 1133 the ex-regent Tadazane dedicated an east-facing Taho pagoda on the site of the former monks' quarters, about a hundred meters to the south of the Uji Bridge, and in 1135 his Uji villa, the Komatsu-dono, was completed, to which he invited Toba. The Komatsu-dono, located to the west of the Ogawa-dono, seems to have later become a temple with the name of Joraku-in. In 1142 Tadazane's mother, known by her title Ichijo-dono, dedicated a new Amida hall within the Ogawa-dono, and Tadazane himself founded a hall of nine Amidas to the north of the Komatsu-dono with images carved by *hogen* Kojo. In 1149 Tadazane built a hall within the Joraku-in for his departed mother, with a statue of Dainichi carved by Inson as the main object of worship. In 1151 he dedicated the Uji Shindo (Uji New Hall), also

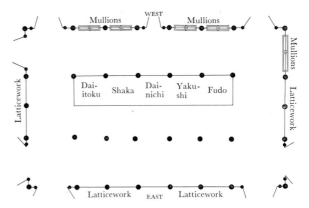

151. Floor plan of Byodo-in Main Hall, adapted from Mon'yoki.

for his mother, and three years later a confessional. Toward the end of the Heian period, formal pilgrimages were made by boarding a boat on the east bank of the Uji River, crossing to the fishing pavilion on the west bank, and thence via corridors to the main hall.

After the start of the Kamakura period, no new structures were added to the Byodo-in with the exception of a palace for Toba, which was built to its north in 1203 but destroyed by fire two years later. Many structures were razed during the military campaigns of Kusunoki Masashige (1294–1336) in 1336, but the Phoenix Hall was spared. The Kannon hall (Figs. 149, 150) to the north of the Phoenix Hall is a Kamakura-period structure, and tradition has it that it was originally a sutra repository, moved to the former site of the fishing pavilion. However, since it fits the dimensions given in the *Mon'yoki* for the original main hall (Fig. 151) and since it is located on approximately the same site, it is more than likely a restoration of the main hall.

DESIGNATED TEMPLES OTHER THAN THE SIX "SHO"

In 1114 the retired emperor Shirakawa dedicated a hall of nine Amidas, named the Rengezo-in, within the precincts of the Izumi-dono

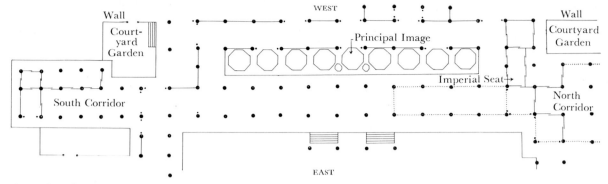

152. Floor plan of Fukusho-in Buddha Hall, adapted from Hyohanki. *Shirakawa, Kyoto.*

at Shirakawa; another nine-Amida hall was dedicated near it in 1130 to mark the first anniversary of his death.

The Shobodai-in was first built to the south of the Hojo-ji under the auspieces of Tokushi (篤子), consort to Emperor Horikawa, but was destroyed by fire in 1117. In 1124 it was rebuilt to the east of the Hojo-ji Tohoku-in, but Shirakawa ordered Ninjitsu, the Tendai patriarch, to move it to the south of the Sonsho-ji, where it was dedicated in 1129. It consisted of a Shaka hall and an Amida hall enshrining nine Amidas carved under the auspices of Emperor Horikawa in 1113. Also in 1129, Ninjitsu had a two-story hall built to house a *joroku* Amida.

The Tokuchoju-in was dedicated at Toba's behest in 1132. Its main hall, enshrining a *joroku* Sho Kannon as the main image, flanked by five hundred life-size figures on the left and a like number on the right, was thirty-three bays in length and faced the east. The Hoshogon-in, also dedicated by Toba in the same year, comprised a buddha hall and a residence. This hall, which faced the east and held nine *joroku* Amida figures, was an impressive structure nine bays wide excluding the aisles, the eaves protruding slightly on the south side; the structure glittered with gold and silver decorations. Toba urged the public to have one thousand statues of Amida carved for him and in

1152 made an initial dedication of one hundred three-*shaku* seated figures of Amida making the *gosho* mudra.

Like the Hoshogon-in, the Kankiko-in—dedicated in 1141 by another lady called Tokushi (得子), who became consort of Toba about a decade after he retired as emperor—had both a worship hall and a residence. Toba constructed the East Palace of the Kita-dono at Shirakawa in 1134, and in its hall, which he called the Komido (Lesser Hall), enshrined a half-*joroku* wooden triad by *hokkyo* Incho showing Amida, his hands in the *gosho* mudra, supported on purple clouds. In 1151 a Taho pagoda was dedicated on the pond islet, and the year following the dedication of the Komido, Consort Tokushi dedicated the Kongosho-in in her Shirakawa palace and the Oshikoji-dono, which lay to the east of the pond and included residential quarters, a gatehouse, and corridors.

Finally, the Fukusho-in was built in 1151 by Fujiwara no Taishi, who had become consort to Toba earlier than Tokushi and was then known by the title Kayanoin. The hall, like that of Toba's Hoshogon-in, faced east, was nine bays wide excluding the aisles, featured slight protrusions of the eaves on the north and south sides, and enshrined nine *joroku* Amida images. The north wing was connected to the residential quarters, as shown in Figure 152. A three-story pagoda dedicated in 1154

faced west on a site east of the flower gardens in the east yard of the hall. It enshrined two images, Shaka and Taho, and had paintings of Shaka preaching on the rear wall and of the Eight Events in his life on the four door panels. When Kayanoin died the following year, her casket was laid to rest beneath the plank floor of the Fukusho-in Gomado. (See foldout opposite page 112.)

At the founding of the Hokkongo-in by Taikemmon'in, who was made consort to Toba while he was on the throne, a large pond was excavated. To the west of the pond were set a hall and a gate, and to the east, a residence and a gate (Fig. 153). The hall, called West Hall, was dedicated in 1130. It was an east-facing structure with a three-bay-wide altar space enshrining a *joroku* Amida by Inkaku and paintings by Myogen. A one-bay-altar-space building called the Big Dipper Hall, dedicated in 1135, stood to the north of the residence and enshrined an image of Ichiji Kinrin, the Seven Stars of the Big Dipper, the Nine Daylight Angels, the Twelve Signs of the Zodiac, and the Twenty-eight Constellations. Beyond the earthen wall to the south of the main hall were a five-story pagoda on the east and a sutra repository on the west, both surrounded by corridors and completed in 1136. The pagoda enshrined a life-size image of Dainichi; its four pillars were decorated with pictures of various divinities of his Diamond and Womb worlds; and its door panels bore representations of the Eight Events in the Life of Shaka. The sutra repository, housing the complete canon, was in the rare, two-story octagonal style, enshrining a set of the Buddhist scriptures written in gold on indigo paper and a life-size sandalwood image of Shaka, and having representations of the Sixteen Arhats on the doors in the eight walls. The scribe Chui was given the rank of *hokkyo* for his work in copying the scriptures. The South Hall, dedicated in 1139, measured nine bays excluding the aisles and enshrined nine Amidas. The main image, by *hogen* Inkaku, was of the half-*joroku* size, while the other eight figures to its right and left were life-size. The *moya* pillars were decorated with the Mandala of Both Worlds of Dainichi with Sanskrit inscriptions. The reredos behind the central

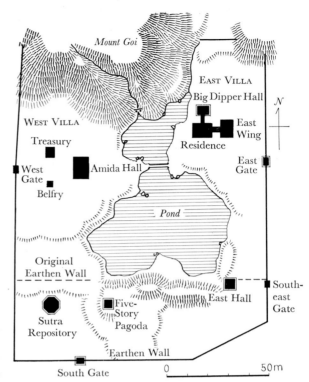

153. *Restoration of Hokkongo-in ground plan as conceived by Osamu Mori.*

image bore representations of the Mandala of the Nine Categories of Rebirth, the Six Manifestations of Kannon, and the Beings of the Six Worlds on its south side, and on its north side a Mandala of Amida's Paradise, while in the four bays to right and left, ten scenes of rebirth were painted on the south side of the reredos and the Nine Categories of Rebirth on the north. The lotus-meditation hall, also built in 1139 as a mausoleum for the former empress, was a one-bay-altar-area structure in the northern precincts, enshrining a stupa ornamented with the traditional seven precious materials of Buddhism, the contents of which included a *Lotus Sutra* written in gold on indigo paper. The doors on the four sides were decorated with scenes from the Lotus Mandala. In 1145 the former empress

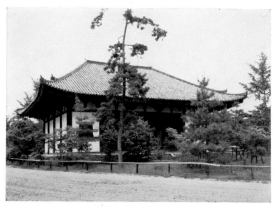

154. *Koryu-ji Lecture Hall. Length of façade, 16.56 m. 1165. Kyoto.*

died at the Sanjo Takakura-no-tei villa and was buried beneath this hall.

The Hokkongo-in thereupon passed to her daughter Toshi, known by her title Josaimon'in, who in 1171 built a small one-bay-altar-space structure, the East Hall, southeast of the pond, in which she enshrined a Chou-*joroku* ("sixteen Chou-dynasty feet"; actually eight feet, for the figure was seated) image of Amida. Nine manifest buddhas were incised in the mirrors of the mandorla, while the nimbus bore eleven esoteric formulas in Sanskrit. The reredos bore representations of the Mandala of Amida's Paradise and the Mandala of the Nine Categories of Rebirth, while on the mirrors attached to two reredos pillars were inscribed the Sanskrit letter symbolizing Amida.

The Amida image presently enshrined in the main hall of the Hokkongo-in (Figs. 75, 88) is of the Jocho school, but opinions on its identification differ. Of three possibilities—the *joroku* figure by Inkaku in the West Hall, dedicated in 1130; the half-*joroku* figure, also by Inkaku, in the South Hall of 1139; and the Chou-*joroku* figure in the East Hall of 1171—the seated half-*joroku* figure (thus four *shaku* in height) in the South Hall can be definitely rejected. The hairline of the present statue is at a height of 6.4 *shaku* (which corresponds to eight Chou feet), making it a Chou-*joroku* figure, and

thus the Chou-*joroku* figure in the East Hall is the only strong contender. However, there remains a possibility that the height of the West Hall figure, if indeed Chou *joroku*, was abbreviated simply to read *joroku*, so our judgment cannot be a definitive one.

EXTANT TEMPLES OF THE INSEI PERIOD

Of the temples representative of the period of *insei*, or rule by the retired emperors, none of those built at Shirakawa, Toba, or the Hojuji-dono survives in its original condition. The main hall of the Rengeo-in, for example, was reconstructed in the Kamakura period. Thus we must look to other remains in the vicinity for direct evidence of the influence exerted by the great construction works in the capital during this period. (See foldout opposite page 152.)

The Joruri-ji temple is located in Kamo-cho, Soraku County, Kyoto Prefecture, near the border of Nara Prefecture. Its three-story pagoda (Figs. 82, 89) was reportedly moved from Ichijo Omiya in Kyoto in 1178. Stylistically, too, it belongs to the twelfth century and thus attracts great attention as a structure built in Kyoto during the period of rule by retired emperors. Its delicate and refined detail confirm this origin.

The great importance of the temple's main hall (Fig. 84) derives from the fact that it is the only hall of nine Amidas with an eleven-bay façade that has come down to us from the Heian period. The image of Yakushi in the main hall (now lost) was dedicated in 1047 by Achiyama Shigeyori, a local magnate. After the temple was installed it was connected with the Kofuku-ji; but, incorporating the increasingly fashionable Pure Land practices, it raised the nine-Amida hall in 1107, with statues dedicated the following year. Like the earlier Amida halls of the Hojo-ji and Hossho-ji, this one is located in the western part of the precincts, facing east, but the images are smaller than *joroku* (Figs. 81, 90, 91), and the interior is distinguished by its simplicity, lacking pillar and door paintings.

SEVEN-BAY HALLS. Examples of seven-bay halls include the Koryu-ji Lecture Hall in Kyoto, the

Taima-dera Mandala Hall in Nara Prefecture, the Ishiyama-dera Main Hall in Otsu, Shiga Prefecture, and what is now the Daigo-ji Golden Hall in Kyoto, which used to be in Wakayama Prefecture.

The oldest of these is the Ishiyama-dera Main Hall (Fig. 99), whose main object of worship is a Nyoirin Kannon. It is a reconstruction of a Nara-period hall destroyed by fire in 1078, the rededication ceremony taking place in 1096. The hall itself is large, but the accouterments are simple, and there are no pillar or door paintings. The oratory attached to the front of the main hall was also destroyed in the 1078 fire; the present one was built in 1602 by Yodogimi, widow of the military dictator Toyotomi Hideyoshi (1536–98).

The Taima-dera Mandala Hall (Fig. 87) comprised a five-bay altar space surrounded by four one-bay-wide aisles. It was refurbished in the early Heian period to house the Taima Mandala. In 1161 the ceiling of the front aisle was removed, an oratory was built in, and a larger roof was erected to cover both structures.

Following the fire at the Koryu-ji in 1150, its lecture hall (Fig. 154) was rebuilt as a five-bay-altar-space structure, that is, having a façade of seven bays; but during repairs carried out in 1564 and 1565 it was shortened to five bays. Structurally it is austere and has no pillar paintings.

The Daigo-ji Golden Hall (Fig. 95) was originally the main hall of the Mangan-ji in Yuasa, Wakayama Prefecture. In 1598, when Hideyoshi ordered the reconstruction of the Daigo-ji, the priest Oki, the commissioner for the undertaking, transported and rebuilt this hall, with its main image and figures of two of the Four Celestial Guardians intact, rather than construct a wholly new hall. Interrupted by Hideyoshi's death, work was completed in the name of his son Hideyori in 1600. The present hall comprises a three-bay-square inner sanctuary with one-bay sanctuaries on left and right and aisles on the four sides. The front aisle was used as an oratory, the great width of which seems to be due to later extension. If we assume the accuracy of an account in the *Kii Zoku Fudoki* (Chronicles of Kii Province Continued), the Man-

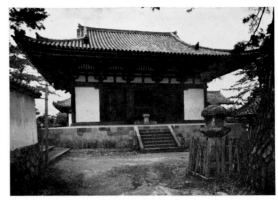

155. *Taima-dera Golden Hall. Length of façade, 16.84 m. 1184. Taima, Nara Prefecture.*

gan-ji was founded by Koshu at the behest of the retired emperor Goshirakawa. It must predate the ex-sovereign's death in 1197, and structural details, indicating the style of the late Heian or early Kamakura period, do nothing to refute this tradition. The images of Yakushi and two attendants, which were moved from the Mangan-ji at the same time as the hall, are clearly from the early Kamakura period, and this fact also helps in dating the hall.

FIVE-BAY HALLS. Examples of five-bay halls, consisting of a three-bay altar space surrounded by aisles, include the Daigo-ji Yakushi Hall and the Taima-dera Golden Hall. Though both are reconstructions of earlier originals, the earthen floors recall the old stylistic conventions of the Nara period. The Yakushi hall was built atop Mount Daigo somewhat after the Juntei hall and Nyoirin hall, which had already been built by the priest Shobo. It appears to be the Yakushi hall for which, together with the Godaido, image making was begun at Emperor Daigo's behest in 907. Construction continued after Shobo's death in 909, when the temple passed to his disciple Kanken, but was completed by 913. Over the next two centuries the hall fell into decay, but in 1121 Jokai, the chief priest, rebuilt it and repaired the images, holding a dedication ceremony in 1124. This is the present Yakushi hall (Fig. 85). The Yakushi triad dates

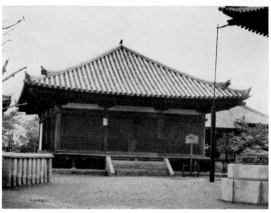

156. *Kakurin-ji Jogyo Meditation Hall. Length of façade,
7.91 m. Late twelfth or early thirteenth century. Kakogawa,
Hyogo Prefecture.*

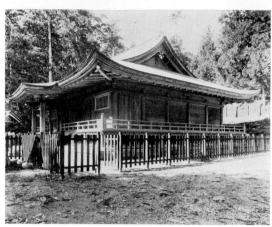

157. *Buraku-ji Yakushi Hall. Length of façade, 11.42 m.
C. 1151. Kochi Prefecture.*

from sometime between 907 and 913. It was prob-
ably during the reconstruction that the *moya,* or
altar space, was enclosed by walls and latticework.

The Taima-dera Golden Hall was founded in
the Nara period but was put to the torch by auxil-
iary troops of the House of Taira advancing from
Osaka during Taira no Shigehira's pillage of the
Nara region in 1180. The present edifice (Fig. 155)
was dedicated in 1184 by Fujiwara no Shin'en,
chief priest of both the Kofuku-ji and this temple.
Standing on a stereobate, this hall enshrines a
Nara-period main image of Miroku in addition to
statues of the Four Celestial Guardians on an altar
that almost fills the *moya.* The hall departs from
the conventional arrangement of a single central
door in the rear wall by having three doors in the
rear as well as in the front, probably because the
pilgrimage route to the important mandala hall
ran between the Golden and lecture halls and it
was therefore desired to give the Golden hall at
least the appearance of facing this route.

THREE-BAY HALLS. During the twelfth century
there was a great vogue for building three-bay halls
—that is, halls with one central bay surrounded by
one-bay-wide aisles so that both front and sides
measured three bays—and halls that were variants

of this form. A typical example of this style is the
Konjikido at the Chuson-ji (Fig. 103); similar forms
are found in the Shiramizu Amida Hall of the
Gango-ji (Fig. 111) in Fukushima Prefecture and
the Amida hall of the Kozo-ji (Fig. 116) in Miyagi
Prefecture, though these are not located in the
vicinity of Kyoto.

Examples in the Kyoto environs are the *jogyo-*
meditation hall (Fig. 156) and Taishido (Fig. 98)
of the Kakurin-ji in Hyogo Prefecture. The Taishi-
do was originally a lotus-meditation hall but gained
its name from its commemorative statue of Prince
Shotoku, or Shotoku Taishi as he is known in Japa-
nese. Excluding the oratory, the building is one
bay with one-bay-wide surrounding aisles, and the
span of the pillars is the same in the *moya* as in the
aisles. Only in the front are there double eaves,
over the oratory, which is separated from the main
part of the building by lattice doors. It is possible,
however, that the secondary eaves were added later.
An inscription on the roof planking made during
reconstruction in 1326 indicates that the hall was
founded in 1112. The *jogyo*-meditation hall is one-
bay square excluding the aisles and has double
eaves on the façade incorporated into the high-
rising hipped roof. The aisles as well as the *moya*

are ceiled. (The aisles of the Taishido were ceiling-less, leaving the roof open-timbered.) Thus the *jogyo*-meditation hall is Heian in style, though built considerably later than the Taishido.

The Gokuraku-in in Kyoto's Ohara, near the Raigo-in founded by Ryonin (1072–1132), was built by Shinnyobo and was repaired at the order of Imperial Adviser and Minister of Civil Affairs Taira no Chikanori as a retreat. Later the Sanzen-in temple was moved to this location, and the main hall of the Gokuraku-in was made the main hall of the Sanzen-in (Fig. 97). It is a one-bay-altar-space structure, but the depth of the altar space is considerably greater than the width—twice as long as the span of the aisle pillars—so that the side walls look four bays long. The *moya* ceiling is formed like a ship's hull (Fig. 96). Enshrined on the altar below is an Amida triad of the *gosho* type (Fig. 94). The inscription concealed within the attendant image of Seishi tells us that the images were carved in 1148, implying that the hall was built about the same time. An example with a similar floor plan is the Great Hall of the Fuki-dera in Oita Prefecture, which we will discuss in the next chapter.

Unusual examples of five-bay-square halls include the Yakushi hall of the Buraku-ji in Kochi Prefecture and the Amida hall of the Hokai-ji in Hino, in southeastern Kyoto. The latter (Fig. 92) consists of a one-bay altar area surrounded by aisles, with double eaves; but because it was to enshrine a *joroku* main image, the *moya* was made particularly spacious, and the aisles were made proportionately wider. The pillars of the aisles do not align with those of the *moya* but are arranged for the greatest convenience. This freedom of pillar arrangement was made possible by abandoning the conventional method of using cambered beams—called rainbow beams because of their shape—to connect the aisle and *moya* pillars, a development indicating that the hall may have been built at the very end of the Heian period or even in the early Kamakura period. The Buraku-ji Yakushi Hall (Fig. 157) has a simple hipped-and-gabled roof and employs the simplest type of bracketing. The three-bay-square inner sanctuary is set somewhat to the rear, so that the pillars of the outer side walls and those of the two sides of the inner sanctuary are not aligned. Later reconstruction has caused the loss of a great deal of its Heian flavor. Of the three main images that it enshrines, that of Shaka dates from 1151, which is generally considered to apply also to the building; but the other two, Yakushi and Amida, seem to be of different dates, casting some doubt on the propriety of dating the hall from the Shaka image alone.

CHAPTER EIGHT

Temples in the Outlying Districts

THE RUINS OF TEMPLES IN HIRAIZUMI

THE CHUSON-JI. At the Chuson-ji in Hiraizumi, Iwate Prefecture, there are remains on a hill of an east-facing hall referred to as the "Great Golden Hall." Immediately in front was the Triple Pond, and traces have been found of a convoluted shoreline, an islet, and bridge foundations. The present sutra repository (Fig. 158) is south of this pond, and the Konjikido lies farther south. But since no corridor has been identified near the former Golden hall, it is doubtful whether this is the hall mentioned in the dedicatory document as enshrining a Shaka triad. To the north of the pond, near the Hakusan Shrine, where a Taho pagoda is supposed to have stood, ruins have been discovered of a long, wide-bayed hall that may have been the "two-storied Great Hall." On low-lying paddy fields to the east of the Konjikido is the traditional site of the Great Pond. Evidence has been found of a pond and islet, and on the west bank, of several buildings including one traditionally considered to have been the Lesser Sutra Repository. Since this pond was much larger than the Triple Pond, it is likely that it was the focus of the Chuson-ji complex, and investigations of this area are presently being carried out. (See foldout opposite page 113.)

The Konjikido stands on a height facing east. It comprises a one-bay altar space surrounded by aisles—that is, a three-bay square—and is of a relatively old style in that the pillars of the *moya* and aisles are aligned. A large altar dominates the *moya*. Enshrined on it are a small Amida triad, the Six Manifestations of Jizo, and two guardians (Fig. 104). On the plank floor below the altar reposes a wooden coffin containing the remains of Fujiwara no Kiyohira. The altar railings, *moya* pillars, and bracketing (Fig. 105) are lacquered and richly decorated with mother-of-pearl, gold lacquerwork, gold- and silver-plated copperwork, and colored-glass inlay. The pillar sheaths of buddhas in circles, worked in gold lacquer, though small in scale are of particularly rich craftsmanship, suggesting that Kiyohira spared no expense and gave the artisans a completely free hand. Because the area around the aisles was lacquered and covered with beaten gold, probably all the way up to the wood-shingled roof, this building has been known by the name Konjikido (Gilded Hall) from the time of Kiyohira's grandson Hidehira down to the present.

The sutra repository also consists of a one-bay altar area and surrounding aisles, but its floor area is larger than that of the Konjikido, and the pillars of the *moya* are all set back somewhat, making the front aisle wider. Along the inside walls on both sides and to the rear run black-lacquered shelves for

sutras, the supporting posts of which have lotus bases. Originally, there was probably no door in the south bay of the rear wall, and if we mentally restore the wall and shelves there, we find agreement with the fourteenth-century account in the *Chuson-ji Kyozo Monjo* (Records in the Chuson-ji Sutra Repository) that nine bays on three sides were lined with seven tiers of shelves. The present appearance of the interior also confirms the statements in the records that the shelves held 536 cases storing transcriptions in gold and silver of the complete canon dating from the time of Kiyohira (Fig. 101) and a copy of the complete canon on indigo paper from the time of Motohira, that a Chinese edition of the complete canon from the time of Hidehira was contained in sixteen Chinese-style chests, and that the main object of worship was Monju, with four attendants. The building was repaired in 1304 and greatly remodeled in the first half of the seventeenth century, when the *moya* pillars and the ceiling were replaced. The beams bearing colored designs and the sutra shelves are older but probably do not predate the repairs of 1304.

The repository is furnished with Heian-period utensils and trappings far more luxurious than the building itself. There is an octagonal altar (Fig. 118) decorated with mother-of-pearl, on which Kamakura-period images of Monju and four attendants are enshrined, along with a priest's platform, lacquered table and candleholders, both ornamented with mother-of-pearl, and a ceremonial gong. The sutra repository mentioned in the dedicatory document of 1126, a two-story structure with a tile roof, is recorded to have enshrined a life-size image of Monju. The Monju in the present repository is thought to be a later copy, but the octagonal altar and other items may be from the older, two-story structure. The unusual shape of the altar suggests that the repository, like the one in the Hokkongo-in, was octagonal in plan. In the Edo period there was a tradition that the upper story had been lost in the fire of 1337, resulting in the present configuration, but this story is doubtful. The original, dedicated in 1124, may have been an ancestor of the present structure, but they

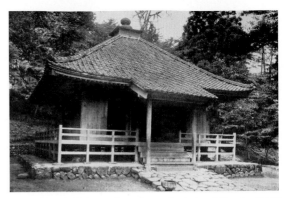

158. Chuson-ji Sutra Repository. Length of façade, 7.75 cm. Thirteenth century. Daichoju-in, Chuson-ji, Hiraizumi, Iwate Prefecture.

are most probably completely different buildings.

THE MOTSU-JI. The Motsu-ji temple was located on flat land below the southern slopes of a hill near the Chuson-ji and faced south on a site demarcated on the south and east by earthworks. One entered through the South Main Gate to face a large pond some 200 meters from east to west and 100 meters from north to south, with an island to which ran bridges in front and back. The wood foundations of the bridges can still be seen in the water. On the southeast bank is a small peninsula with a stone arrangement and a submerged strand set with pebbles. On the southwest bank are artificial hillocks and rockwork. On to the north, water is led through more rockwork, and there is a boat landing. Except for considerable silting up of the west bank in later times, the site well preserves the twelfth-century style of pond garden (Fig. 110). Crossing the bridges, one would face the Golden hall called the Enryu-ji. From the stereobate and foundation stones, we see that the hall was a three-bay-altar-space structure furnished with double eaves and that it was connected by L-shaped corridors to a bellhouse and a sutra repository, both three-bay-square buildings on the banks of the pond. To the northwest of the Golden hall was a lecture hall, comprising a three-bay altar space surrounded by aisles, with double eaves on the façade. This

159. Aerial view of site of Kan Jizaio-in from northeast, with site of Motsu-ji in upper right.

building was unusual in that the stereobate was sheathed in wood instead of the commoner stone. East of the Golden hall and to the east of the present Jogyodo, a lotus- and a *jogyo*-meditation hall were aligned north and south. Five-bay-square halls—that is, three-bay altar spaces plus aisles— these buildings had verandas on all four sides and a connecting corridor, like the lotus and *jogyo* halls in the West Compound of the Enryaku-ji (Fig. 9). Unlike the latter, however, these were not equal in size: the *jogyo*-meditation hall was larger, although whether this was due to the requirements of ritual or to differences in the dates of construction is difficult to say. The *Azuma Kagami* mentions only the *jogyo* hall, so it may be that the lotus hall was not built until after 1185–90.

In the western part of the precincts was another building, the Kasho-ji. The surviving high stereobate and large foundation stones indicate that it was a hall of a three-bay altar space plus aisles, with double eaves like the Golden hall, but considerably grander in scale. The hall was plank floored, probably with broad verandas on all four sides and wing corridors to right and left. The ground at the southern ends of the corridors has been so disturbed that it is impossible to determine whether there were other buildings, such as a bellhouse or sutra repository. (See foldout opposite page 113.)

This arrangement of a Golden hall with wing corridors, bellhouse, and sutra repository situated beyond a large excavated pond with an artificial islet, and a main gate opening across the pond, had already been begun at the Chuson-ji; but the design of the Motsu-ji, due to its flat location, was much grander in scale. Indeed there is a strong suspicion that the portion from the South Main Gate to the Golden hall was modeled after the Hossho-ji in Kyoto; but unlike the Hossho-ji, where the Golden hall enshrined Dainichi, at the Motsu-ji the main object of worship in the Golden hall was Yakushi. Yakushi was also the focus of the Kasho-ji, the last temple raised by Motohira, and probably indicates the direction of his personal beliefs.

THE KAN JIZAIO-IN. At the Kan Jizaio-in, the traces of a large pond with an islet and the rockwork on its banks are well preserved in paddy fields. Recent excavations have revealed many details that, in conjunction with the account in the *Azuma Kagami,* enable us to form a clear picture of the appearance of the site at the time of the temple's foundation. (See foldout opposite page 113.) The outer gate at the south edge of the precincts was a simple structure of two uprights, and all trace of the South Main Gate near the pond seems to have disappeared. Traces of the bridges to the front and rear of the islet have not been found. The rockwork near the waterfall on the western bank employs the largest garden rocks in Hiraizumi, while the small pebbles used in the submerged strand at the north of the east bank are painstakingly arranged. On the north bank of the pond was the Greater Amida Hall, of a one-bay altar space plus aisles, which may have had double eaves, and to its east was the seven-by-three-bay Lesser Amida Hall. Both faced south. A stone finial that probably graced the roof of the Greater Amida Hall is extant. Between the two halls have been discovered traces of a small square pond, its bottom covered with rounded stones. If we go by the usage of Kyoto, it would appear that this was a residential quarter, the Greater Amida Hall being the liturgical hall and the Lesser Amida Hall the residence. The east bank of the pond bears traces

of two buildings, traditionally held to be a Fugen hall and a bellhouse. In front of the South Main Gate of this temple several dozen hectares of ground were laid out with rows of warehouses and dozens of imposing buildings, while on the western edge of the precincts, between the Kan Jizaio-in and the Motsu-ji, were dozens of garages for noblemen's vehicles, attesting to Hiraizumi's importance as the trading hub for the "six remote districts" at the end of the twelfth century.

THE MURYOKO-IN. At the Muryoko-in, the surrounding physical features, the pond and islet, and traces of the buildings are well preserved. Further details have been revealed in excavations conducted in recent years. (See foldout opposite page 113.) This temple faced east toward the Nekoma-ga-fuchi bank on a site to the south of the present Takadachi palace. The earth excavated for the large pond was used to form high embankments at the east and west borders of the precinct. Entering the East Main Gate, one crossed a long bridge to the first islet and a shorter bridge to the second, on which stood the main hall with wing corridors to right and left. No trace, however, remains of the pilings for the bridges to the islets. The main hall, a three-bay square with double eaves on all sides, was virtually identical in style and scale with the Phoenix Hall of the Byodo-in, and the wings were even longer, indicating Hidehira's determination to leave a monument in no way inferior. On the islet in front of the main hall the remains have been discovered of a chapel comprising a one-bay altar space with aisles on three sides, and in front of it, a subsidiary building and two free-standing corridors. Since we know from the petition of 1334 that there was a stage in front of the Chuson-ji Golden Hall, it is possible that this chapel also served as a stage and that the two corridors accommodated musicians. The *Azuma Kagami* indicates that there should also be a three-story pagoda.

Hidehira, taking a leaf from the book of his father, Motohira, whose Motsu-ji was modeled on the Hossho-ji in Kyoto, had decided to make a copy, with certain structural modifications, of the Phoenix Hall of the Byodo-in, which had been built more than a century before. The Shokomyo-

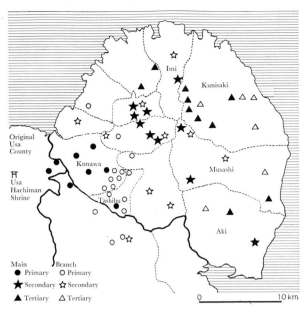

160. *Map of Rokugo temples, adapted from* Bungo Takada-shi Shi *(A History of the City of Bungo Takada).*

in too, built forty years earlier at Toba by the retired emperor of that name, was a copy of the Byodo-in; and Regent Tadamichi, who inscribed the gate tablet of the Shokomyo-in, is reputed to have done the same for Motohira's Motsu-ji. It is an interesting speculation, given the connections linking them, that the retired emperor Toba and Tadamichi may have influenced the Hiraizumi Fujiwaras in the founding of the Muryoko-in.

SUBSIDIARY TEMPLES. Both the Chuson-ji and Motsu-ji had under them a considerable number of subsidiary temples. A list appearing in the petition of 1334 enumerates the Ganjoju-in and Ruriko-in, each enshrining a *joroku* Yakushi; the Joju-in, Shakuson-in, and another Joju-in, with Shaka triads; the Yakujuo-in, with Yakushi and Kannon; the Kosho-in and Bussho-in, each with a *joroku* Amida and Yakushi; the Kongo-o-in, with Dainichi in his Diamond World; the Daikyo-o-in, with wooden images of the buddhas of Both Worlds of Dainichi; as well as the Senju-in and the Taisha-kudo. Although the buildings have undergone ren-

ovations, a number of images made in the twelfth century are still in their original form, and these will be brought together for safekeeping when the intended repository, the Sanko-zo (meaning "storehouse in praise of the three Fujiwara rulers"), is completed. The images and sutras contained in the Konjikido and the repository, as well as the stately tranquillity of the architecture itself, are a fitting monument to the efforts of the three generations of the Hiraizumi Fujiwara family to absorb and even rival the Buddhist culture of Kyoto in the period of government by retired emperors.

INFLUENCE OF HIRAIZUMI CULTURE. In due time the glory of the three generations of the Hiraizumi Fujiwara reached other regions of northern Japan. In what are now Miyagi and Fukushima prefectures, more than a hundred miles south of Hiraizumi, there are two temples particularly deserving attention as twelfth-century examples of the cultural influence of Hiraizumi. They are the Amida halls of the Kozo-ji in Takakura, Kakuda, Miyagi Prefecture, and the Ganjo-ji at Shiramizu in Iwaki, Fukushima Prefecture. Tsunekiyo, father of Fujiwara no Kiyohira, had one of his strongholds in Watari, which bordered Kakuda on the east, an indication of the great age of the ties between this region and the Fujiwaras.

After the Earlier Nine Years' War, Kiyohira's mother was remarried to Arakawa Takesada of the House of Kiyohara. Takesada was succeeded by Sanehira, his son by his first wife. Sanehira adopted Kaido Narihira. In the meantime, a girl was born to Minamoto no Yoriyoshi and the daughter of Takè Munemoto, governor of the province of Hitachi. Since she was the younger sister of Yoshiie, he gave her to Kiyohira to be brought up as the latter's own child, and in 1083 Kiyohira obtained Yoshiie's agreement to betroth her to Narihira. Narihira by then had become a powerful lord ruling five districts, including Iwaki, one of which he passed on to each of his children. When Narihira was killed in the Later Three Years' War, his wife, it is said, took vows under the name Tokuni and founded the Ganjo-ji at Shiramizu. A fifteenth-century copy of the ridgepole plaque of the Ganjo-ji tells us that she built an Amida hall in 1160

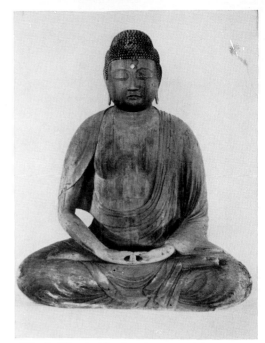

161. Buddha Amida. Wood; height of image, 83.9 cm. Twelfth century. Fuki-dera Great Hall, Oita Prefecture.

and that the ceremony installing the Buddhist images was held in the seventh month of that year. But since Yoriyoshi died in 1075 at the age of eighty-seven, it is inconceivable that his daughter could have survived until 1160. Thus it seems that to accept the date 1160 would necessitate excluding the possibility that the temple was founded by Narihira's wife. The Iwaki Fudoki, a chronicle of the area compiled sometime between 1661 and 1672, has it that Tokuni was Hidehira's younger sister and that he gave her in marriage to Taira no Takayuki, later called Narihira, with the district as her dowry. This would make the 1160 dating acceptable, but it conflicts with the known dates of Narihira, who was a contemporary of Hidehira's father, Motohira. One way or another the records appear to be in error.

An Edo-period chronicle describes the Ganjo-ji as having a stream to the east, paddy fields to the

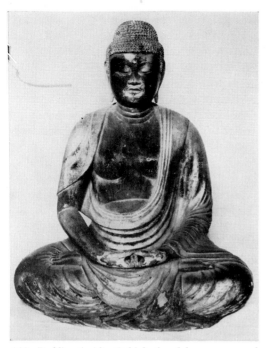

162. Buddha Amida. Gold leaf and lacquer on wood; height of image, 87.5 cm. Twelfth century. Fuki-dera Priests' Quarters, Oita Prefecture.

south, a great road to the west, and Mount Kyozuka to the north, down which poured two cataracts. Edo-period maps and the present lay of the land, however, reveal that the site was closely ringed with hills on the east, west, and north, and that there were more hills at some distance southward. The temple was set on a small flat and, like the ruined temples of Hiraizumi, had a large pond with an islet, on which was built an Amida hall. Excavations conducted in recent years have revealed traces of the pond and of rockwork. (See foldout opposite page 113.)

This hall, also called the Shiramizu Amida Hall (Figs. 111, 112), comprises a one-bay altar space and four aisles, with the pillars of the *moya* and of the aisles aligned. It resembles the Konjikido in that the altar is set somewhat toward the rear of the *moya,* and the construction of the enclosing wooden walls and doors in them is similar. Traces of color

still remain on the pillars, walls, beams, and transoms within.

The images enshrined on the altar—Amida making the *gosho* mudra (Fig. 113), two attendant bodhisattvas, and two guardians—are original, and Amida's mandorla and pedestal too are well preserved. The Amida's posture is different, but the treatment of the garments is close to that of the main images on the central and the right (north) altars of the Konjikido. The two attendants also show points of similarity to those on the three altars of the Konjikido. The two guardians are clearly of the same type as those on the Konjikido central altar and seem to have been copied from the latter. The probability that the images of Hiraizumi and Ganjo-ji were made by sculptors of the same school is so great that it was thought in the Edo period that they were the work of one artist or even that the Ganjo-ji itself was inspired by a dream of the Amida at Hiraizumi.

According to the ridgepole plaque of 1667, quoted in the *O-U Kanseki Bunro-shi,* a chronicle of Mutsu and Dewa compiled in 1719, the Amida hall of the Kozo-ji (Fig. 116), in Takakura, was originally built by Hidehira's wife in 1177. Like the Konjikido and the Ganjo-ji Amida Hall it is composed of a one-bay altar space and surrounding aisles, with aligned pillars. Construction is simple, employing the simplest method of bracketing. The *joroku* Amida (Fig. 115), originally the main image, dates from the twelfth century, and its robust physique and coarse curls bespeak the influence of a style predating Jocho.

TEMPLES AND IMAGES OF THE KUNISAKI PENINSULA

THE USA HACHIMAN SHRINE. One ancient myth holds that Prince Tsunuka Arashito of the southern Korean kingdom of Okara crossed the seas to Japan in pursuit of a beauty who had been transformed from a sacred stone and who later became the goddess of two Shinto shrines in Japan named the Himekoso Shrines: one in Kunisaki County, Oita Prefecture, in northeastern Kyushu, and one in Naniwa (present-day Osaka). Without going so far as to accept the assertion that

the Kunisaki Himekoso Shrine was located on the small island of Himeshima off the north coast of the Kunisaki Peninsula, we can see from this tale that from the earliest times connections existed between Kunisaki, the southwestern terminus for shipping in the Inland Sea, and Naniwa, the eastern terminus, and that there was contact with foreign cultures. Not long after Buddhism was introduced to the Yamato court in the sixth century, tradition has it that the high priest of Toyokuni (Oita Prefecture) was summoned to the palace, where Emperor Yomei (r. 585–87) lay ill, to preach the Buddhist law and gain his recovery. This event indicates that Buddhist influence in this area was very old.

About the time of this priest's summons to the Yamato court, legend has it, another important Shinto deity, Hachiman, made his appearance in Usa. The Usa Hachiman Shrine, traditionally reputed to have been founded during the reign of Emperor Kimmei (r. 539–71), was moved several times until established on its present site in 725, during the Nara period. The Miroku-ji was built in 738 as its tutelary temple. In 737 the court informed the Hachiman Shrine, as well as the Sumiyoshi and Kashii shrines in what is now Fukuoka Prefecture, of an insult suffered at the hands of the Korean kingdom of Silla. In 740, appointing Ono no Azumabito as commander to suppress the rebellion of Fujiwara no Hirotsugu (c. 710–40), an officer at Dazaifu, the court made a special appeal to the Hachiman Shrine for prayers of intercession. The year after the rebellion was quelled, the court expressed its appreciation with the gift of a crown of gold brocade; the *Konkomyo Saisho-o-kyo* (Sutra of the Golden Light) in ten scrolls, written in gold and wound on red sandalwood sticks; the *Lotus Sutra* in eight scrolls; eighteen candidates for the priesthood; land for twenty households; and five horses. The court also built a three-story pagoda, the East Pagoda, for the Miroku-ji, which was completed in 743; but it was not until later that the three-story West Pagoda was built.

As this historical sketch shows, from the time of the Hirotsugu rebellion a close relationship existed between the Hachiman Shrine and the imperial court. The tie was strengthened in 749 when, charged by an oracle to be guardian deity of the casting of the colossal buddha statue for Nara's Todai-ji, Hachiman is said to have extended his influence to Nara, the capital. The chief priestess Omiwa Morime accompanied Empress Koken (r. 749–58) and her parents in carrying out the prayer rituals for the Todai-ji. At that time, court ranks were bestowed on Hachiman and the goddess Hime, and the following year the two deities together were deeded land for 1,400 households and 140 hectares of paddy fields, the perquisites of their rank. This was a great improvement in the fortunes of the Hachiman Shrine when compared to its rural origins before 740. In 767 it was decided to build a tutelary temple for Hachiman's consort Hime over the next four years, and if this project went as planned, the Hachiman Shrine would have boasted two tutelary temples, something absolutely without precedent. As the Heian period dawned, Hachiman, the Shinto deity, had "Great Bodhisattva" added to his appellation, further showing the shrine's extremely intimate relationship with Buddhism.

THE TEMPLES OF ROKUGO. In Rokugo (the Six Districts) in Kunisaki there were a total of twenty-eight main temples, graded as primary, secondary, and tertiary, and thirty-seven branch temples belonging to them. They are enumerated at length in a list compiled in 1167 and included in the *Dazai Kannai-shi* (Records of the Dazaifu Jurisdiction; 1804–41). Another list, prepared in 1228 and also included in the *Dazai Kannai-shi,* shows some discrepancies: one treated as a secondary main temple in the 1167 list is here given as a tertiary main temple; a tertiary main temple as a secondary main temple; and a tertiary branch temple also as a secondary main temple. Moreover, one of the secondary main temples is now designated the union, or general, temple. At any rate, the eight primary main temples were clustered closest to the Usa Hachiman Shrine, with most of their branches to their east. The ten secondary main temples and their branches lay to the north or farther east and for the most part occupied the center of the peninsula. The ten tertiary main temples and their

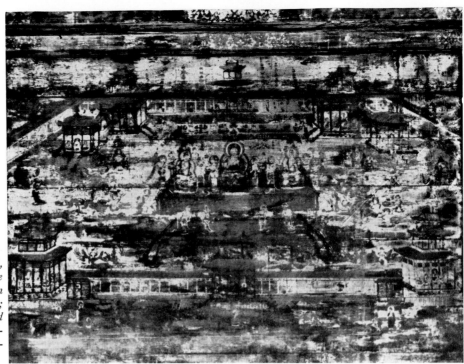

163. Amida's Pure Land, painting on reredos of image of Buddha Amida. Colors on wood; height, 165.4 cm.; width, 228.8 cm. Second half of twelfth century. Fuki-dera Great Hall, Oita Prefecture.

branches were the most remote, located farthest north and east on the peninsula. The map (Fig. 160) suggests a geographical separation of the three classes of main temples, but they overlap and no precise boundaries can be drawn. Assuming the continued expansion of Buddhist culture from Usa, one might be tempted to conclude that the primary temples were founded first, followed by the secondary and tertiary temples in that order, but in fact only a minority bear out this hypothesis. There must have been many internal factors leading to periodic revisions in rank before compilation of the 1167 list.

THE FUKI-DERA GREAT HALL. The Great Hall of Fuki-dera (Figs. 122, 123, 129, 130) in Oita Prefecture consists of a one-bay altar space and four aisles, but in order to leave a greater space for the front aisle, where worshipers would stand, the pillars in the side walls were set in such a way as to make four equal bays. As a result the plan of the

building is somewhat greater in depth than in breadth, and the front pillars of the *moya* do not align with the pillars in the outer walls. Because of this plan there are no tie beams joining the *moya* and aisle pillars, and the traditional open-timbered roof over the aisles has been dispensed with in favor of the new lattice-style ceiling. The plan of this hall differs from the older style of aligned pillars, exemplified by the Konjikido and other three-bay halls throughout northern Japan; it represents a clear advance over the two three-bay halls at the Kakurin-ji—the Taishido (1112), with extended eaves on the façade, and the Jogyodo, in which the extended eaves were continued into the interior space of the building itself. Improving even on the plan achieved by the Sanzen-in Main Hall (c. 1148), with the four side bays of equal width and square pillars for the aisles, at the Fuki-dera the two front pillars of the *moya* are out of alignment with the side pillars. This indifference to alignment of

164. *Adoring bodhisattvas, detail from painting on upper part of east wall of Fuki-dera Great Hall. Height of entire painting, 29.7 cm. Twelfth century. Oita Prefecture.*

the *moya* and aisle pillars became very popular in the Kamakura period. The provision of a ceiling over the aisles, a feature added to the Ganjo-ji Amida Hall only centuries later, was approximated in the Kakurin-ji Jogyodo, but the Jogyodo is thought to have been built considerably later than the Taishido. (See foldout opposite page 152.)

It would seem reasonable, judging by this kind of construction technique, to place the founding of the Fuki-dera Great Hall at just after the middle of the twelfth century—not too long before 1168, when we encounter mention of this temple in a reliable record. This accords with a judgment expressed in the notes to *Fuki-dera no Hekiga* (Fuki-dera Murals), published by the Bijutsu Kenkyujo (Art Research Institute) in 1938, which was based on painting styles.

The altar in the *moya* now enshrines a single Amida, but another Amida of virtually identical style and size (Figs. 161, 162), with two attendants, is now enshrined in the priests' quarters. Until completion of a repair project (1912–13) both Amidas

stood on the Great Hall altar, so that we can no longer be sure which was the original main object of worship. We can confirm, however, that both show the placid and benign features of the Jocho style, and the physique and garments of the two attendants in particular evoke the attendant images on the central altar of the Konjikido, and emphasize the fact that the Jocho style of sculpture had permeated every remote corner of Japan.

The interior decoration comprises Esoteric paintings on the *moya* pillars; fifty seated figures of Amida on the walls above these pillars; a *jodohen* (Fig. 163) on the front surface of the reredos and figures of the Thousand-armed Kannon and the Twenty-eight Protectors of Buddhism on the rear surface; and groups of buddhas and bodhisattvas on the walls above the side pillars (Fig. 164). The light, clean outlines of these well-preserved group pictures, filled out with light shading, have achieved a rare elegance of form, and the coloring of the floral patterns on the beams and transom of the *moya* is also very fine.

TITLES IN THE SERIES

Although the individual books in the series are designed as self-contained units, so that readers may choose subjects according to their personal interests, the series itself constitutes a full survey of Japanese art and will be of increasing reference value as it progresses. The following titles are listed in the same order, roughly chronological, as those of the original Japanese editions. Those marked with an asterisk (*) have already been published or will appear shortly. It is planned to complete the English-language series in 1976.

The "weathermark" identifies this book as a production of John Weatherhill, Inc., publishers of fine books on Asia and the Pacific. Supervising editor: Akito Miyamoto. Book design and typography: Meredith Weatherby. Layout of illustrations: Akito Miyamoto. Production supervision: Yutaka Shimoji. Composition: Kenkyusha Printing Co., Tokyo. Engraving and printing of color plates: Nissha Printing Co., Kyoto, and Benrido Printing Co., Kyoto. Monochrome letterpress platemaking and printing and text printing: Toyo Printing Co., Tokyo. Binding: Makoto Binderies, Tokyo. The typeface used is Monotype Baskerville, with hand-set Optima for display.